SPECTACULAR HOMES
of South Florida

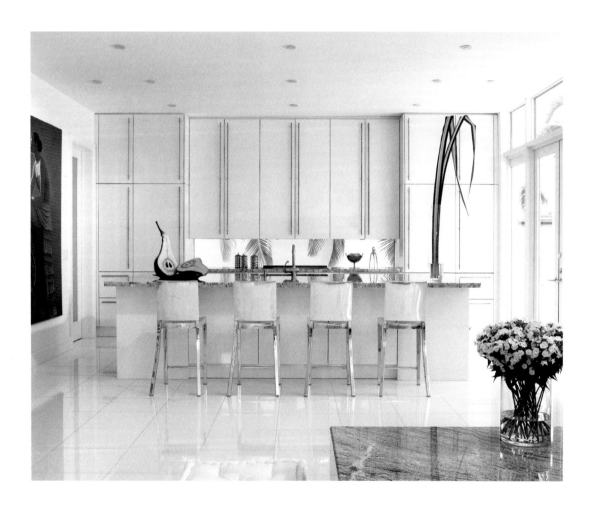

AN EXCLUSIVE SHOWCASE OF SOUTH FLORIDA'S FINEST DESIGNERS

Published by

13747 Montfort Drive, Suite 100
Dallas, Texas 75240
972-661-9884
972-661-2743
www.panache.com

Publishers: Brian G. Carabet and John A. Shand

Printed in Malaysia

Distributed by Gibbs Smith, Publisher
800-748-5439

PUBLISHER'S DATA

Spectacular Homes of South Florida

Library of Congress Control Number: 2004117269

ISBN Number: 978-0-9745747-5-2

First Printing 2005

10 9 8 7 6 5 4 3 2 1

On the Cover: Tui Pranich, Tui Pranich Associates
See page 55 *Photo by Troy Campbell*

Previous Page: Alexandra Karram, Alexandra Karram Interiors, Inc.
See page 35 *Photo by Joe Lapeyra*

This Page: Rodney Harrrison, Rodney Harrison Design Associates
See page 81 *Photo by Dan Forer*

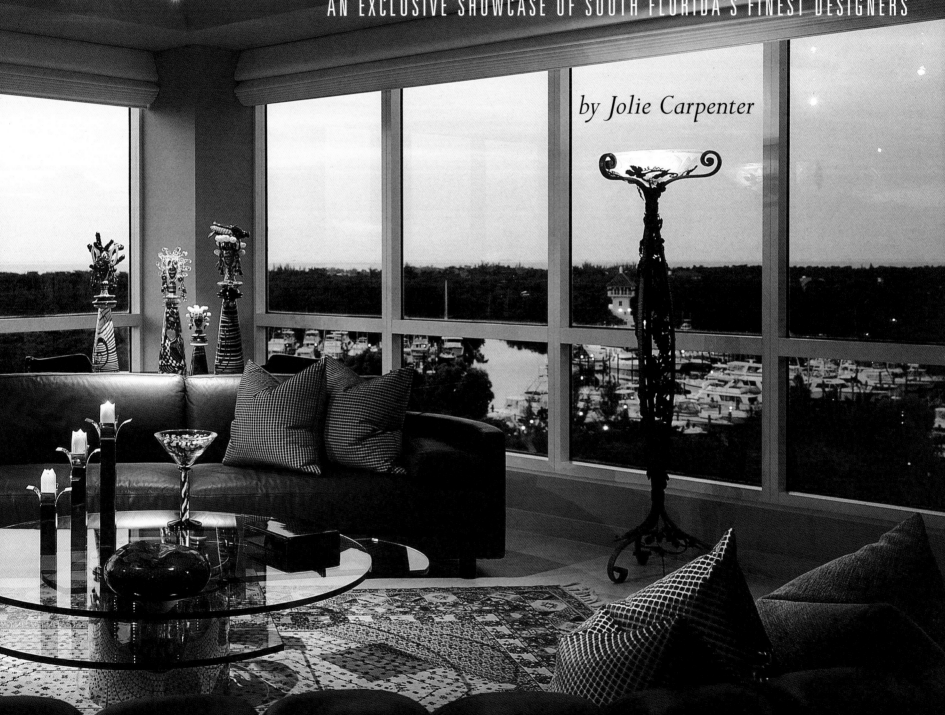

SPECTACULAR HOMES
of South Florida

AN EXCLUSIVE SHOWCASE OF SOUTH FLORIDA'S FINEST DESIGNERS

by Jolie Carpenter

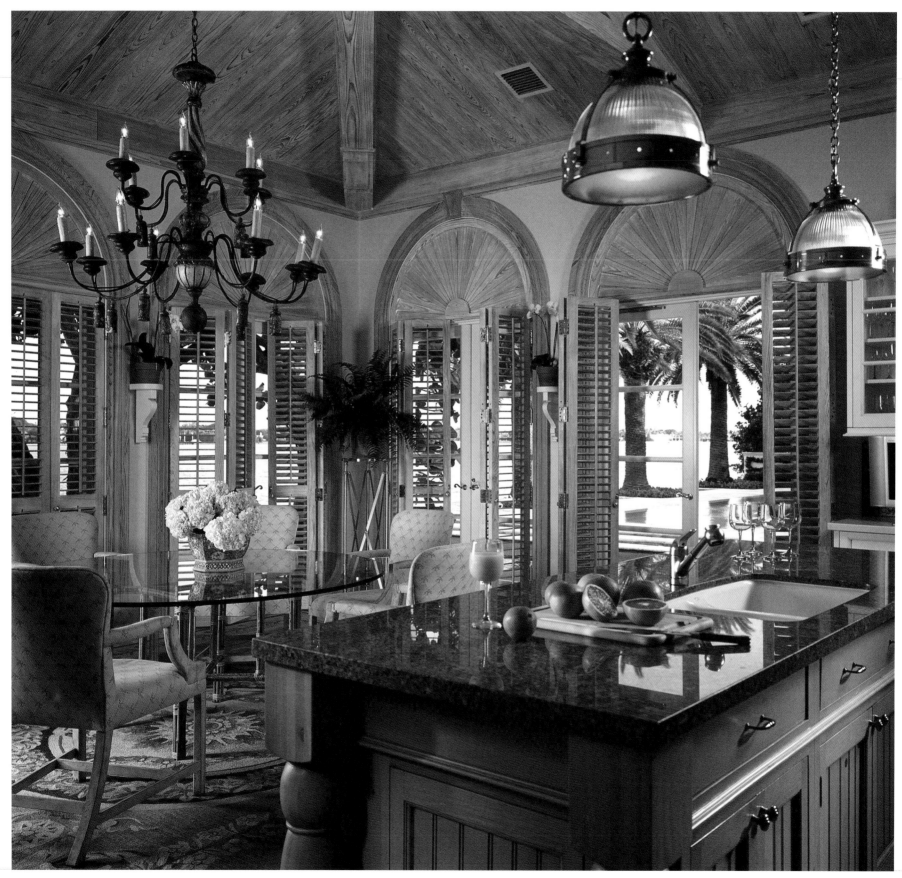

Introduction

A spectacular home is as subjective as our individual love of art, music, even one another. Understanding and appreciating the contribution of all of these things in our lives is what *Spectacular Homes of South Florida* has meant to me. Interior design and the professionals that create the extraordinary spaces we live in, love in and ourselves create in, are showcased in this very special collection.

Being in high-end publishing for over 15 years and a native of South Florida, the endeavor of creating *Spectacular Homes of South Florida* was a perfect match. As most who know me would agree, there is little I do without passion and conviction. I truly believe in a passion for living that should reflect in all we do and who and what we surround ourselves. Discovering and in some cases reuniting with these amazingly gifted individuals was a true labor of love for me and that passion for what each of these designers create is reflective throughout these pages.

With the Atlantic Ocean and beautiful beaches as the backdrop, the pages that follow feature some of the most magnificent homes and express the unique lifestyle that South Florida has to offer as well as the breathtaking talent and vision of the designers who have touched them. From the mansions of the Palm Beaches, to the oceanfront condos of South Beach, to our own "Venice of America" in Ft. Lauderdale…our relatively small coastal communities are vast and rich in diversity. That diversity is well represented in the artistic endeavors of those we have showcased.

My thanks to everyone who has been a part of this journey and made it yet another great adventure. Many thanks to our production team for your tireless efforts in making this book all that it is. I would also like to personally thank my family and friends, especially Brian, Troy, Ashley and Mom for your support and all my love to John, Peter and my little Elle.

If one picture is worth a thousand words, I invite you to enjoy this "novel" of inspiration.

Beth Benton

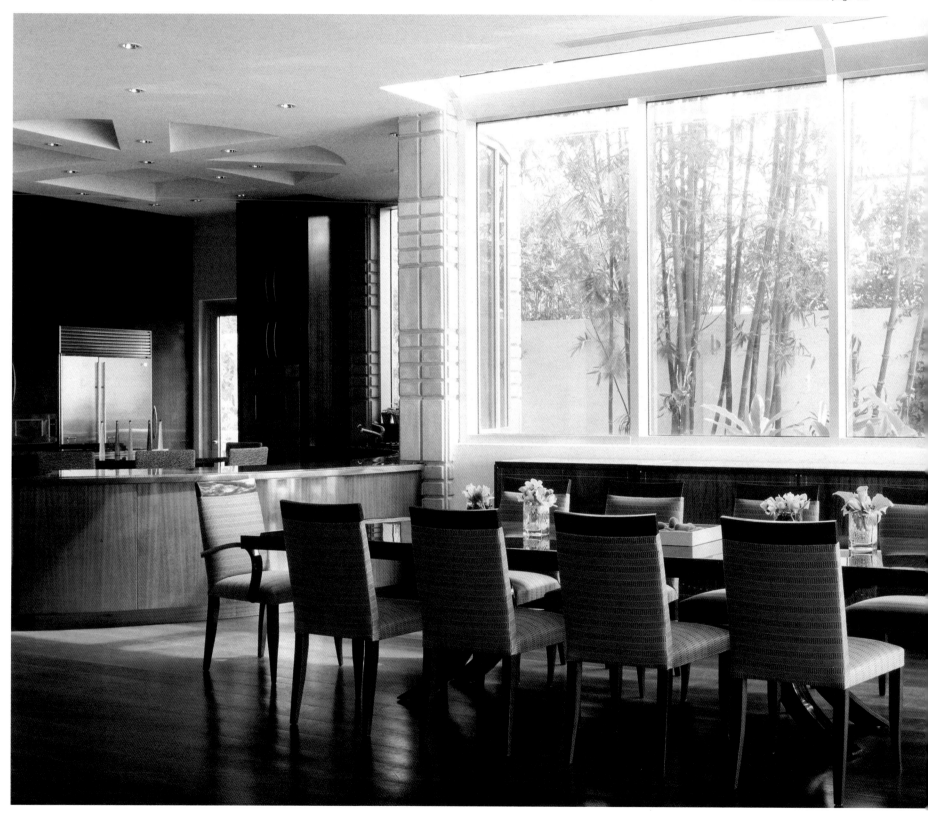

Table of Contents

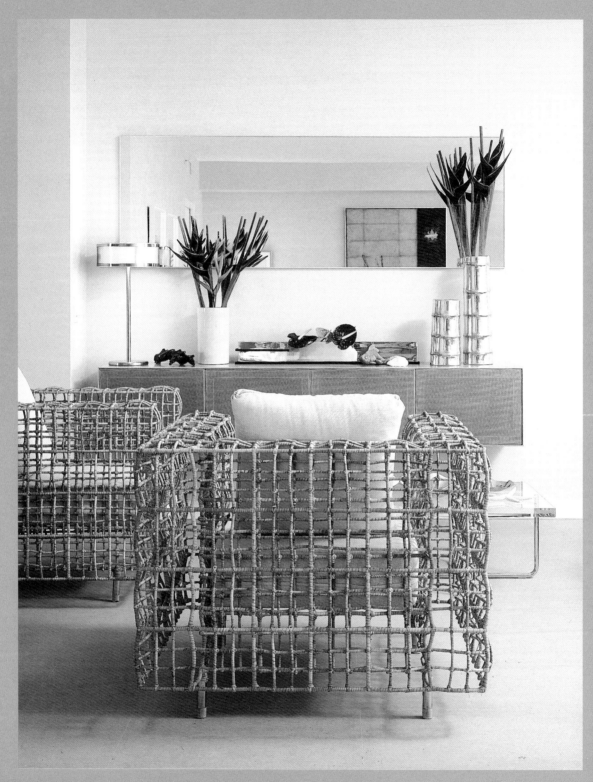

The Palm Beaches

CHAPTER ONE

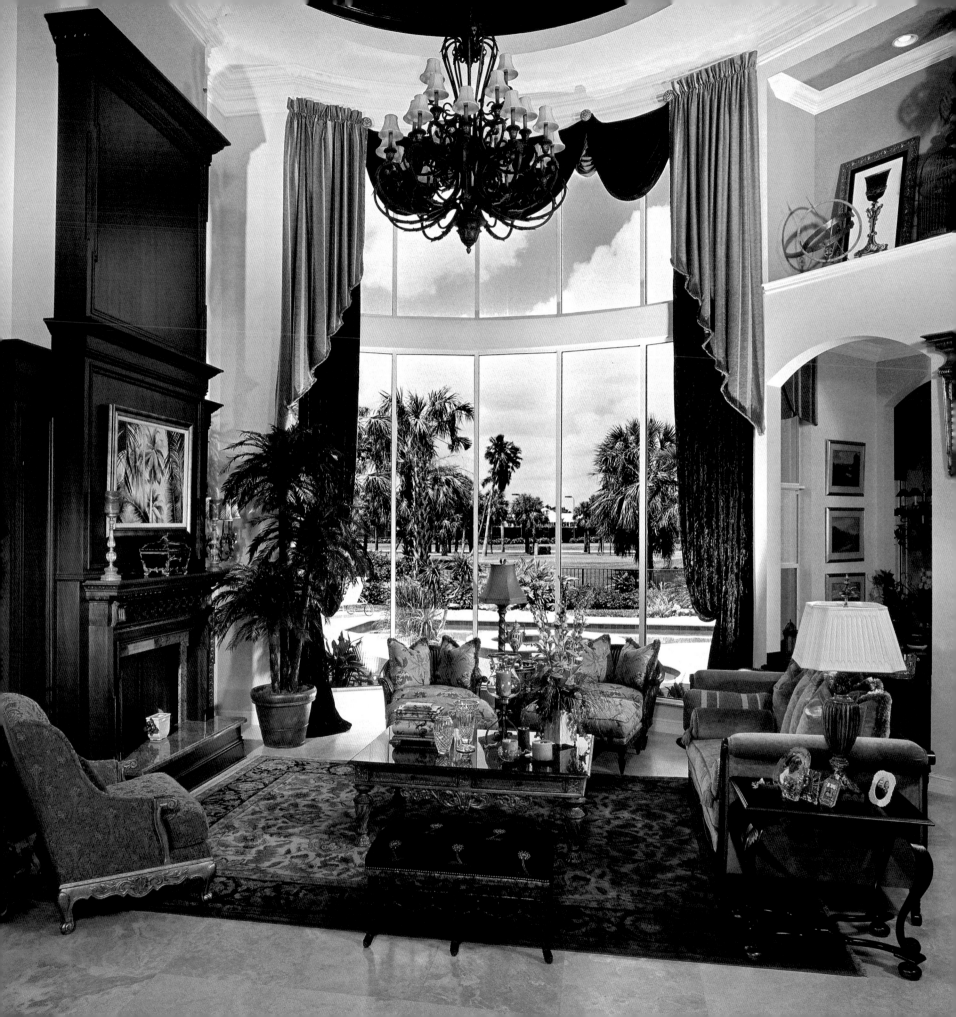

jeffrey bellfy
and noreen sachs

Jeffrey Sachs Design, Inc.

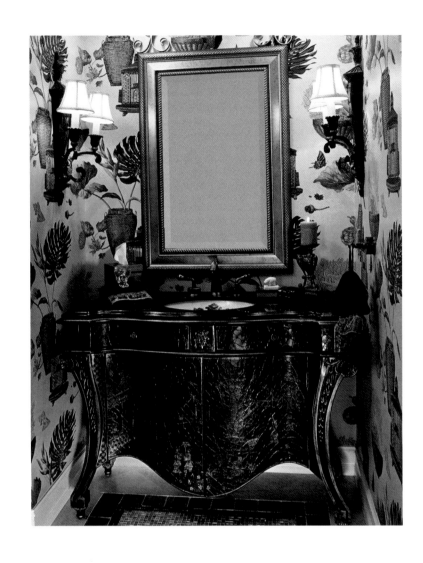

After years of working at separate companies, interior designers Jeffrey D. Bellfy and Noreen Sachs decided to coalesce their talents, passion and experience and open one of the most successful interior design firms in Florida, Jeffrey Sachs Design, Inc.

For these two able designers, it is a match made in heaven, as they aren't just business partners, they are also husband and wife. Each with their individual styles and experiences, their partnership provides opportunities to design diverse traditional, contemporary, and eclectic spaces for all clients.

Jeffrey began working in the industry at 16 years old in the warehouse of Pierson Interiors, an upscale interior design firm. In 1979, he opened his own firm to exercise his own ideas and sold it when he relocated to Florida. Noreen earned a bachelor of fine arts degree majoring in both interior design and ceramics and graduated magna cum laude from the University of Michigan School of Art and Architecture. After graduation, she started her career with Smolen Design Associates in Southfield, Michigan, and then Direct Interiors Design Group in Florida.

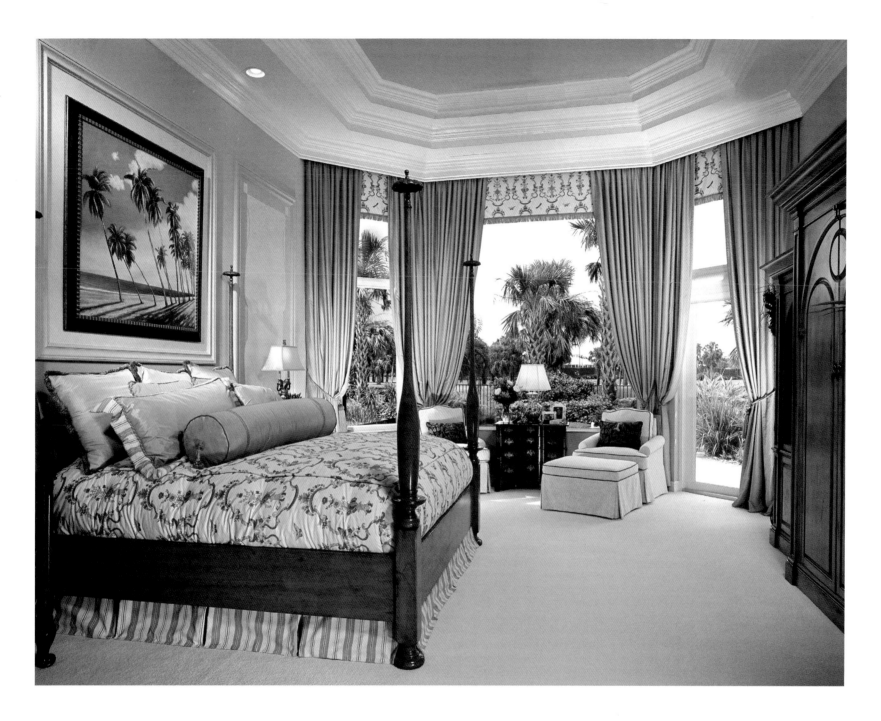

Jeffrey and Noreen crossed paths professionally while in Michigan, where they often teamed on projects while at separate firms. A few years later, they made a lifetime commitment to each other, moved to Florida and in 1995 opened the doors to Jeffrey Sachs Design, Inc.

Strictly a word-of-mouth design firm, they have had many celebrity and high-end clientele. Jeffrey's strong background in history and architecture and Noreen's creative artistic ability helps the duo create unique designs that are timeless and classic. Diligent and dedicated designers, the pair completes each job seeing it through to the finest detail, making certain the client is as happy as they are with the final product. To that end, they give their clients their maximum effort and their extensive library of resources and tools to implement the final result.

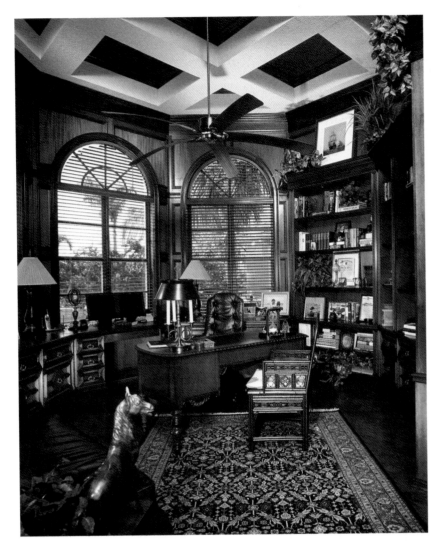

FACING PAGE
A warm toned four poster bed with carved finials is a soft accent against a serene celadon, with hand painted panels flanking the bed. A custom designed television/armoire opposite the bed is fauxed in an antiqued celadon rubbed finish. Smooth side panels and valances enhance the window to soften the large expanse, but do not interfere with the view beyond. The painting above the bed is reminiscent of the South Florida tropical landscape.

TOP LEFT
Jeff and Noreen designed this octagonal library in solid mahogany in two tones. Traditional in design, it is both functional and aesthetically pleasing, giving the owner a sense of warmth and security. Wood clad flat panel walls, with applied molding and custom arched wood trims the arched windows. A raised coffered ceiling is molded with crown to match the cabinetry below and enhanced by an iridescent burgundy grass cloth.

TOP RIGHT
The seating area is focused on a custom designed entertainment wall unit that is designed to appear as an old retro fit European cabinet. Retractable full height doors open to reveal a flat screen television and pull-out pilasters open to house tapes, CDs, DVDs and stereo equipment. Lighted stained glass transom doors allow natural light to diffuse through during the day and create a warm amber glow after dark. Natural raffia applied on the coffered ceiling adds color and texture. Tomlinson sofas covered in deep chocolate chenille and red fleur-de-lies pillows add punches of color that are repeated in the Harden bar chairs covered in Robert Allen petit point bar stools. A large Century cocktail table services the two sofas and two Bradington Young leather lounge chair and ottomans.

Jeffrey Sachs Design, Inc.
Jeffrey D. Bellfy
Noreen Sachs
630 U. S. Highway One
Suite 101
North Palm Beach, FL 33408
561-863-3325
FAX 561-863-3326

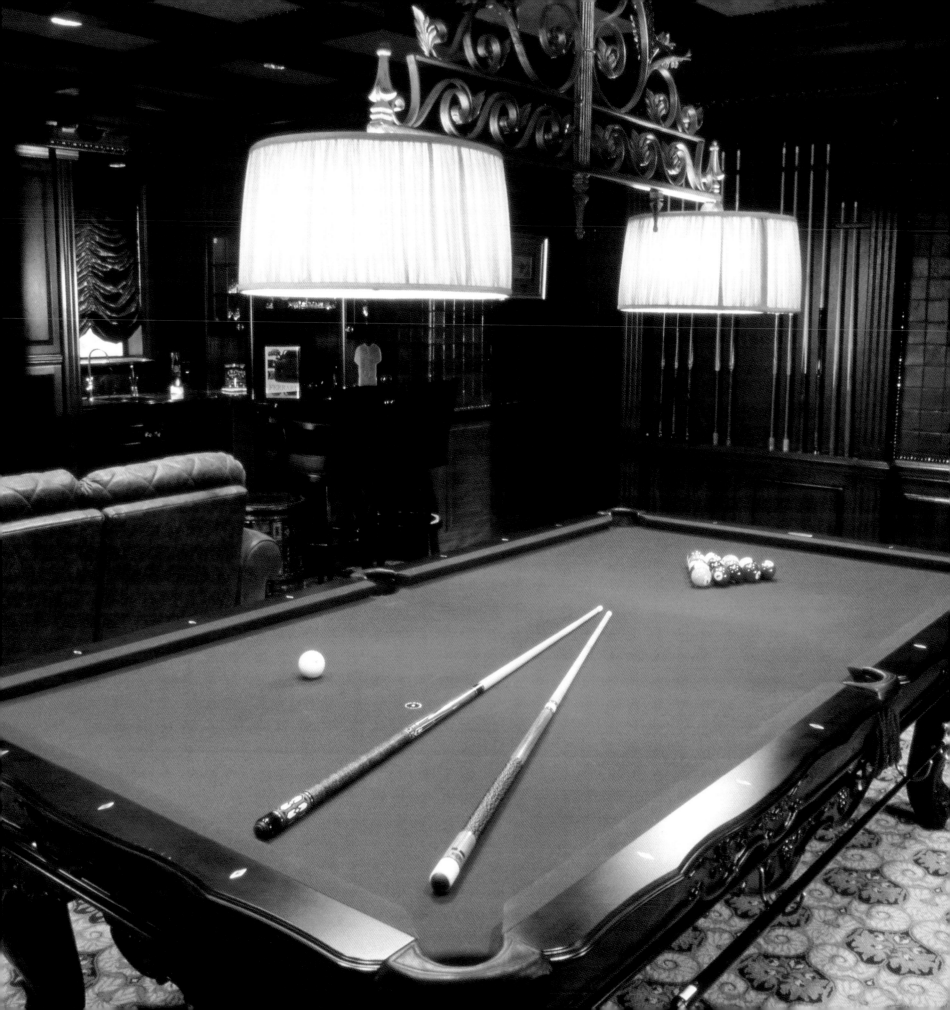

christine
and roy brown
Museo

LEFT
Enjoy an old world retreat in this Gentlemen's Billiard Room decorated with mahogany and leather walls, a classic pattern rug, and velvet curtains.

ABOVE
Read the paper and relax or entertain friends with a beautiful casual dining experience.

Christine and Roy Brown discovered how compatible their personalities and design philosophies are while working together at a small residential firm in Boca Raton. With his background in industrial design and her artistic strength, they decided to merge their complementary skills and start their own firm. They founded Museo five years ago, and today, business is thriving.

Theirs is a true partnership. Roy has a degree in industrial design from Auburn University, where he studied with Drs. Schaer and Pfeil,

both of whom had trained at the Bauhaus. Christine studied art education at American University, has a design degree, and participated in Harvard's study abroad program. The husband-and-wife team works together on every project and their clients benefit from the depth of expertise and knowledge they provide.

Museo specializes in single-family custom designed houses from Jupiter down to Fort Lauderdale. Roy and Christine regard each project as the beginning of a new

relationship—after all, many of them last at least two years—and they take great care to establish a congenial rapport with their clients. As a matter of fact, a number of their clients have become their friends over the years.

Christine and Roy are known for classic designs; homes that stand the test of time. Whether tailored transitional or traditional style, the Browns use fine fabrics, furnishings, art, and their clients' own personal objects to create homes that are casually elegant. Roy's exceptional technical skills were put to the test when he designed a house for a quadriplegic in which everything was controlled by voice command, touch screen computer, and infrared remote. The opportunity to apply cutting-edge technology was very exciting to Roy; the opportunity to significantly enhance his client's quality of life was even more exciting.

Roy and Christine own a design store that is brimming with Italian handcrafted furniture, elegant glassware, hand-painted dishes, and a wealth of decorative pieces by local artists. The meticulously designed pieces in the Museo store embody the Brown's emphasis on quality and craftsmanship; values that are at the heart of their interior design work.

16

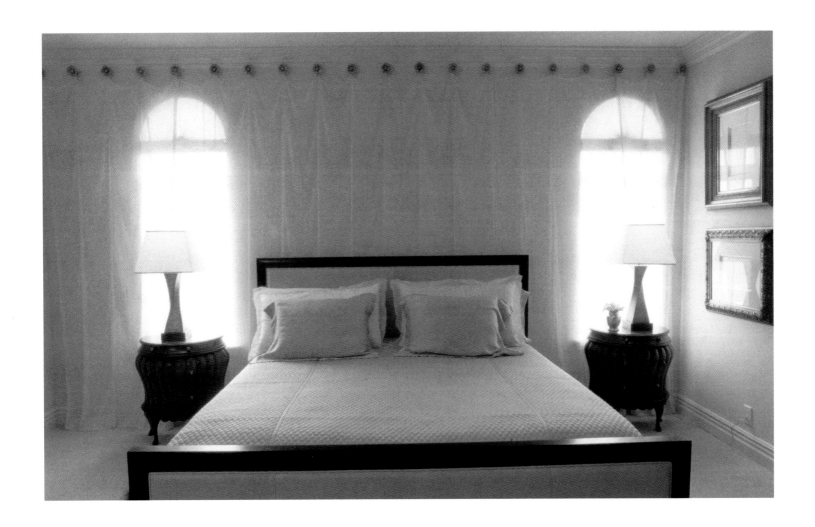

More about Christine and Roy…

FOR CHRISTINE AND ROY, WHAT IS THE MOST REWARDING ASPECT OF BEING AN INTERIOR DESIGNER?

With his background in industrial design, Roy savors the experience of transforming an idea or a concept into reality. Christine finds it rewarding to create for her clients a space that reflects their personal style; that makes them feel as if they've truly come home.

WHAT SINGLE ELEMENT BRINGS A HOUSE TO LIFE?

Interesting paint finishes or art work.

WHAT PERSONAL INDULGENCE DO CHRISTINE AND ROY SPLURGE ON?

As the parents of a one-year-old, they have a heartfelt appreciation of spas, and, especially, of massages!

WHAT ARE SOME DESIGN TECH-NIQUES CHRISTINE AND ROY HAVE USED IN THEIR OWN HOME?

Like many designers, they feel their home is a work in progress. They are currently experimenting with blurring the line between outdoors and indoors through the installation of fountains, garden sculptures, outdoor lighting, and outdoor rugs.

WHAT IS ONE OF ROY'S MOST UNIQUE ACHIEVEMENTS?

In 1988, Roy won the Borg-Warner Design Award for designing a sewing machine. Singer manufactured and sold Roy's design.

Museo
Christine and Roy Brown
Christine and Roy Brown, IDSA, IDS
157 Pineapple Way
Delray Beach, FL 33444
561-274-9700
www.museoshop.com

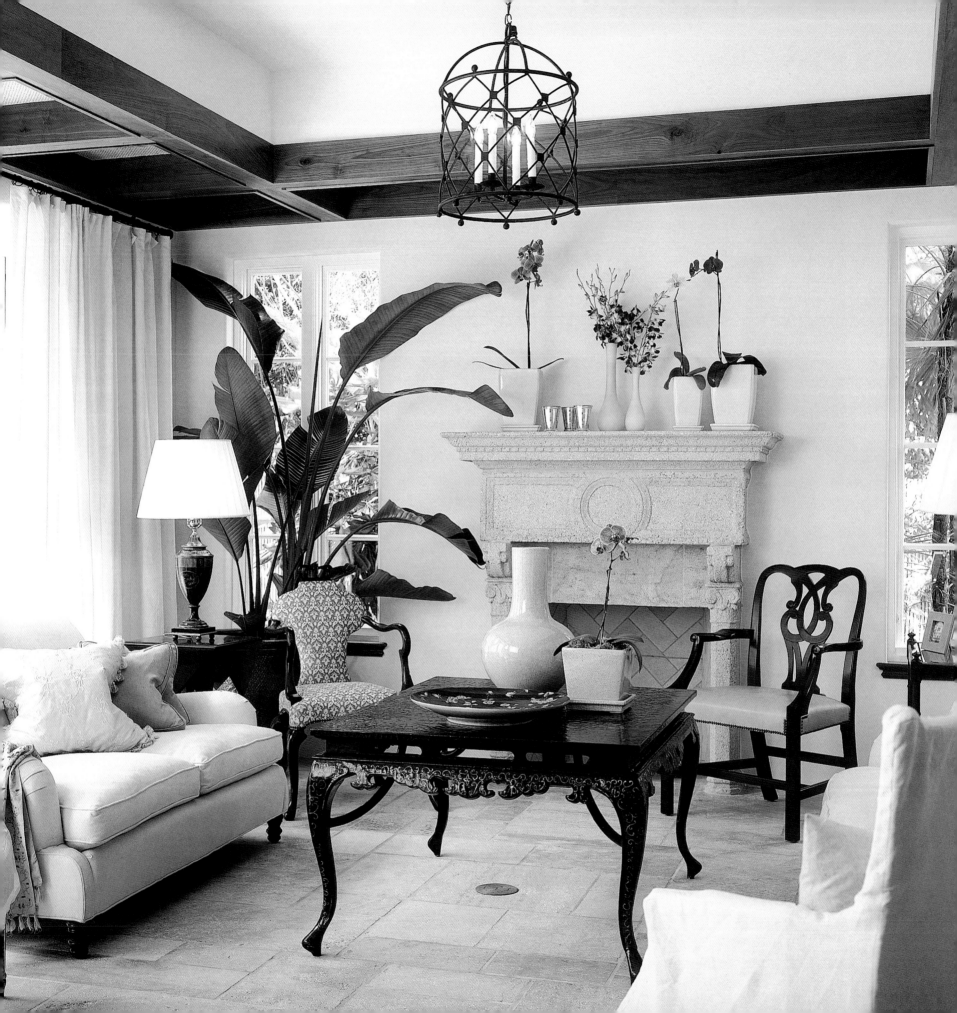

eddy doumas
and lisa kanning
Worth Interiors

Over five years ago, Lisa Kanning and Eddy Doumas met at a Colorado design firm. At the time, Eddy was a 13-year industry veteran who enjoyed designing attractive backdrops for the homeowner's furniture and partnering with architects to bring design at a home's inception. Lisa, a passionate, energetic designer, savored the opportunities to furnish homes and create lasting, ongoing relationships with clients.

Recognizing each other's hardwork and creative talents, as well as the breadth of experience and diversity they could provide to their own clients, the pair ventured out and formed Worth Interiors in Vail. Business boomed and they were in great demand, leading to another office in Palm Beach, where Lisa had daydreams of working in the morning and heading to the beach in the afternoon. Fortunately, success struck again and Worth Interiors has been thriving ever since, proving a truly successful partnership, although leaving no time for the beach. "Lisa takes her professional life seriously and gets very

involved with clients and totally immersed in projects," said Eddy.

"Working with Eddy has been inspirational," said Lisa. "The traits he has described are things I've learned from him."

Also inspired by the architectural vision of David Adler and Addison Mizner—their Palm Beach office is in a Mizner-designed building—and design icons Andree Putnam and David Hicks, the team reinterprets classic styles and updates them according to a client's lifestyle.

Their projects range from the historic preservation of a 1922 Chicago estate to a contemporary renovation of an ocean side house in Vero Beach and the construction and furnishing of a Mediterranean style home in Palm Beach, and an extensive roster of projects nationwide. While Eddy works in Vail and Lisa in Florida, they still enjoy the opportunity to team up on projects in the Northeast, where they are being awarded more and more work. Because their offices are located in resort locations, many clients are eager to reinterpret the design experience in their primary residences. "There's a comfort level when you've worked on some-one's home already," said Lisa.

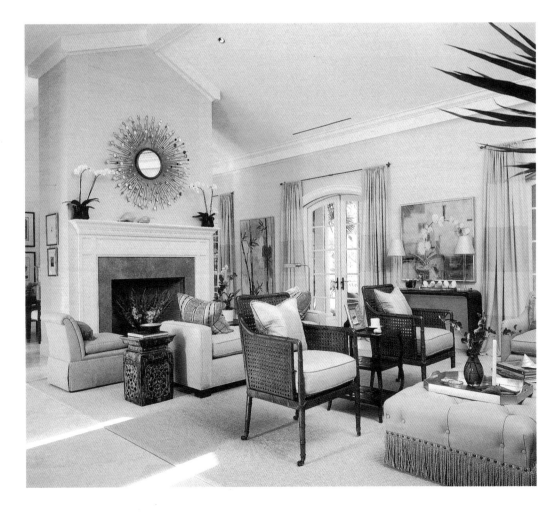

Whether it's traditional or contemporary, Lisa and Eddy prefer a cleaner sensibility in design. "That may mean neutrals or softer colors on larger upholstered pieces and bolder colors in pillows, accessories and art. Colorful rugs also help ground a room. Scale and proportion are also crucial when designing a pared down interior," explains Lisa.

Worth Interiors' designs have been featured in *Florida Design, House Beautiful* and *Architectural Digest*.

More about Eddy and Lisa…

WHAT IS THE HIGHEST COMPLIMENT THAT EDDY AND LISA HAVE RECEIVED?

Lisa says the praise from a satisfied client is always the most rewarding. She recently completed a residence on the ocean in Vero Beach and the client walks around chanting, "I love my house." She explains, "You can't beat that!" Eddy says that the highest compliment is when a client rehires the team for a second or third project.

WHAT PERSONAL INDULGENCES DO YOU SPEND THE MOST MONEY ON?

Lisa's weakness is shoes and Eddy loves to travel.

WHAT ONE ELEMENT OF STYLE OR PHILOSOPHY HAS EDDY AND LISA STUCK WITH FOR YEARS THAT STILL WORKS TODAY?

Less is more. The layering of a room is important; one must know when to quit.

WHAT ONE SINGLE THING WOULD LISA DO TO BRING A DULL HOUSE TO LIFE?

Lisa finds that adding a grasscloth wall covering makes a big difference. The texture creates an interesting backdrop for all types of furnishings whether they are traditional or contemporary.

Worth Interiors - Florida
Lisa Kanning
90 Via Mizner
Worth Avenue
Palm Beach, FL 33480
561-655-1101
FAX 561-655-0515

Worth Interiors - Colorado
Eddy Doumas
30 Benchmark Rd #103
Avon, CO 81620
970-949-9794
FAX 970-949-4252
www.worthinteriors.com

lisa erdmann
Lisa Erdmann & Associates

As the daughter of a successful real estate developer in South Florida, Lisa Erdmann literally grew up with blueprints and site plans. Independently minded, she decided to apply her myriad talents to the creative side of the business.

Lisa started her award-winning design career working for Donghia Furniture/Textiles in New York City, where she rose to the position of Director of Product Development by age 25. After working for an Upper East Side home furnishings start-up, Lisa's own entrepreneurial spirit led her to return to Florida and open her boutique firm in 1994.

Today, Lisa Erdmann & Associates has enjoyed more than a decade of success. Her firm works on such diverse projects as elegant private residences, high-end builder's spec homes, yachts, corporate offices and a variety of hospitality installations. The firm offers full-service interior design, space planning and project management, with experience in both in-depth renovations and new construction.

Lisa works closely with her clients to ascertain their vision, needs and dreams, and the possibilities are endless. She is committed to her clients and their satisfaction and will do what it takes to ensure their dreams come true—from walking them through the decorating process to scouting for the perfect furnishings in the market stalls of London and Paris. For Lisa, however, the most rewarding part of her job is the installation—when she can watch the culmination of the client's dreams and her firm's vision and hard work come to life.

Having completed projects in New York, the Caribbean and throughout many of the most prestigious areas in South Florida, the firm's tremendous success is based on their collective design expertise, access to worldwide resources and a determined belief in client satisfaction. Lisa's firm has been noted for its excellence locally, regionally and nationally, including numerous design awards and publication in many leading design and lifestyle magazines.

From the beginning to the end of a project, Lisa's generous experience and all those years spent pouring over blueprints and plans, maximize the client's experience and ensure a unique, sophisticated and livable design.

BELOW LEFT
Hidden in an exclusive golf and beach enclave, this home's master bedroom exudes a crisp, inviting atmosphere. Sea breeze blue faux finished walls and applied molding treatments complement the wonderful mix of colors and patterns in the Brunschwig & Fils drapery and custom bedding.

BELOW RIGHT
A hand-painted antique chest sits below framed hand-colored turtle prints, and coordinates beautifully with the creative mix of two lovely silver palm tree candlesticks and an antique French iron container holding a leopard orchid.

RIGHT
Rich colors and patterns enhance the old world feel of the family room in an estate home designed for a client in the Bear's Club.

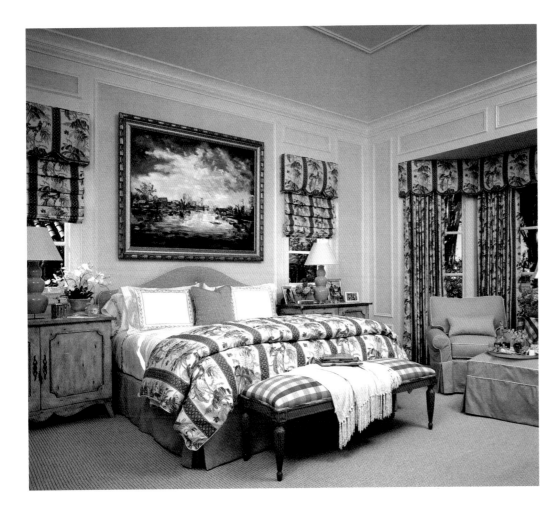

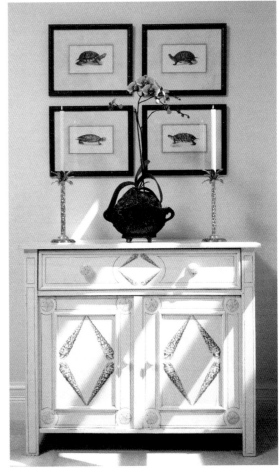

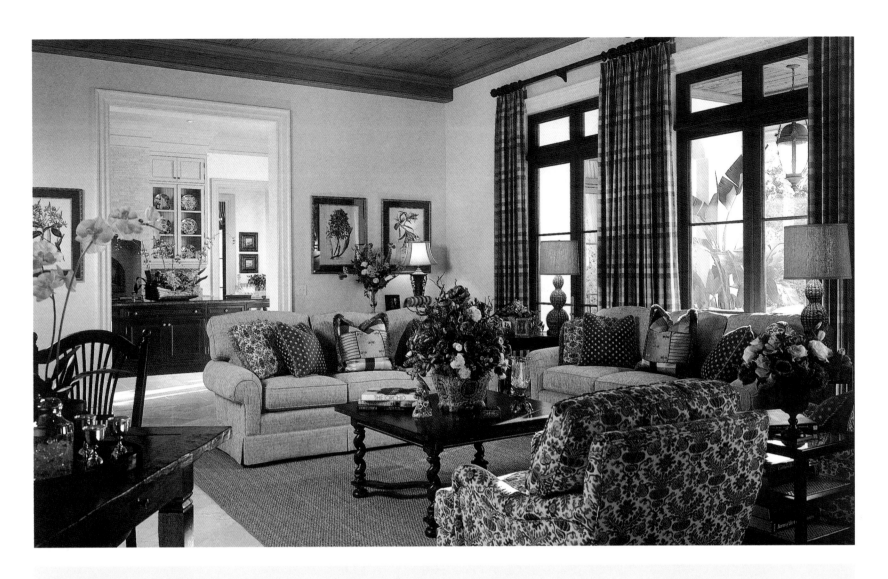

More about Lisa…

WHAT PERSONAL INDULGENCES DO YOU SPEND THE MOST MONEY ON?

She loves antiques and paintings and finds them irresistible sometimes, especially when they have amazing character. Recently, she has been purchasing accent tables, hall chairs and a gothic pew for a client. She also found a fabulous French armoire for a master bedroom.

WHAT SINGLE THING WOULD YOU DO TO BRING A DULL HOUSE TO LIFE?

If she could only pick one thing, it would be paint. She loves crisp "off-white" moldings with a contrasting wall color and Dove White ceilings.

WHAT ONE ELEMENT OF STYLE OR PHILOSOPHY HAVE YOU STUCK WITH FOR YEARS THAT STILL WORKS FOR YOU TODAY?

She likes to mix rich and beautiful textiles with interesting and antique furniture. For instance, textiles should have a great hand, and a piece of furniture with a great shape adds so much style to a room. She also believes antique pieces with great character lend that character to the room.

Lisa Erdmann & Associates
Lisa Erdmann
777 South Flagler Drive
Suite 116
West Palm Beach, FL 33401
561-833-9009
www.lisaerdmann.com

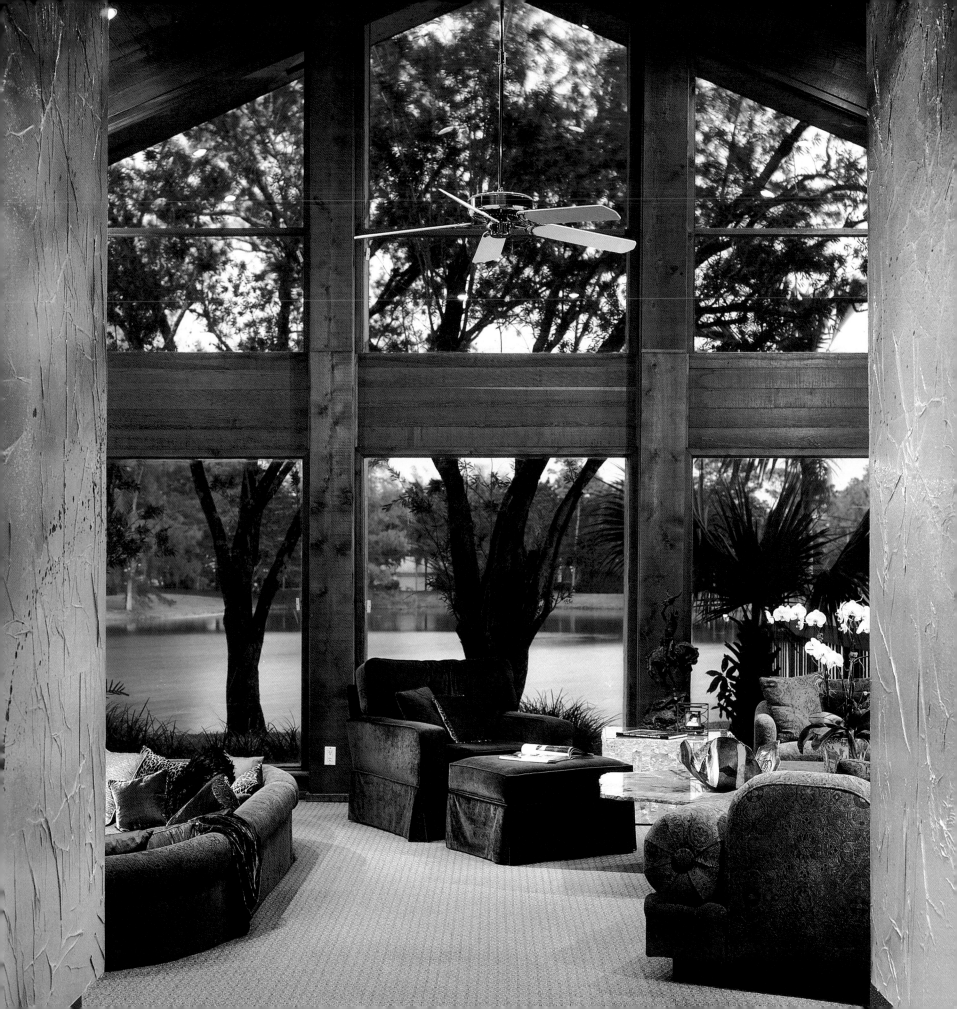

nancy feldman
The Art of Placement, Inc.

Nancy Feldman grew up surrounded by creativity. Her dentist/sculptor father and singer mother bought old homes in Massachusetts that they restored with the help of craftsmen from around the world—and with the help of their young daughter. From a very early age, Nancy went antiquing with her parents to furnish these homes and was involved in decisions of remodeling such as plastering and wall treatments. She was brought up to believe anything was possible, and brings this positive attitude to her work as an interior decorator today.

Based in Boca Raton and working with a team of talented artisans from all fields, Nancy's firm, The Art of Placement, Inc., offers her clients a wide range of services. From one-day makeovers to large-scale interior projects, they offer design service packages that are tailored to her clients' needs. One of her personalized services is the 48 Hr. Move-in, in which Nancy and her crew place the furniture, hang all the art, and provide the new home-owners with a list of recommended additions she can procure and install for them, if they choose. For one client who was moving from

overseas, she even put an outgoing message on their answering machine and had champagne chilling in a bucket to welcome them home.

Nancy involves her clients in the process from the inception of a project, so she invites them to meet in her home office suite. They can walk through her home—an eclectic blend of contemporary art, Asian and African artifacts, saturated color, and overstuffed chenille couches—to get a sense of her personal style and to get ideas for their own homes. While she loves an interesting mix, Nancy doesn't have a signature style in her work, preferring to take her cue from her clients. Whether it's creating a cozy Kasbah-like feel in a studio

apartment or a sleek, elegant interior for a contemporary home, she learns what her clients like and makes it happen.

An Allied member of ASID, Nancy has been an interior decorator for 20 years. Before opening The Art of Placement, she and her husband renovated and resold homes, apartments, and condos. Starting her own design firm was the natural next step. The Art of Placement has been open for eight years, and—true to Nancy's family legacy of creativity—her five-year-old granddaughter has already made it clear she wants to join Nancy someday in the business.

More about Nancy…

WHAT IS THE MOST UNUSUAL DESIGN ELEMENT NANCY HAS USED IN A PROJECT?

In collaboration with a bachelor client, she hung 100-pound model airplanes from the 20-foot-high ceiling of his formal living room.

WHY DOES NANCY LIKE DOING BUSINESS IN FLORIDA?

Florida attracts people from all over the world. It's fascinating to work with such a diverse clientele.

WHAT IS THE MOST BEAUTIFUL OR IMPRESSIVE HOME NANCY HAS SEEN IN FLORIDA?

Villa Viscaya in Miami is unsurpassed—it makes her believe in miracles.

WHAT PERSONAL INDULGENCE DOES NANCY SPLURGE ON?

Nancy enjoys fine dining.

The Art of Placement, Inc.
Nancy Feldman
20938 Pacifico Terrace
Boca Raton, FL 33433
561-479-2290

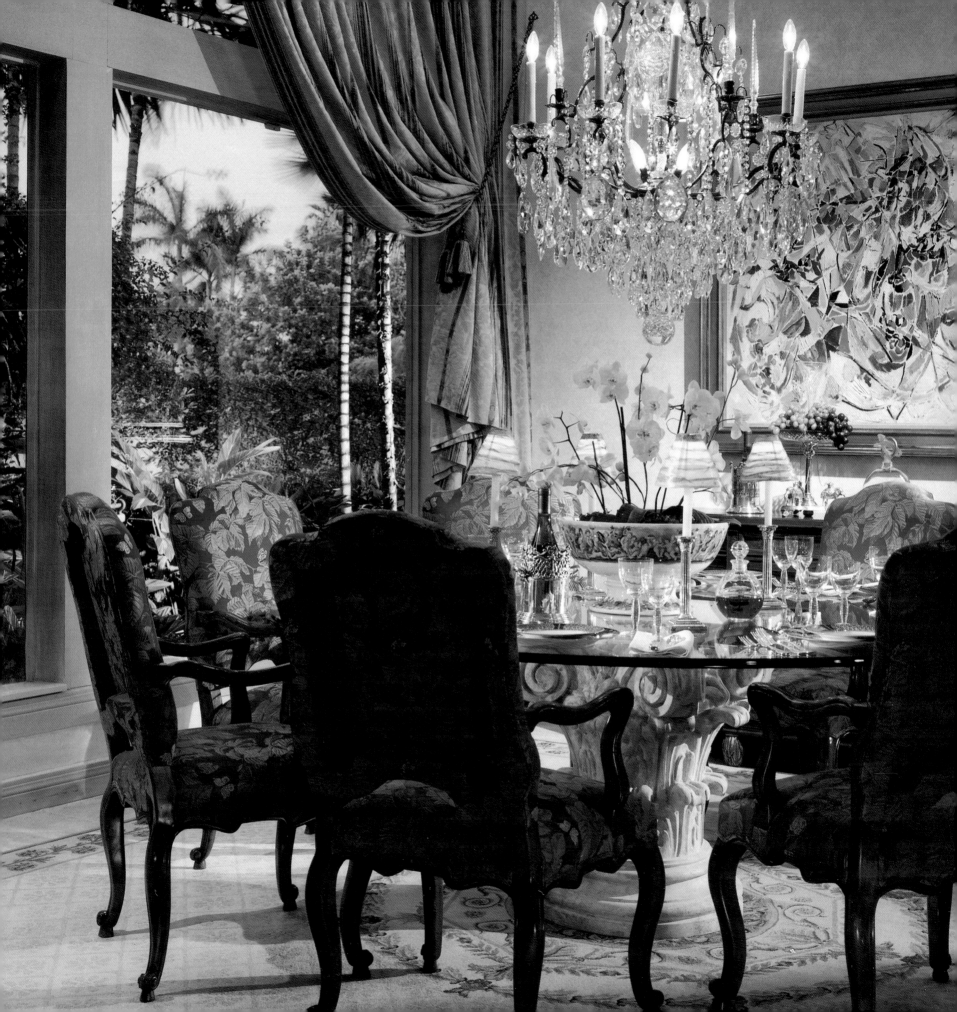

judy howard
J/Howard Design Inc.

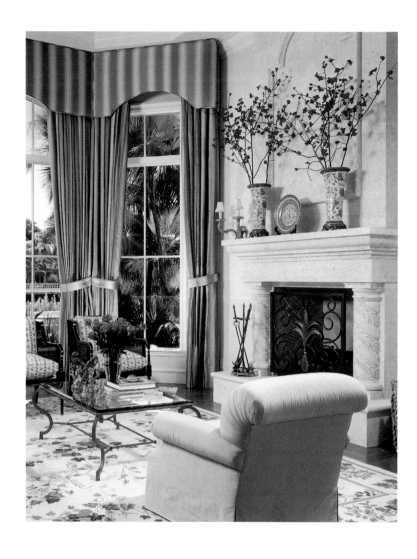

Originally, Judy Howard planned to be an art professor. She went to art school at the University of Colorado where she took an intensive course load of fine art, interior design, and architecture classes. During a break after graduation, she designed a friend's home and Judy hasn't looked back since.

In interior design classes, she instantly gravitated to Sister Parish's signature style of couture effortlessly blended with comfort; to the unexpected touch of a quilt tossed over a sofa in a formal living room to create a look as welcoming as it is beautiful. The quality of the acclaimed designer's work resonated deeply with Judy, and today, J/Howard Design Inc. has earned a reputation for designs that are chic, classic, and comfortable.

Based in Delray Beach, Judy, a Florida state licensed designer, is listed in the international edition of *Who's Who in Interior Design* and has been seen in *Architectural Digest*, *Veranda* magazine, and *The New York Times*. She also has been featured in *Florida Design*, among other publications. She has worked

with many of her clients for over 20 years, designing for some of them four, five, and six homes worldwide. She establishes a close connection with them, building a bond of trust that makes the design experience a thoroughly enjoyable one—both for her client and herself. She and the five-person staff at J/Howard Design Inc. take a very individualistic approach to each project, learning what their clients want and then transforming their wishes into reality.

Judy is fascinated by the idiosyncrasies of each job and welcomes the opportunity to create one-of-a-kind solutions. For one of the country's top collectors of 1960s and 1970s art, Judy choreographed the entire home design around the art collection. To keep the focus on the art, Judy installed streamlined furniture in

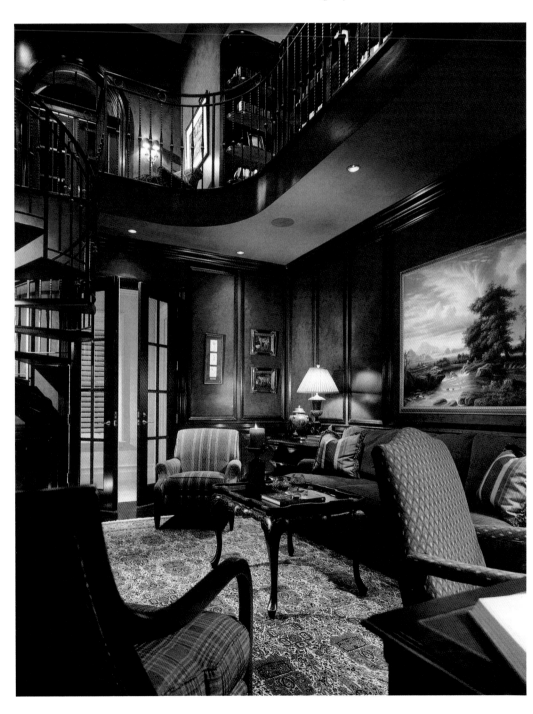

a neutral color palette ranging from ivory to medium brown. The furnishings she selected were of the highest quality with clean, lyrical lines, and superb, unembellished woodwork. State-of-the-art lighting highlighted the art as the focal point of the room.

With many of her clients returning to home entertaining after a long hiatus—a trend she embraces wholeheartedly—Judy is often faced with the challenge of designing formal dining rooms and living rooms that get heavy use. Using sumptuous fabrics as beautiful as they are durable, she designs stunning rooms for living. While each job is vastly different from the next, certain values remain constant, and for Judy, quality and comfort are at the top of the list.

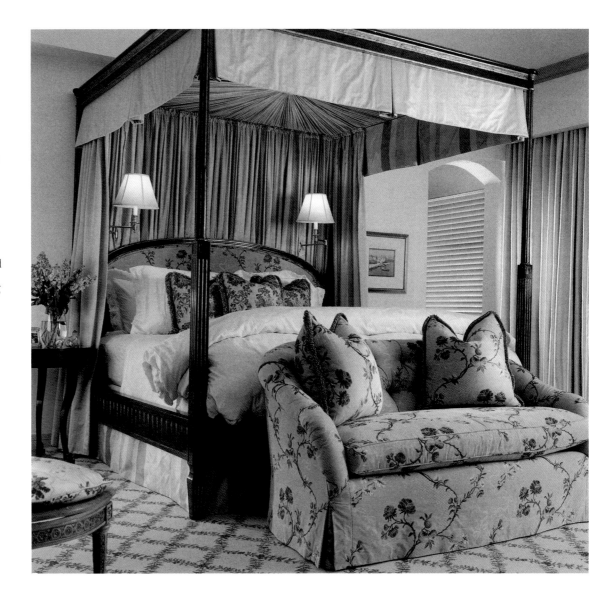

More about Judy…

WHAT PHILOSOPHY HAS DESCRIBED JUDY'S WORK OVER THE YEARS?

She emphasizes quality, honesty, and service.

WHAT ARE SOME OF JUDY'S FAVORITE THINGS IN HER OWN HOME?

Judy accessorizes with things she has collected throughout her life—cherished objects from her parents and her travels. She has an extensive paperweight collection, and loves orchids.

IF JUDY COULD ELIMINATE ONE DESIGN STYLE FROM THE WORLD, WHAT WOULD IT BE?

Victorian.

WHAT DOES JUDY ENJOY DOING, WHEN SHE'S NOT WORKING?

She loves to cook and enjoys fine wine and travel.

J/Howard Design Inc.
Judy Howard, ASID, NCIDQ
25 Seabreeze Avenue
Delray Beach, FL 33483
561-274-9354
www.jhowarddesign.com

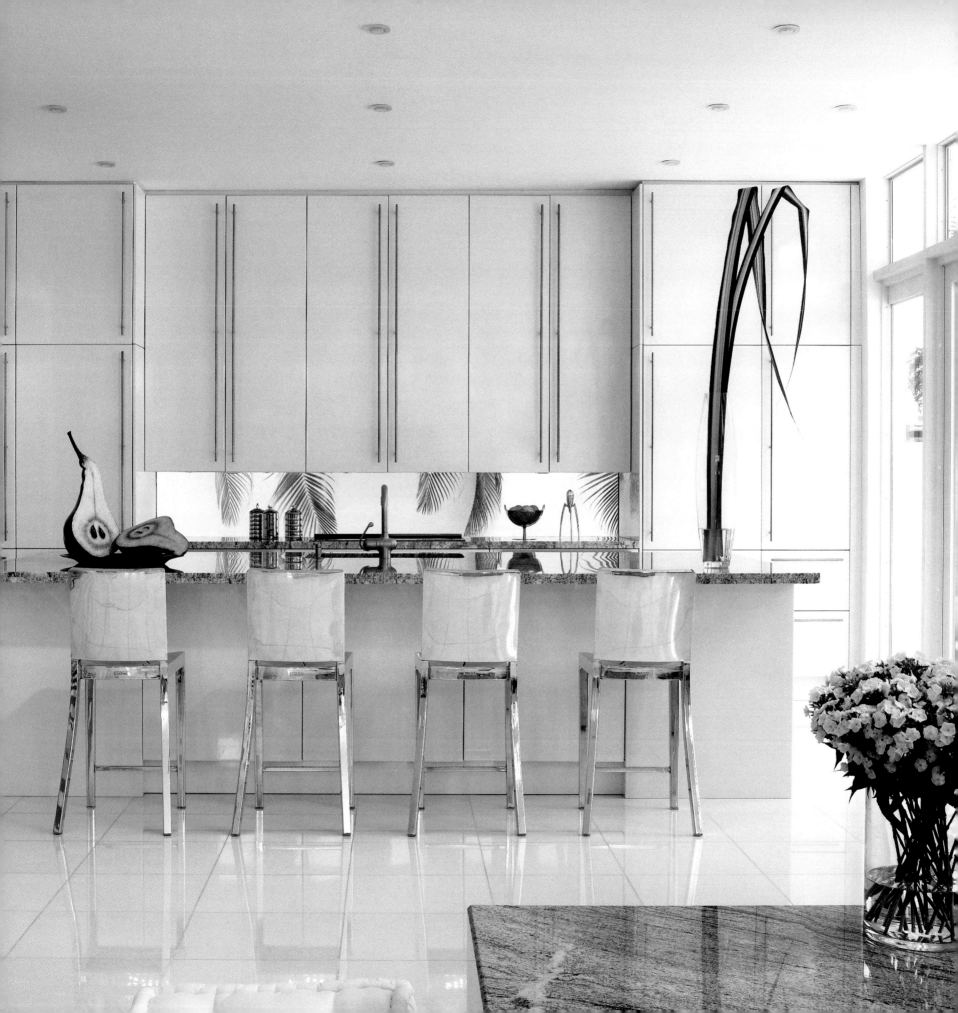

alexandra karram

Alexandra Karram Interiors, Inc.

When you research Alexandra Karram's interior design business on the Internet, what comes first is not a list of her interior design accolades. Instead, there is a story about her selfless six-year involvement with Women of Tomorrow, an organization that works to improve the self-esteem of teenage girls, and her determination to make a difference in the lives of these girls. In 2005, her commitment was rewarded as Alexandra was named "Mentor of the Year."

Alexandra's dedication, passion and caring spirit for her community involvement are just as evident in her relationships with her interior design clients.

Born and raised in New York, Alexandra graduated from the Art Institute of Fort Lauderdale. She opened Alexandra Karram Interiors, Inc., 15 years ago and now has three full-time employees. She is a member of ASID and was previously on its board of directors, IFDA, and was on the DCOTA Advisory Board in 2001 and 2004.

Inspired by architect Richard Meier, Alexandra is also encouraged by her close-knit family who she says, "are all in the design field and I truly appreciate their individual approaches to style."

She thoroughly enjoys the creative process and "being able to create many different environments. No two projects are ever the same, and it is refreshing to offer that type of creative freedom to each design." Alexandra also intimately understands the design process from both the designer's and the client's perspectives. "The home in Boca Raton that I worked on since college and eventually moved into is a truly beautiful home. I feel this way because I involved such thought, design, and labor into it, the finished outcome was extremely fulfilling." She also works hard to make sure her clients feel that same sense of beauty and fulfillment on their own projects.

Her numerous honors include ASID Design Excellence; Art Institute Outstanding Alumni Achievement Wall of Fame; ASID Outstanding Community Service Award; ASID Design Excellence Award; and Palm Beach Dream House Award. Her work has been published in *Miami Herald Home & Design, Boca Raton, Florida Design, Palm Beach Illustrated, Architectural Digest, Florida International Magazine, Southeast Home Builder & Remodeler, Palm Beach Post,* and *Boca Raton News.*

More about Alexandra…

WHAT PERSONAL INDULGENCE DO YOU SPEND THE MOST MONEY ON?

Alexandra loves art because it provides me with inspiration.

WHAT ONE ELEMENT OF STYLE OR PHILOSOPHY HAVE YOU STUCK WITH FOR YEARS THAT STILL WORKS FOR YOU TODAY?

The one element of style that has always been present in her life, which still works for her today, is apparent in the way she dresses. She dresses in the same way she designs: clean and simple, and in an organized fashion.

IF YOU COULD ELIMINATE ONE DESIGN/ARCHITECTURAL/ BUILDING TECHNIQUE OR STYLE FROM THE WORLD, WHAT WOULD IT BE?

Alexandra would not eliminate any design, architectural or building style from the world because she sees each one as an opportunity or a challenge. To her, that in itself is beautiful.

WHAT IS ONE THING MOST PEOPLE DON'T KNOW ABOUT YOU?

Although Alexandra loves contemporary design, her dream is to restore and renovate an original castle in Scotland.

WHY DO YOU LIKE DOING BUSINESS IN FLORIDA?

She feels that Florida offers a constant excitement and vibrant culture, which cultivates an entrepreneurial spirit. She enjoys doing business in Florida because this environment offers her a challenge and reward at the same time.

Alexandra Karram Interiors, Inc.
Alexandra Karram
720 E Palmetto Park Road
Boca Raton, FL 33432
561-447-7711
FAX 561-394-9901
www.karram.com

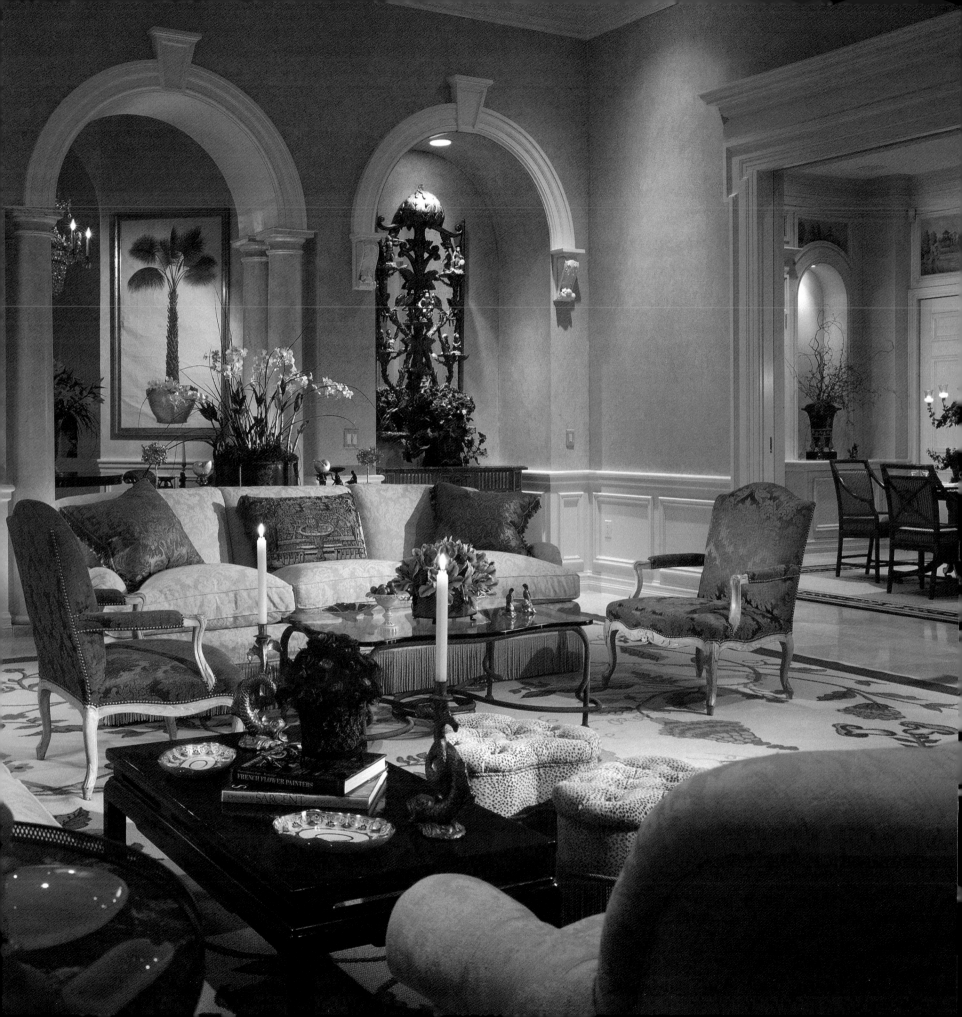

bill kopp

Smith Interior Design Group

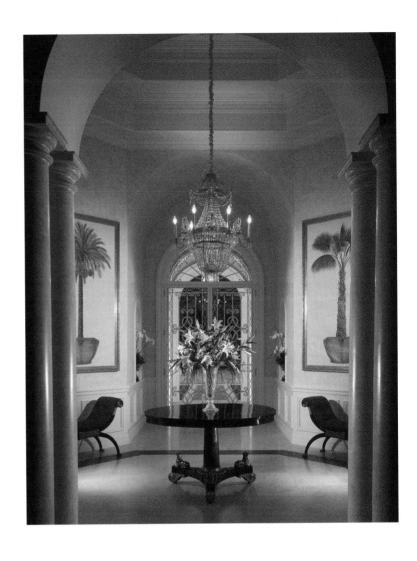

A graduate of the New York School of Interior Design, Bill relocated to Florida six years ago to work specifically with noted Palm Beach architect Jeffery Smith of Smith Architectural Group to head up the newly formed Smith Interior Design Group. Smith Architectural Group wanted to offer clients a high-end design that ensured a harmony between architecture and interior design—a concept that appealed to Bill. Smith Interior Design Group also offers complete interior design services to independent clientele as well. As well as Palm Beach, Bill's projects take him all over the country.

With over 26 years of experience in the design field, including a 15-year career with the prestigious interior design firm of McMillen Inc., in New York City, Bill regularly extends one essential, yet simple, piece of decorating advice to all of his clients, "Be true to your taste, not the trends."

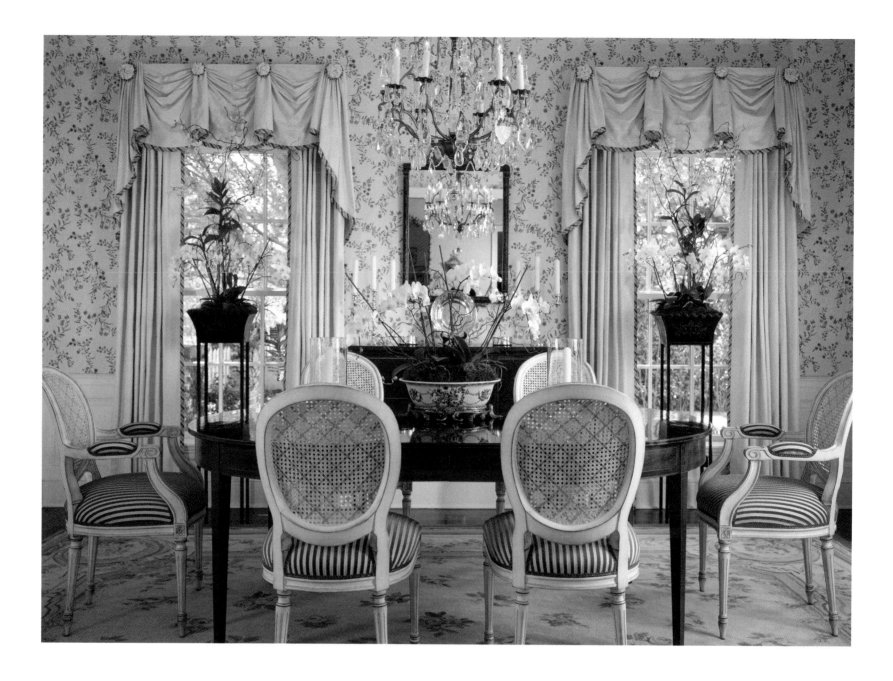

In order to bring their vision to life, Bill needs a thorough sense of what his clients want to achieve, plus a deep understanding of their likes, dislikes and needs. However, while some clients can describe their dream home, some clients are unaware or have a hard time conveying their true decorating style. Bill works closely with his client and through renderings, discussions and pictures, he can assist them in visualizing the final result.

Occasionally, Bill will travel with his clients to antique shows or to Europe and Bill considers these trips to be a high point of the client-designer relationship. This hands-on experience provides valuable insight and information, even for his long-term clients whose tastes and needs have changed over the years.

With this crucial information at hand, Bill can successfully design a room that meets—and

ABOVE

This inviting dining room incorporates several soft patterns on the chairs and the wall that complement each other well. The two-color scheme keeps the room uncomplicated to the eye.

often exceeds—the client's expectations. His traditional designs are fresh and timeless and blend his palette of warm colors—corals, blues, greens and yellows—with eclectic and modern design elements to create a uniqueness to the room. He also avoids trendy design that lacks longevity.

Most of Bill's designs are for first-, second-, and even third-time homeowners. He envisions each project as a puzzle—carefully synchronizing each piece to work harmoniously with the room. Whether his challenge is to incorporate a client's existing furniture and household objects into a design or update the piece to create a new modern look, Bill achieves a beautiful final product.

Bill is influenced by his many travels through Europe, especially in Paris, Rome and London,

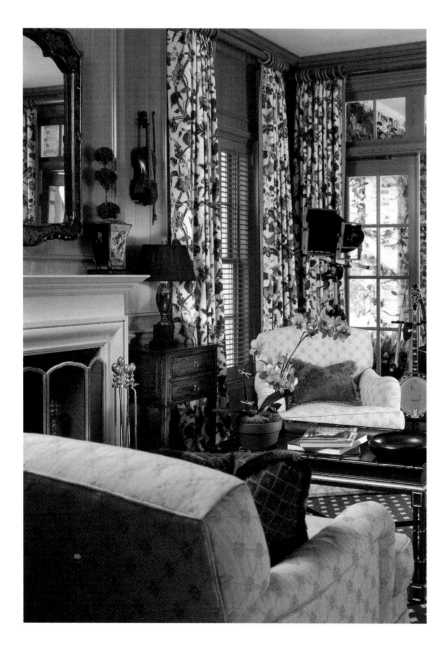

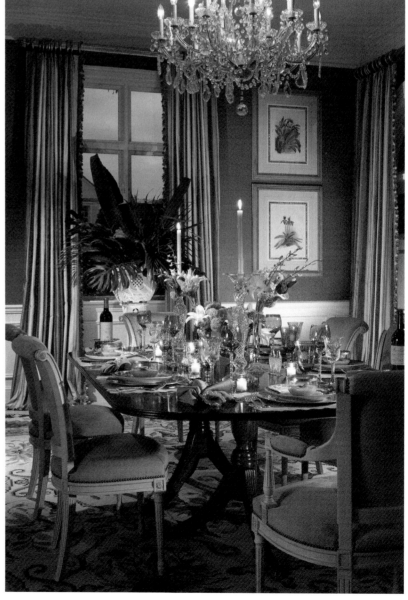

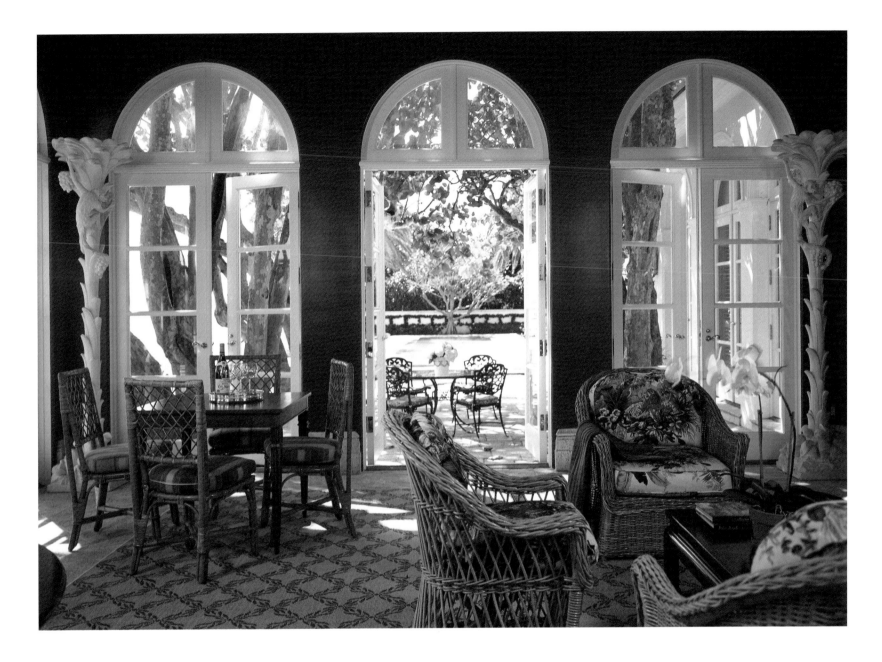

and his exposure to antiquities. "It's fascinating to see how ancient products have aged so beautifully and how we're just now able to replicate some of this beauty through state-of-the art products," explains Bill. Through his journeys, he has broadened his color palette, sharpened his eye and developed a more sophisticated decorating style.

Yet he knows that today clients want a place to call home. They want less of a showroom and more of a living room. They want to enjoy their kitchens and family rooms and yet have that balance of timeless and sophistication. With his wide range of knowledge and expertise, Bill Kopp delivers just that—timeless and sophistication—that his clients love.

ABOVE
This Chinese red room, while warm and cozy, maintains a cool feeling with the unadorned windows allowing ample light to flow through the room.

FACING PAGE
With a view like this, the owner wanted to spend more time on the Loggia. Bill's simple design, combined with the beautiful hand-painted walls, complements the view.

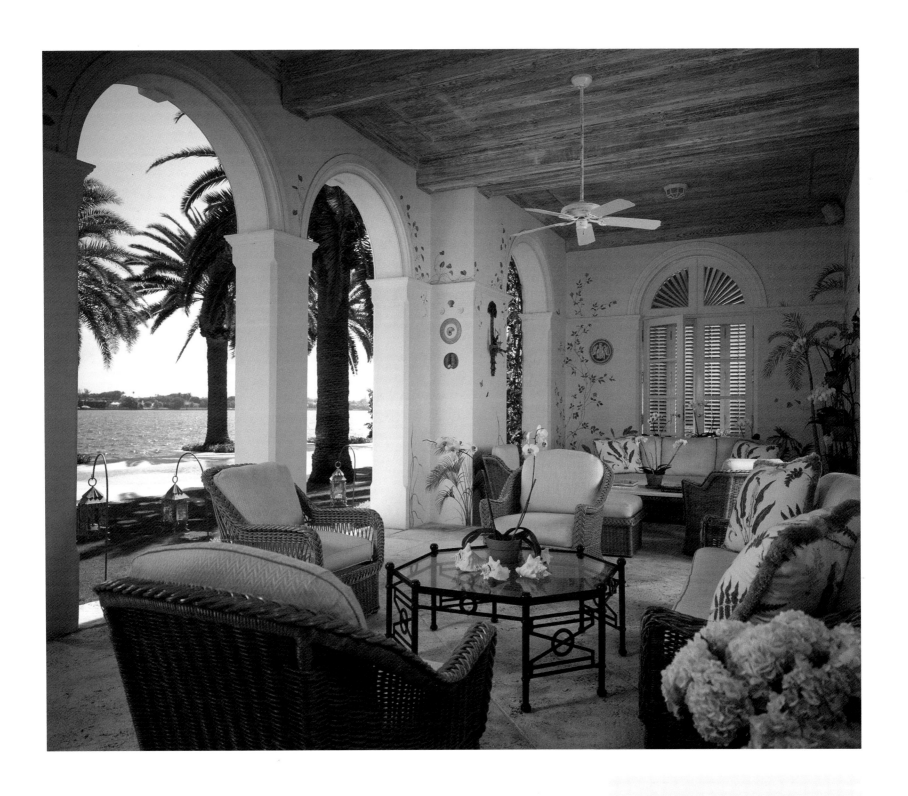

Smith Interior Design Group
Bill Kopp
242 South County Road
Palm Beach, FL 33480
561-832-5156
FAX: 561-832-3902

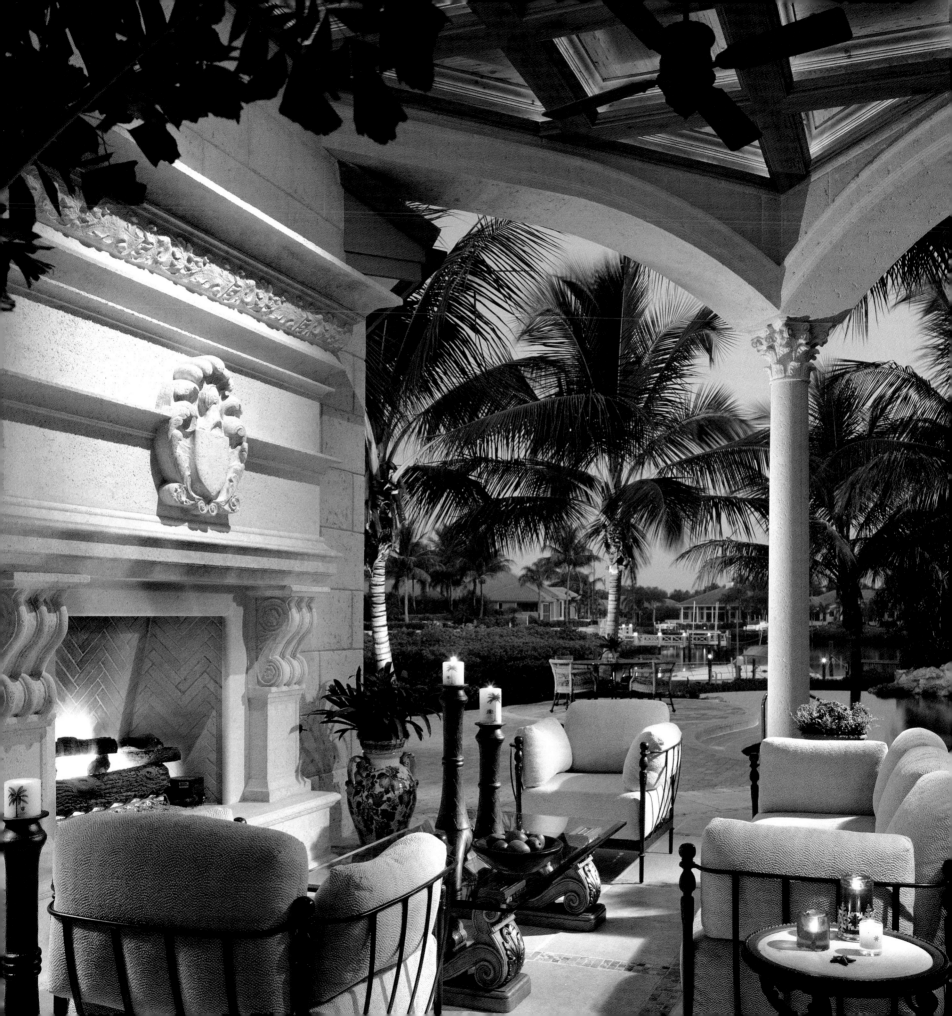

donald lilly

Donald Lilly Associates Interior Design

Donald Lilly is a modern-day renaissance man. Having studied fine art and architecture at McDaniel College in Maryland and earned his degree in interior design from the Art Institute of Fort Lauderdale, Don has been inspired throughout his career by the work of Michelangelo, Andrea Palladio, and Frank Lloyd Wright. An admirer of Leonardo da Vinci, he is, himself, an accomplished inventor. He has developed several new products and currently has a patent pending on an innovative trim molding that incorporates a light source within it to illuminate and accentuate ceiling details.

Don has had his own design business for over 15 years, working primarily in Palm Beach County on luxury custom homes as well as yachts and commercial resorts. He recently got the commission to design the Harrick Hotel— a 24-story, 140-unit luxury condo/hotel in downtown West Palm Beach. Over the years he has had the opportunity to work on a number of landmark buildings in Palm Beach designed in the 1920s by renowned designers Addison

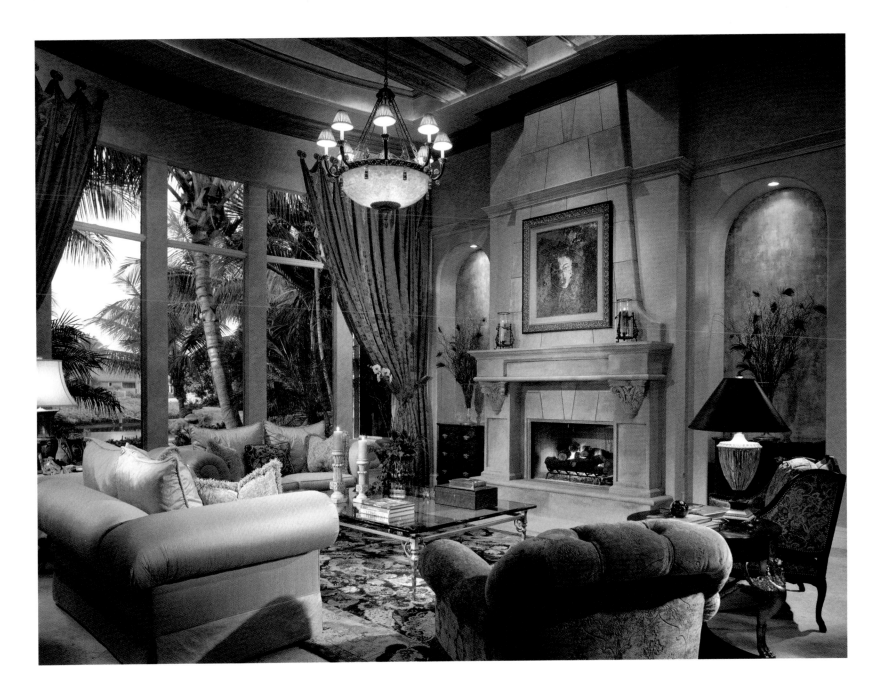

Mizner and Maurice Fatio, both of whom have been a great source of inspiration to Don.

The majority of residential projects he works on are transitional Mediterranean in style. Transitional Mediterranean can be tailored to his clients' individual taste, with less emphasis on matching and more focus on creating a good marriage between a broad range of pieces that are compatible in scale and balance. By blending rustic Spanish objects, superb lighting fixtures and inlaid accent pieces from Morocco, and rich and ornate Italianate decorative elements, Don creates homes that reflect the personal taste of his clients.

Whether he's restoring a house designed by Mizner in the 1920s or working on a brand-new home, Don works as a team with owners, architects, and contractors to create a space that is as true to its architecture as possible. He handles much of the architectural detail

ABOVE
A colorful "Jamali" original hangs above the carved stone fireplace. Luxurious fabrics, furnishings and finishes along with the designer's patent pending Crownlight™ moldings illuminate the hand-painted beams.

NEAR RIGHT
An eloborate groin-vaulted ceiling along with massive mahogany doors and arched transom, original artwork, elaborate stone inlays and faux finishes.

FAR RIGHT
Unique architectural detailing, dramatic lighting and overscaled furnishings incorporate balance and harmony in this spectacular oceanfront residence.

himself including drywall detailing, custom built-in furnishings, custom millwork, lighting design, and audio-visual design. He is involved in each phase of a project, from the first meetings with his clients where he gets to know their tastes and gains an understanding of the functionality of the project, through construction supervision, to the final hanging of artwork.

As testimony to his exceptional attention to detail and ability to deliver homes that reflect the personality and lifestyle of his clients, Don was commissioned by the Saudi Arabian royal family to design an entire living compound. On a vast property, he designed a customized villa for each of the seven children in the family, each with a different theme ranging from traditional to contemporary, Japanese to

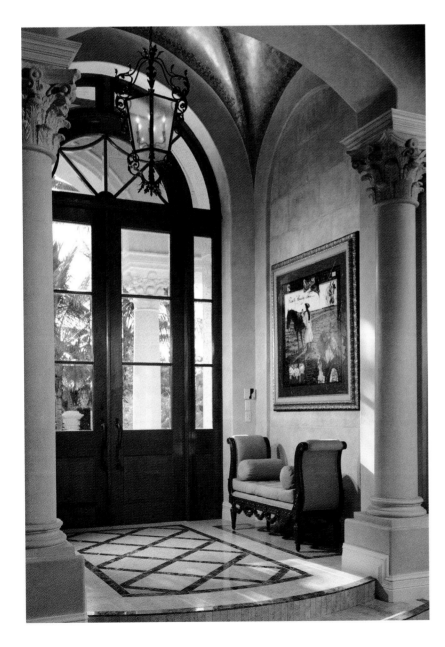

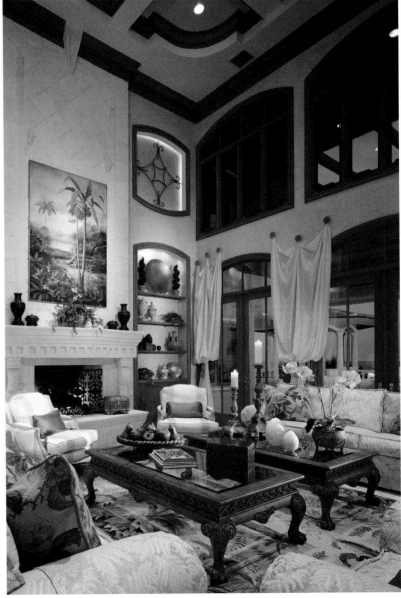

Moroccan. In addition, Don designed the parents' 20,000-square-foot villa, a restaurant, and the men's recreation center/spa.

Don is a licensed interior designer and president of the Florida South Chapter of the American Society of Interior Designers (ASID), the largest chapter in the United States. He is a multiple award-winning designer whose work has appeared in numerous national magazines as well as international books including *Great Designers of the World*. His work has graced the front

and back covers of four consecutive volumes in this series, and he wrote the foreword to each of these volumes.

Don's philosophy is that in the design business, it's necessary to roll with the punches; that designers have to be flexible in order to face the new challenges confronting them daily. With an extensive roster of clients and a portfolio brimming with diverse projects, Donald Lilly is clearly up for the challenge.

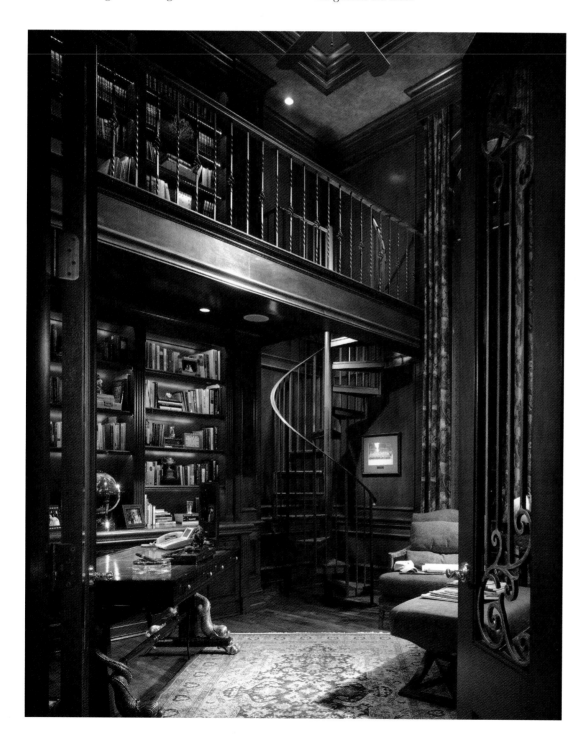

LEFT
Stained mahogany French doors with hand-forged iron inlays create a dramatic entrance to this masculine two-story paneled library. State-of-the-art video conferencing, exquisite furnishings and the designer's patent pending Crownlight™ enhance the coffered ceiling and shelving.

RIGHT
A tranquil tropical oasis best describes this spectacular pool area.

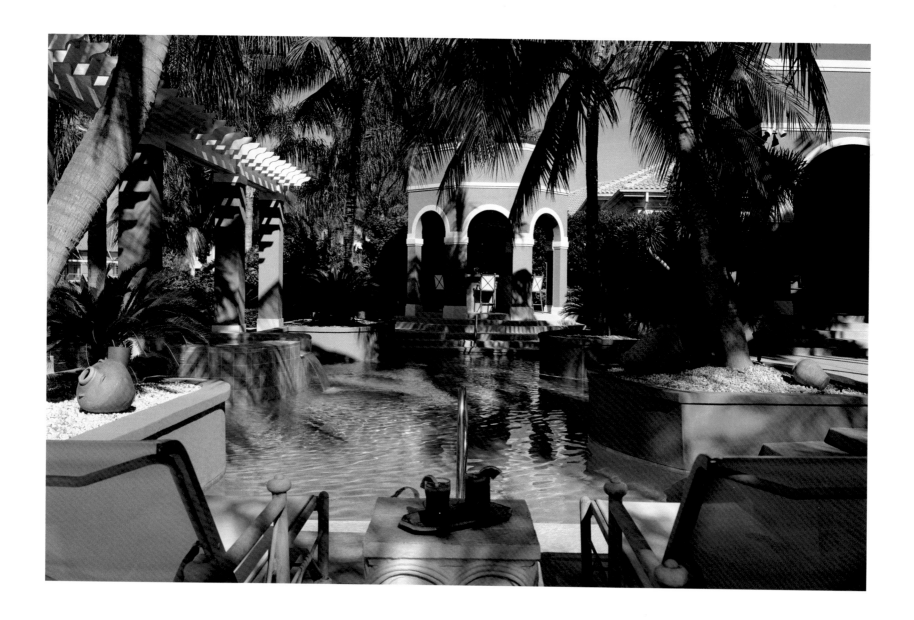

More about Don…

WHAT DESIGN ELEMENT HAS THE LARGEST IMPACT ON A HOME?

Interior lighting can make or break a project. Proper lighting is essential—whether projected onto artwork or positioned to enhance the interior architectural detail. Designers also need to capitalize on the way in which natural lighting affects a space, day and night.

HOW DOES DON DESCRIBE HIMSELF?

He's easy-going, focused, and not too serious.

Don firmly believes in working hard, playing hard, and laughing often!

WHAT DOES DON DO IN HIS SPARE TIME?

Don loves to travel—especially to Paris and Italy. He gets inspiration simply walking down the streets where there are so many examples of ingenious architecture from more than 500 years ago.

WHAT IS DON'S FAVORITE PERSONAL COLLECTION?

Don has a collection of over 40 small inlaid and carved boxes from his travels. He is fascinated with their joinery and detail.

**Donald Lilly Associates
Interior Design**
Donald Lilly, ASID
935 Town Hall Ave.
Jupiter, FL 33458
561-746-5010
www.donaldlillyassociates.com
IB #26000663

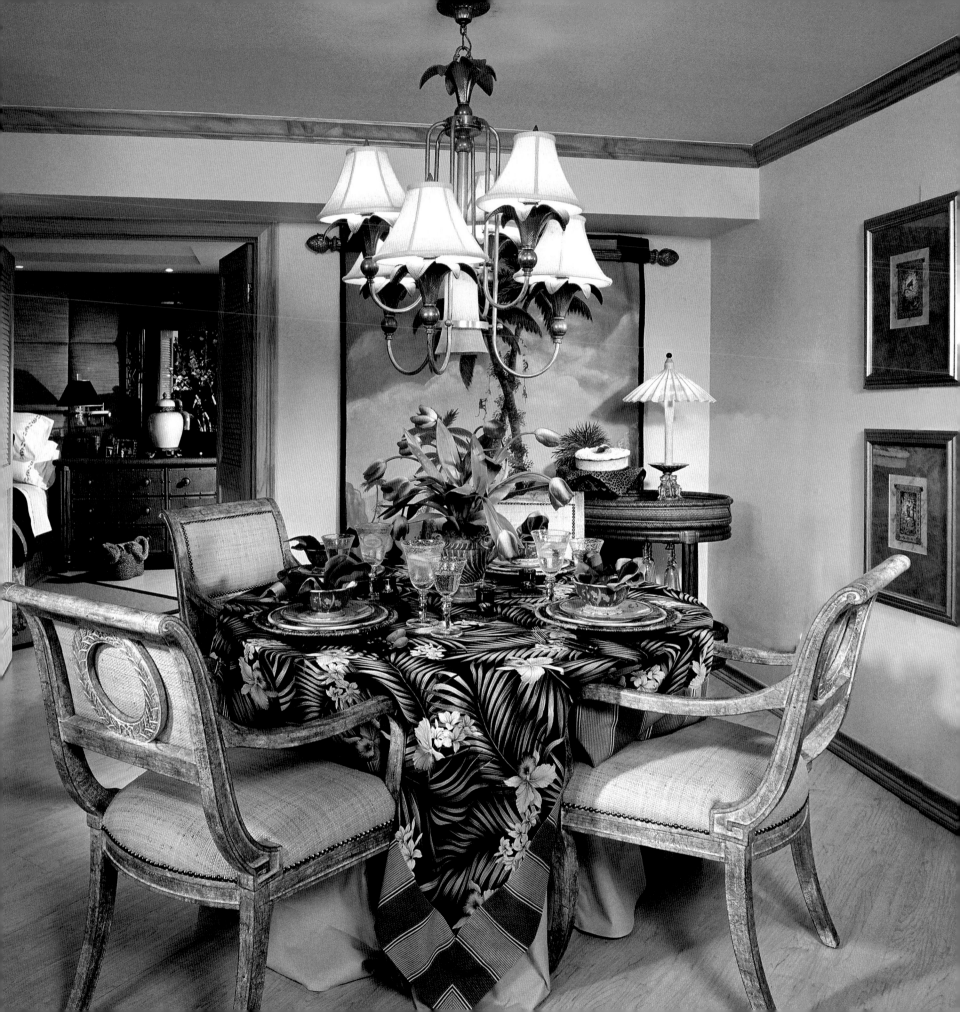

ted paskevich
Creative Furniture Two

In his own words, Ted Paskevich admits he "didn't choose to be a designer, the world of design chose him." From early on, Ted was an observant and creative child, paying special attention to his uncle who upholstered furniture for a living. The construction and design aspects of the trade intrigued him, securing his destiny as an interior designer. During his college years he followed his calling by designing window displays and working in a furniture store. His dream of designing turned into reality, ultimately leading to a career in interior design.

"Anyone can sell you furniture, but not everyone can make it dance," explains Ted, who has been making his clients' designs dance for 30 years while bringing his energy and creativity to each project.

Six years ago he opened Creative Furniture Two (CF2), a Delray Beach based design firm, with his partner Wes Ramer and staff of four. Avoiding a cookie-cutter approach, Ted creates a look for each room keeping in mind his client's personality. He doesn't impose his own personal design likes and dislikes, but works

with his client's preferences and lifestyle. He feels that the different elements in a home should create a harmony as they do in his own very eclectic abode.

Considering most of CF2's clients are second-time homeowners, they are willing to try fresh ideas, hoping to push the envelope when it comes to the interior design. They want something new and different. Ted is ready to work with clients open to unique design alternatives.

"I like to present possibilities they would never have thought of on their own," he said. As an example, he explains how opposite colors bring a vibration and an energy to a room.

"To be a good designer, you must be part psychologist, marriage counselor and referee," quips Ted, but most importantly, his favorite part of being an interior designer is the client's happiness at the end.

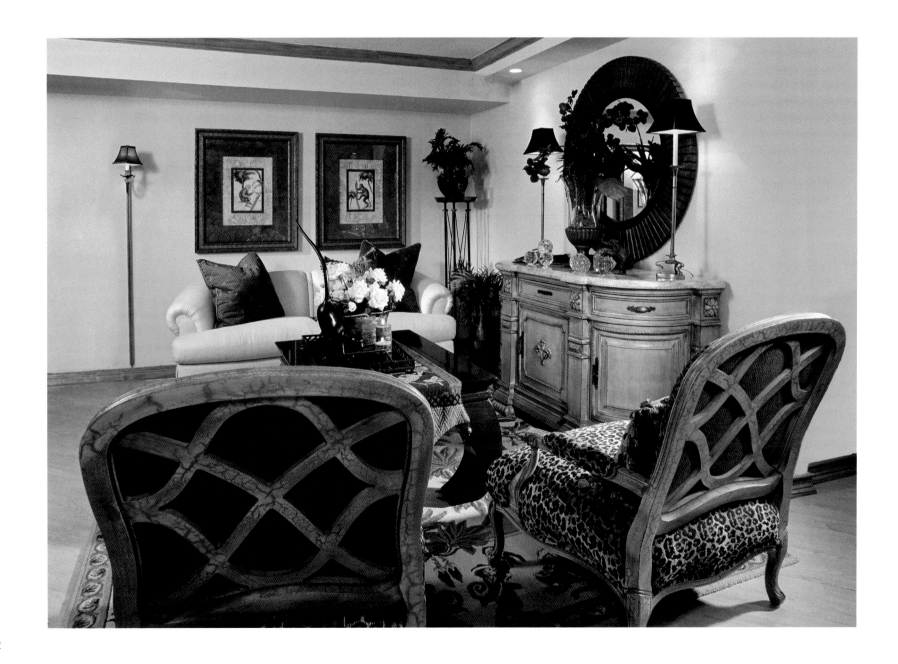

Ted's other accomplishments and awards include: Professional member ASID in 1980; published in *Who's Who in Interior Design* 1988, 1989; First prize, Interior Design as an Art Form—Butler Art Institute, Youngstown, Ohio; American Cancer Society show houses, Cleveland, Ohio; Junior League show houses in Boca Raton, FL; and published in *Palm Beach Life*, *Florida Design*, and *Architectural Digest*.

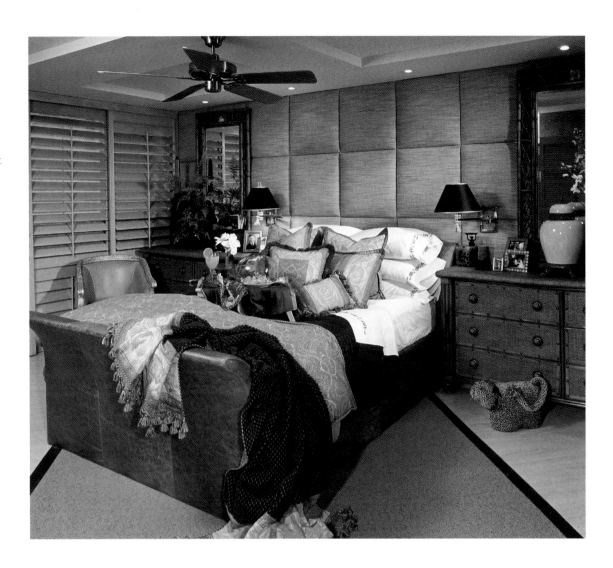

LEFT
As the rich wine accents enhance the tropical theme, the dramatic cocktail table hints at a touch of the Orient. The mix of fabrics and design of the chairs, certainly speak of that eclectic mix.

RIGHT
The upholstered wall along with the vintage leather bed are joined with rattan accents to carry through the West Indies theme. The shutters, ceiling fan and florals, offer up a true sense of an island retreat.

More about Ted…

WHAT COLOR BEST DESCRIBES YOU AND WHY?

Ted loves to describe himself as the color red, because, like the hue, he's exciting, bold and daring. He likes to push the limits, is outspoken, quick, witty and has a great sense of humor!

WHO HAS HAD THE BIGGEST INFLUENCE ON YOUR CAREER?

The masterful artist Leonardo Di Vinci ,who he calls "inventive, creative and a visionary," has inspired Ted.

WHAT IS THE MOST UNUSUAL DESIGN OR TECHNIQUE YOU USED IN ONE OF YOUR PROJECTS?

Ted had clients that owned a dance studio and, for their home, they wanted a dramatic, theatrical dining room. So he created a three-level angled ceiling, and a dining room table with a 10-foot mirrored top and malachite base. He installed a smoked mirror on one wall and treated the window with a fabric lambrequin accented with angled smoked mirror inserts as well as smoked mirrored verticals. The room was accented in shades of purple and green and the explosive accent was an extraordinary crystal chandelier over the table that danced off of every color and mirrored angled in the room. It was like a room full of prism fireworks. Ted says, "This bizarre commission was like putting my client's fantasy into motion."

Creative Furniture Two
Ted Paskevich
151 Pineapple Way
Delray Beach, FL 33444
561-272-5228
FAX 561-272-5017

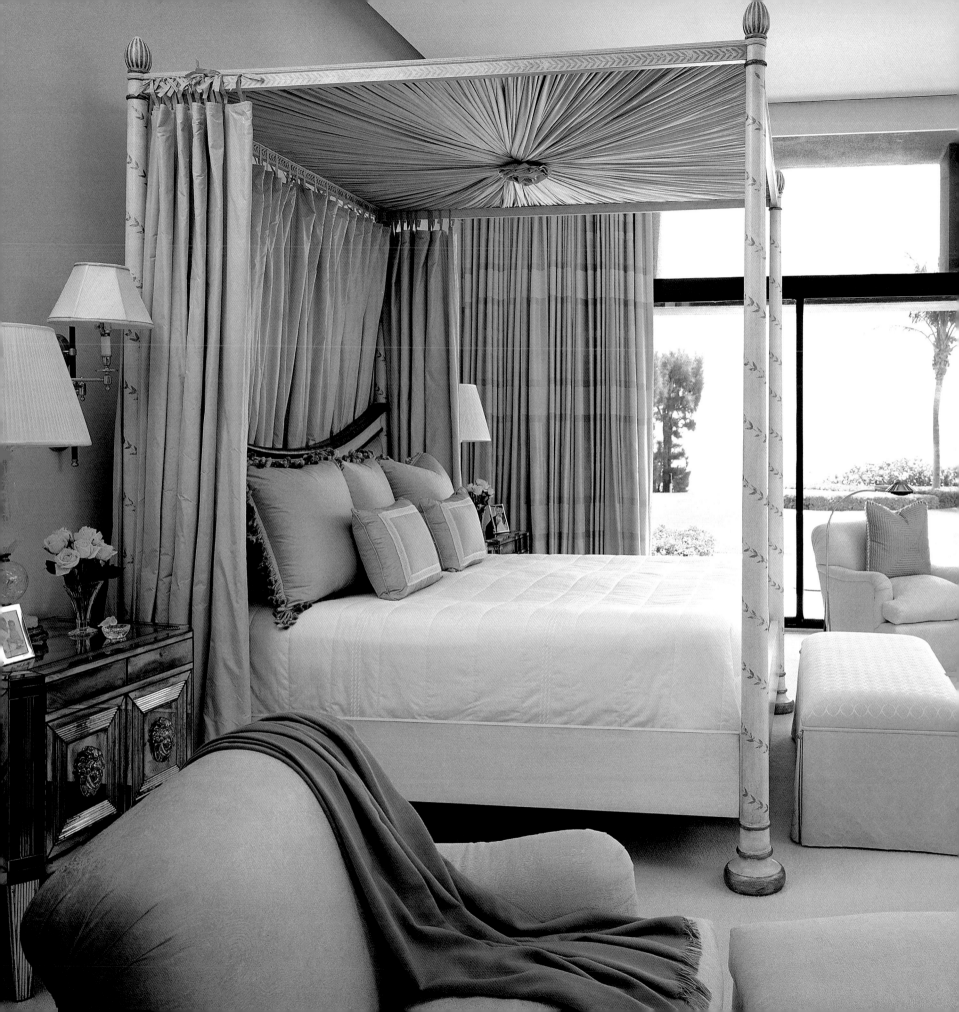

tui pranich
Tui Pranich & Associates

LEFT
The master bedroom overlooking the ocean has an over-size canopy bed to give the room a good sense of proportion.

ABOVE
This entry foyer uses an exaggerated console table and mirror to give the room a good sense of proportion. Flanking the console table is a pair of French antique wall sconces from Paris.

At a very early age Tui Pranich traveled extensively with his father, who, at the time worked for the United Nations, and then for World Bank. From their home in Bangkok they traveled throughout Asia and Europe, as well as the United States. Tui observed and analyzed the sights and colors of his exotic surroundings—a habit that remains with him to this day and serves him well in his work as a world-class designer.

Twenty years ago, he founded Tui Pranich & Associates, a design firm specializing in

prestigious, large-scale residences. Today, he has showrooms in New York, Chicago, Ft. Lauderdale, and Miami, a design office in West Palm Beach, a staff of more than 45 people, and a roster of distinguished clients. In addition to a vast array of residential projects, Tui Pranich & Associates has designed the Founder's Room in the Kravis Performing Arts Center.

Tui Pranich & Associates is internationally recognized for sophisticated, classic home design. They often work with the same clients over many years, designing for them homes in several

different locales including New York, Boston, Colorado, and the Bahamas. As discriminating as his clients are, Tui is equally discriminating about the jobs he works on, taking on projects he feels passionate about, and working with clients whose taste and approach to design are compatible with his own. His clients tend to be open-minded and willing to try new styles and new materials, which suits Tui perfectly.

Equally comfortable working in contemporary, traditional, and deco, Tui loves residential design because it offers him the opportunity to work in so many different styles. He and his design staff avoid trends, favoring instead timeless design that reflects the personality of their clients. It's essential to Tui that his clients feel that it's their house, not a decorator showcase. To this end, he incorporates personal collections into his designs, and

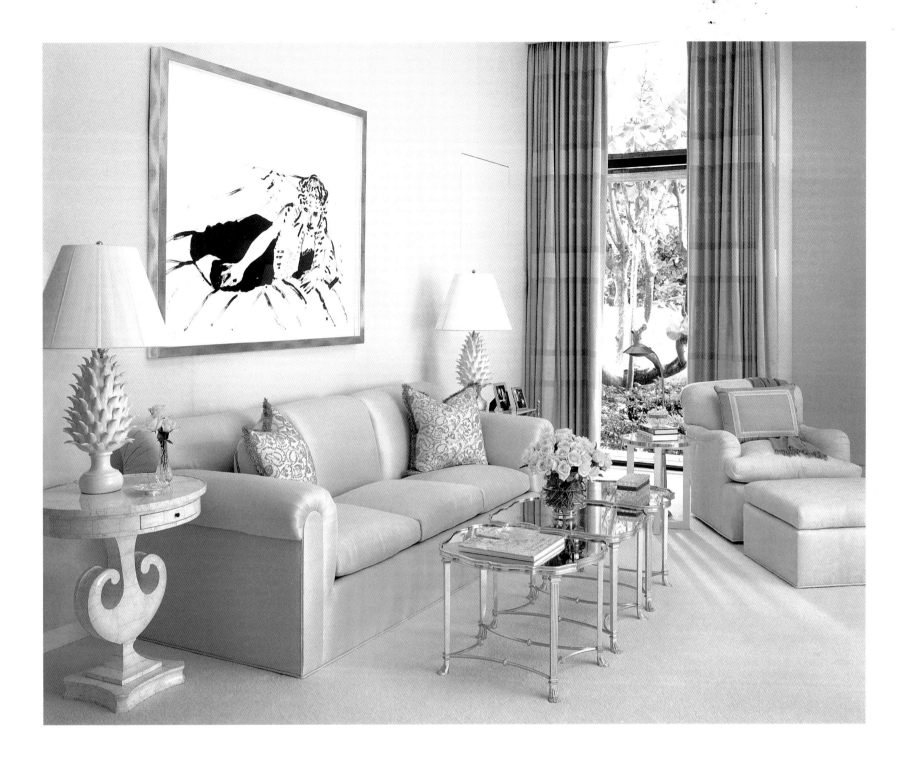

LEFT
An original exterior garden pavilion, made out of old coquille stone, gives the house old Palm Beach charm.

ABOVE
Master bedroom sitting area creates a soft yellow tone. Wall and furniture are upholstered in pale yellow silk
fabric. Art work by David Hockney.

creates home style that is eclectic and never overdecorated or overly matching, using soft colors that are easy to live with that blend from one room to another.

Tui applied his peerless ability to deliver individualistic design to a 30,000-square-foot house in Palm Beach. To create a design for the vast living room—1,600 square feet with soaring ceilings—Tui, a graduate of Cornell's five-year architecture program, capitalized on his in-depth knowledge of scale to create furnishings that were in proportion with the size of the room. Sofas, chairs, coffee tables, and cabinets were all exaggerated in scale, while upholstered pieces and color added warmth, and Venetian plaster walls provided depth and sheen. Through his trademark ingenuity and unerring sense of style, Tui transformed what could have been a formidable, overfurnished room into a warm, welcoming space.

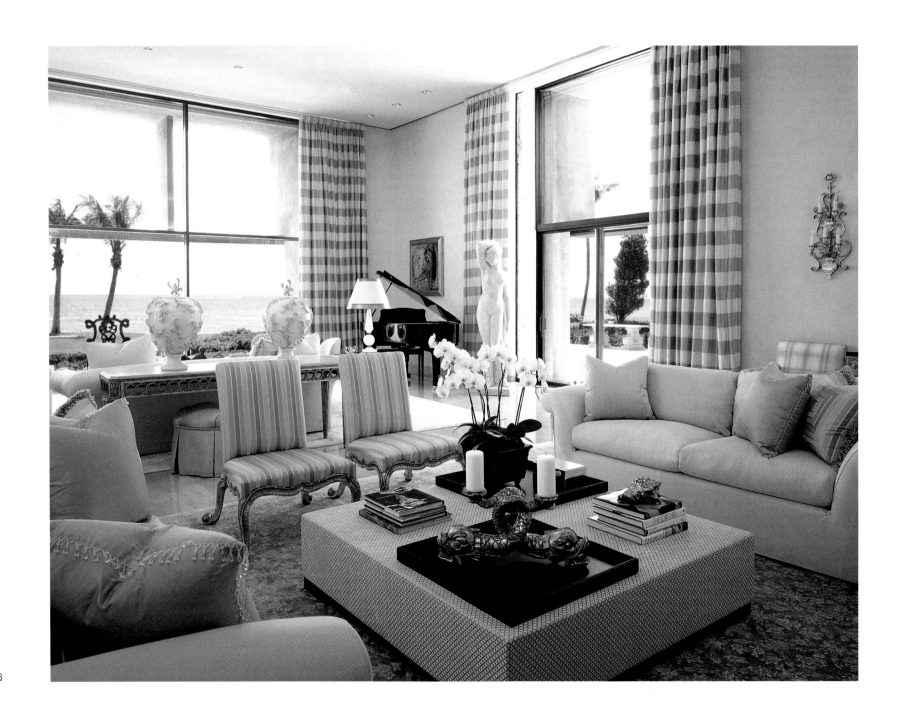

More about Tui…

DOES TUI HAVE ANY PERSONAL COLLECTIONS?

For a number of years, Tui has been collecting prints. His collection includes work by Andy Warhol, David Hockney, and Frank Stella, among others. He is also excited to have recently started collecting photography.

WHAT DOES TUI BELIEVE TO BE THE MOST IMPORTANT ELEMENT IN HOME DESIGN?

Nothing else livens up a room the way art does. Art is the most essential element in design— even more so than furniture.

WHAT ARE TUI'S MAJOR SOURCES OF INSPIRATION?

Travel provides Tui with endless inspiration. Everyday experiences like observing the windows of Barneys or Bergdorf Goodman in New York City and analyzing the use of fabrics and lighting in new restaurants also provide invaluable fresh perspective.

WHAT DOES TUI ENJOY DOING IN HIS SPARE TIME?

Tui loves buying and renovating homes. He has a home in each city where he has a showroom or office—in New York, he has an apartment in the meat-packing district, a traditional town house in Palm Beach, a Deco home in Miami where he stays on weekends and an apartment in Paris. Once a home is fully decorated and furnished, he moves. Tui estimates that he moves an average of every two years.

WHAT TYPES OF BOOKS DOES TUI ENJOY READING?

He loves books about history, people, and personalities as well as architecture and design books.

Tui Pranich & Associates
Tui Pranich, ASID
777 S. Flagler Drive
West Tower Suite 800
West Palm Beach, FL 33401
561-655-1192

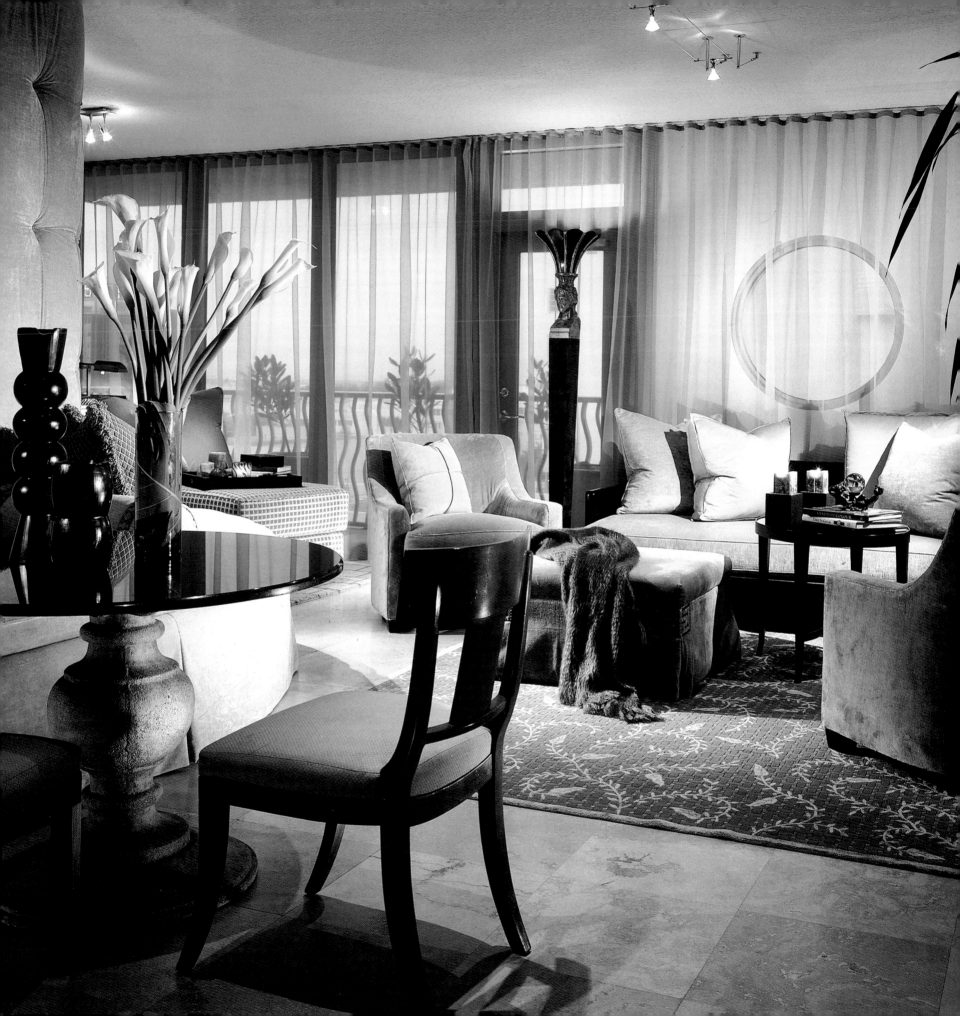

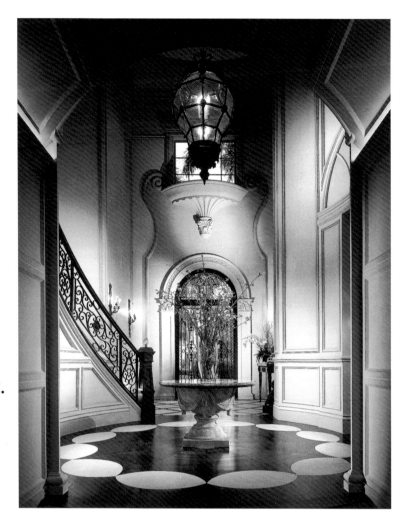

marc thee
Marc-Michaels Interior Design, Inc.

Before a project begins, Marc Thee, founder and co-CEO of Marc-Michaels Interior Design, suggests to clients, "Let's create livable rooms that invite people to put their feet up, not rooms that look like they belong in a museum."

Influenced by a relaxed style that comes from living in Florida with its warm resort climate, Marc likes to inject a barefoot elegance into the most formal interiors. With office locations in Winter Park and Boca Raton, he is the lead designer and heads up a creative staff of 65 experienced designers. The firm creates award-winning interiors for private residences, yachts, model home merchandising and commercial projects.

Marc offers his clients an innovative combination of interior design and interior detailing—a service that he pioneered. The firm's expertise extends to millwork, built-in furniture and cabinetry design, interior elevations and ceiling design, global sourcing, and custom furnishings. Whether the client's taste is old-world traditional or warm contemporary, Marc-Michaels will create an unparalleled living space.

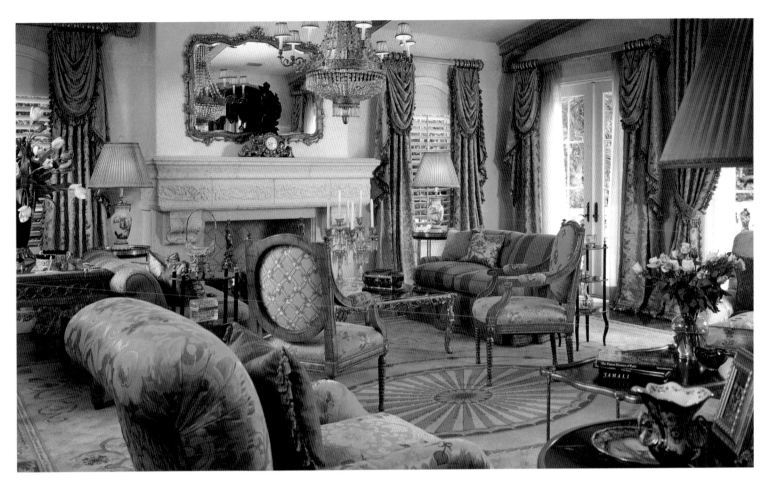

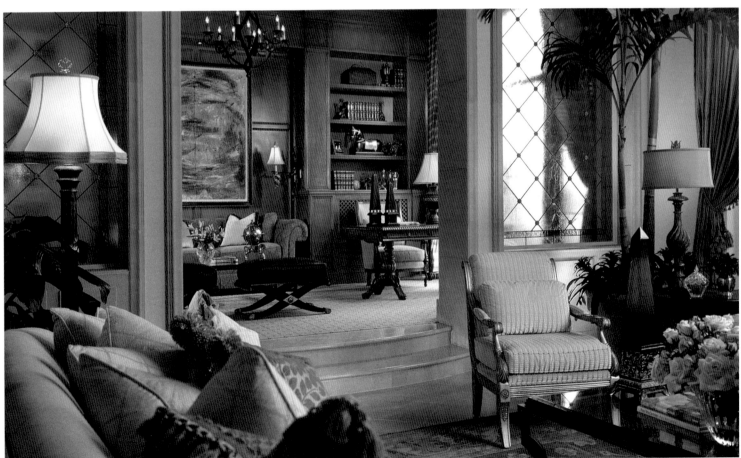

LEFT
Extraordinarily opulent, this always-in-style "Old Palm Beach" living room resonates good taste with vibrant brocades in shades of coral, jade, and lemon. Antique chandeliers, occasional tables and Aubesan rug are highlights of the room.

BELOW LEFT
Adjacent to the living room, this inviting home office features cherry cabinetry, leaded glass inserts and a stone surround between the two spaces. Steps create additional drama.

BELOW
Classical architecture is celebrated with this formal columnade of corinthian columns designed to support the second-story bridge.

RIGHT
Though highly elegant, this room also has a relaxed undertone with a broken edge, random pattern stone floor, cotton velvet upholstery, and warm plastered walls.

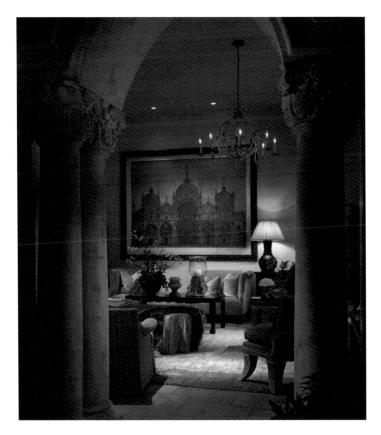

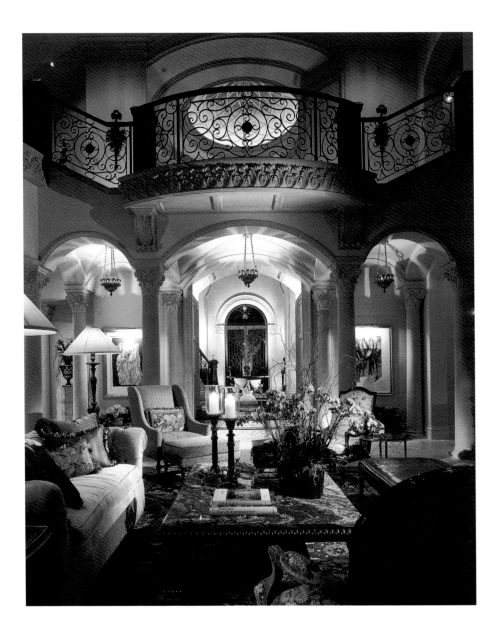

Marc-Michaels Interior Design opened its doors 20 years ago and has since grown into one of the most respected design firms internationally. *Architectural Digest* has consistently named the firm to their list of the "World's Top 100 Designers." Marc is often a guest speaker and seminar presenter at international and regional Builders' Shows as well as numerous charity events. His approach to design has also garnered the firm over 350 national and regional design awards.

The diversity and synergy of the Marc-Michaels team allows the designers to quickly complete and install projects of any size. Most importantly, Marc admits he "has fun with the process" and makes sure his clients do, too.

Marc-Michaels Interior Design, Inc.
Marc Thee
Michael Abbott
720 W. Morse Blvd.
Winter Park, FL 32789
407-629-2124
www.marc-michaels.com
Florida License #1B-C000158

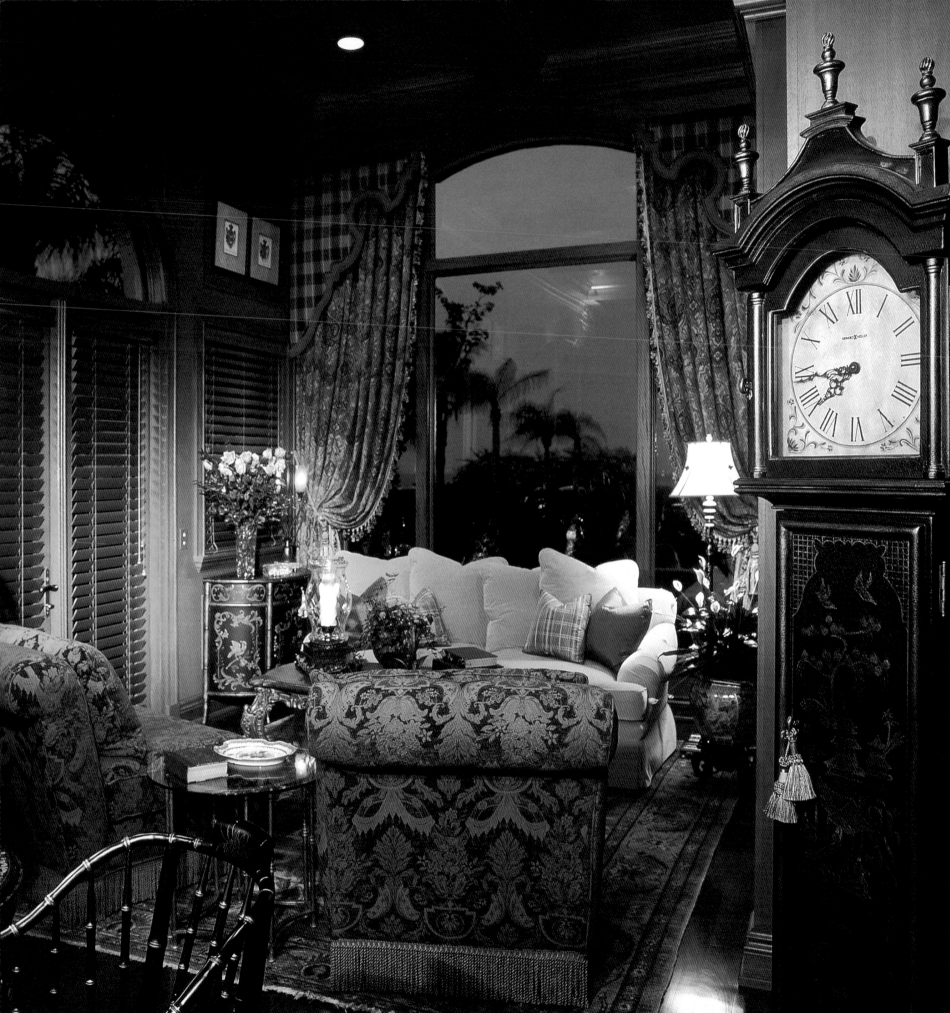

bernadette upton
Bernadette V. Upton, ASID

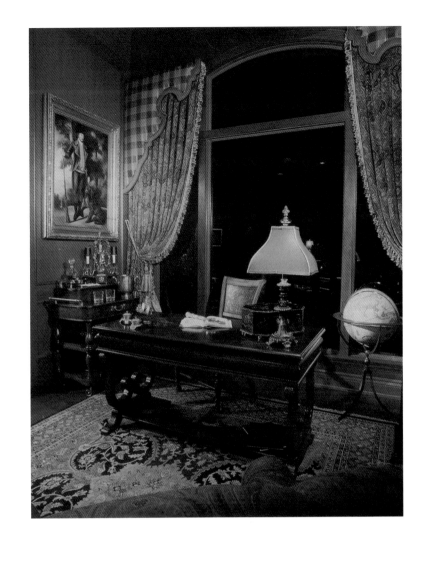

Most interior designers are pleased if they create a space that is comfortable and attractive. When Bernadette Upton designs a room for her clients, she makes sure it's health-friendly too. She has dedicated her career to environmental interior design and is an advocate for safer and healthier homes.

Bernadette is a Florida-licensed interior designer, ID# 713, past president of the American Society of Interior Designers (ASID), Florida South Chapter, lecturer, consultant and the owner of EcoDecor, an eco-friendly home furnishings line

and green resource center. She has specialized in environmental interior design since 1982, and is a founding member of the National ASID Sustainable Design Council. She is a member of the Florida Green Building Coalition (FGBC) and is a Leadership in Energy and Environmental Design (LEED) Accredited Professional with the U. S. Green Building Council (USGBC).

Starting out sewing draperies for a New York design firm when she was 18, Bernadette fell in love with the design business, but "people

would discourage me and say it was a 'tough' business." Proving the naysayers wrong, Bernadette graduated from the Willsey Institute of Art and Interior Design on Long Island and was with Carls Furniture, and Bloomingdales as director of design prior to starting her own design business.

Since then, Bernadette's strength and tenacity have made a compelling difference in the design industry. Her greatest passion is incorporating earth-friendly practices into her designs and aiding those with environmental sensitivities. She has even created an entire green-friendly product line of paints, linens and furniture to assure that her clients are getting only the highest quality and safest products available.

She has been a featured speaker for numerous conferences and seminars on indoor air quality issues, hosted "Air Time," a radio talk show, has

BELOW
This living room as well as the entire home was designed for Beverly Green, a very chemically-sensitive person, which necessitated extreme detail to design a "healthy environment."

NEAR RIGHT
In another client's master suite the wallcovering used is made from 100% rice paper, while the king bed has an organic latex rubber foam mattress that further enhances rest and relaxation.

FAR RIGHT
From natural bedding to natural window fabrics, Bernadette proudly poses in the eco-friendly master suite that she designed.

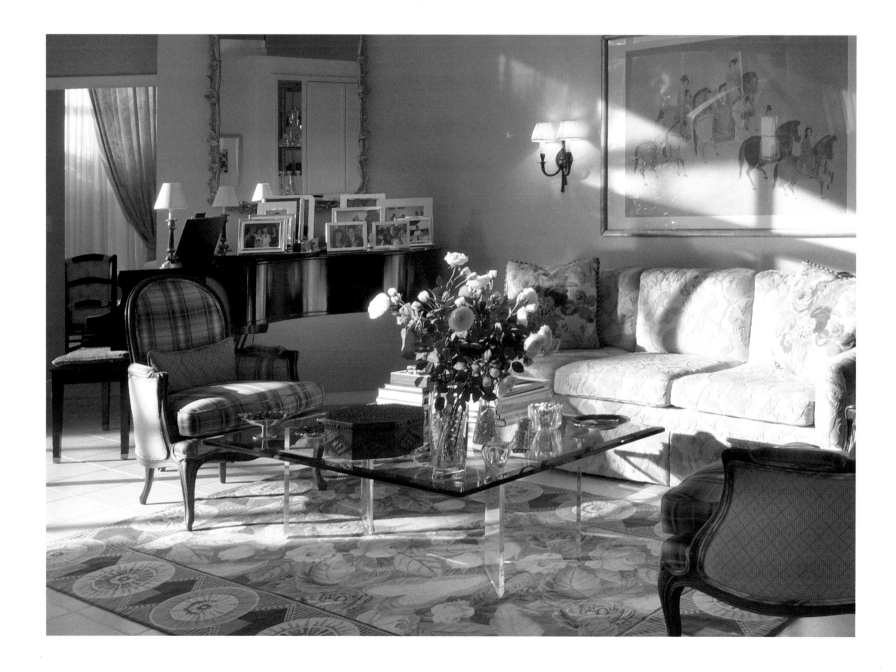

designed interiors for many organizations such as the Florida Conservation Lodge Foundation and the American Lung Association's (ALA) Health House Program. Serving on the ALA Southeast Florida Board for nearly a decade, she co-authored "A Baby's Breath" program, which educates expectant parents on the importance of creating a healthy nursery and home.

Her advocacy is that "interiors should be beautiful and breathable."

More about Bernadette…

WHAT PERSONAL INDULGENCE DO YOU SPEND THE MOST MONEY ON?

Bernadette's long, hard-working days and time constraints leave her little time for cooking, so eating out daily in restaurants is her indulgence.

NAME ONE THING PEOPLE DON'T KNOW ABOUT YOU.

Bernadette owns a jukebox and loves to dance to old time rock and roll!

WHAT IS THE MOST UNIQUE/IMPRESSIVE HOME YOU'VE SEEN IN FLORIDA? WHY?

The most unique and impressive home that she has seen is one that was owned by a former client, Rose Kennedy in Palm Beach. It was a house designed by famed architect Addison Mizner. She found the house to be classic yet charming, a stunning combination.

WHO'S HAD THE BIGGEST INFLUENCE ON YOUR CAREER?

From a design perspective, Anita Mueller, an Atlanta based designer. From a business ethics and people skills perspective, Fred Freedman, President of Carl's Furniture and from an environmental stewardship perspective, Penny Bonda, FASID, environmental interior designer/writer and ASID National Past President..

Bernadette V. Upton, ASID
Interior Designer
EcoDecor, Inc.
Bernadette V. Upton
531 US Highway #1
Suite D
North Palm Beach, FL 33408
561-845-5433
FAX 561-845-5588

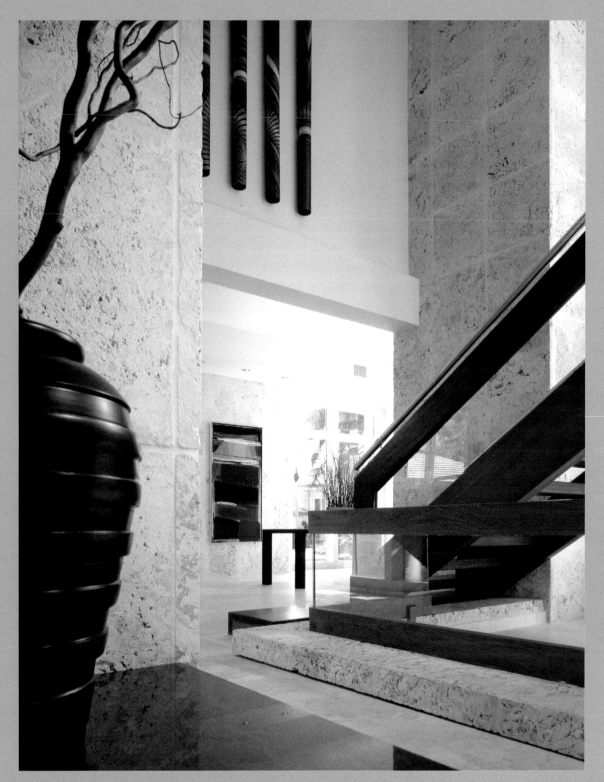

TOBY ZACK, TOBY ZACK DESIGNS, page 109

Greater Fort Lauderdale

CHAPTER TWO

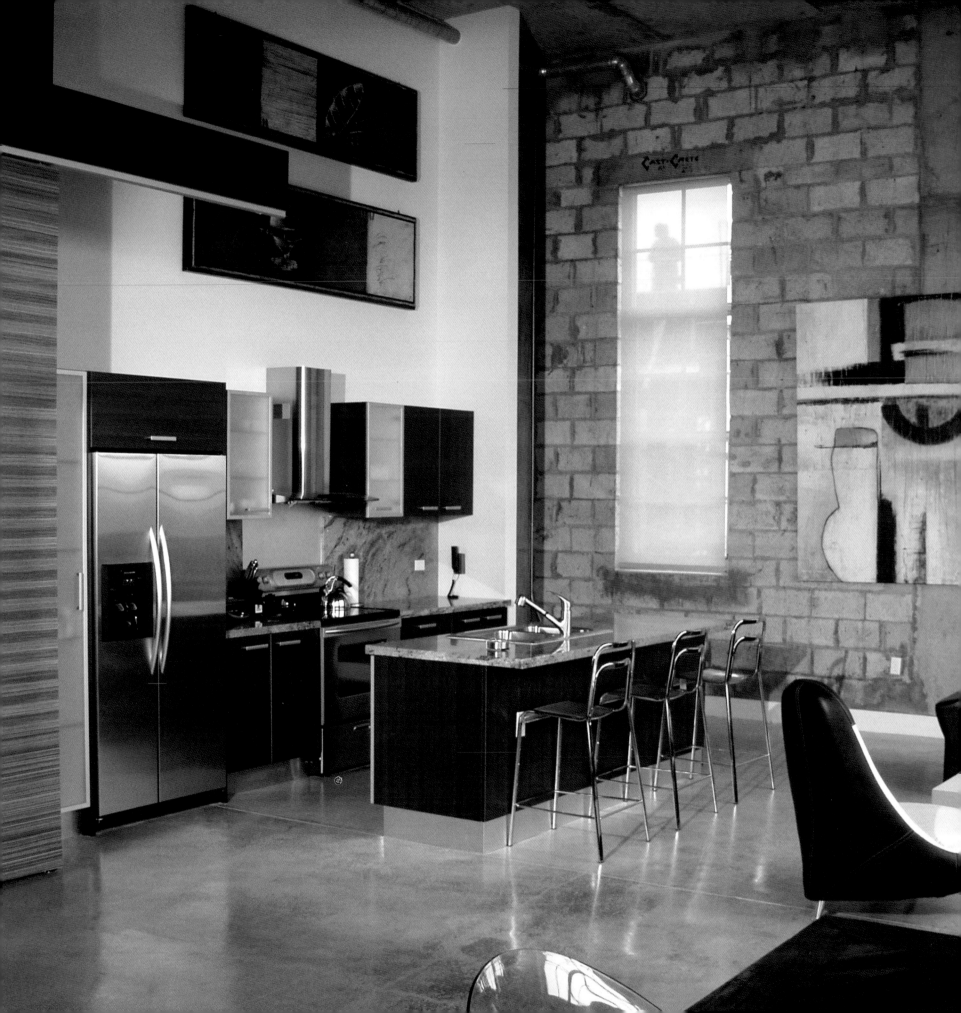

cesar and christine conde

Casa Conde Inc.

When clients arrive at the Casa Conde office for a meeting, most of them gravitate to the Tuscan farm table in the kitchen rather than the formal conference room table. Located in a Fort Lauderdale house Casa Conde purchased and remodeled, the space makes people feel at home. The company possesses a strong client base that is continually growing from enthusiastic referrals and an elite collection of vendors who have earned its trust for quality and reliability. But more than any other reason, Casa Conde fulfills its mission of masterful, personally-driven design from an incredibly talented core of young designers. While the individual members are all highly motivated and share a common passion for the aesthetic, they each contain diverse, yet complementary skill sets that are in turn orchestrated by husband and wife, Cesar and Christine Conde, the company's founders and principals.

The range of projects Casa Conde undertakes is as diverse as the clientele in South Florida. Some of the more sought-out bars, night clubs, lounges and restaurants owe part of their panache to Casa Conde's artistry. The company focuses, however, on residences, and they

recently completed a project in a Fort Lauderdale loft that exemplifies the interactive relationship they strive to achieve with each client. After intensive meetings during which Casa Conde gained a conceptual understanding of what their client desired, the team scoured through the landscape of vendors for just the right fabrics, furniture, and fixtures. The result of this partnership was a home that exceeded the

expectations of the company's client—a beautiful, clean, minimal, industrial feel. In their own words: "You've made the impossible possible."

Casa Conde relishes creative challenges. Whether designing a traditional estate home in Palm Beach or a modern Fort Lauderdale loft, Casa Conde's design approach is open-minded and versatile. Much of the

BELOW
This living room space is an art collector's dream. It has a subtle palate with a splash of vibrant colors.

FACING PAGE
A glimpse of a well thought out space for entertaining. The angular bar visually directs the flow into the other gathering areas.

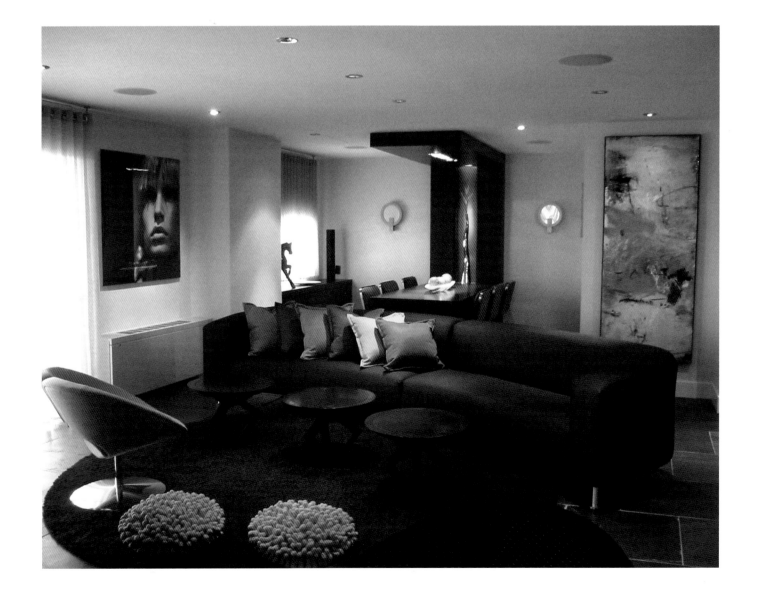

success of their projects is based on the close connections they create with their clients, making the design process more meaningful and enjoyable for all involved. In the words of one Victoria Park client: "Cesar exudes a quiet confidence that, at the same time, excites and reassures, as he shows me creative possibilities that I, as a layman, could not fathom. But throughout the journey, he has seemingly tucked away his ego—embracing (and enhancing) my own vision, rather than imposing his own."

More about Cesar and Christine…

HOW DO CESAR AND CHRISTINE DESCRIBE THEMSELVES?

Cesar and Christine admit to being very critical, with high standards. Together they value time a great deal, are generous, and love to share experiences with friends and family.

WHAT ARE SOME OF THE MAJOR INFLUENCES IN CESAR AND CHRISTINE'S DESIGN?

Basically it's a collaboration of influences starting from painters like Marc Chagall,

Paul Cézanne and Toulouse-Lautrec, architects like Antonio Gaudi with his Sagrada Family Cathedral in Barcelona, and Santiago Calatrava with his City of Arts and Sciences in Valencia.

WHAT IS CESAR AND CHRISTINE'S MAIN PASSION BESIDES DESIGN?

Cesar and Christine and their staff enjoy traveling, especially to the Old Continent and cities like New York and Montreal. There they enjoy the architecture, great food and their diverse cultures.

WHAT IS CESAR AND CHRISTINE'S FAVORITE BOOK?

They recommend *The Substance of Style*, by Virginia Postrel. It explores the evolution of aesthetics, defines who we are, our growth as consumers, and what appeals to us visually.

Casa Conde Inc.
Cesar Conde
Christine Conde
4632 N. Andrews Avenue
Fort Lauderdale, FL 33309
954-491-1185
www.casaconde.com

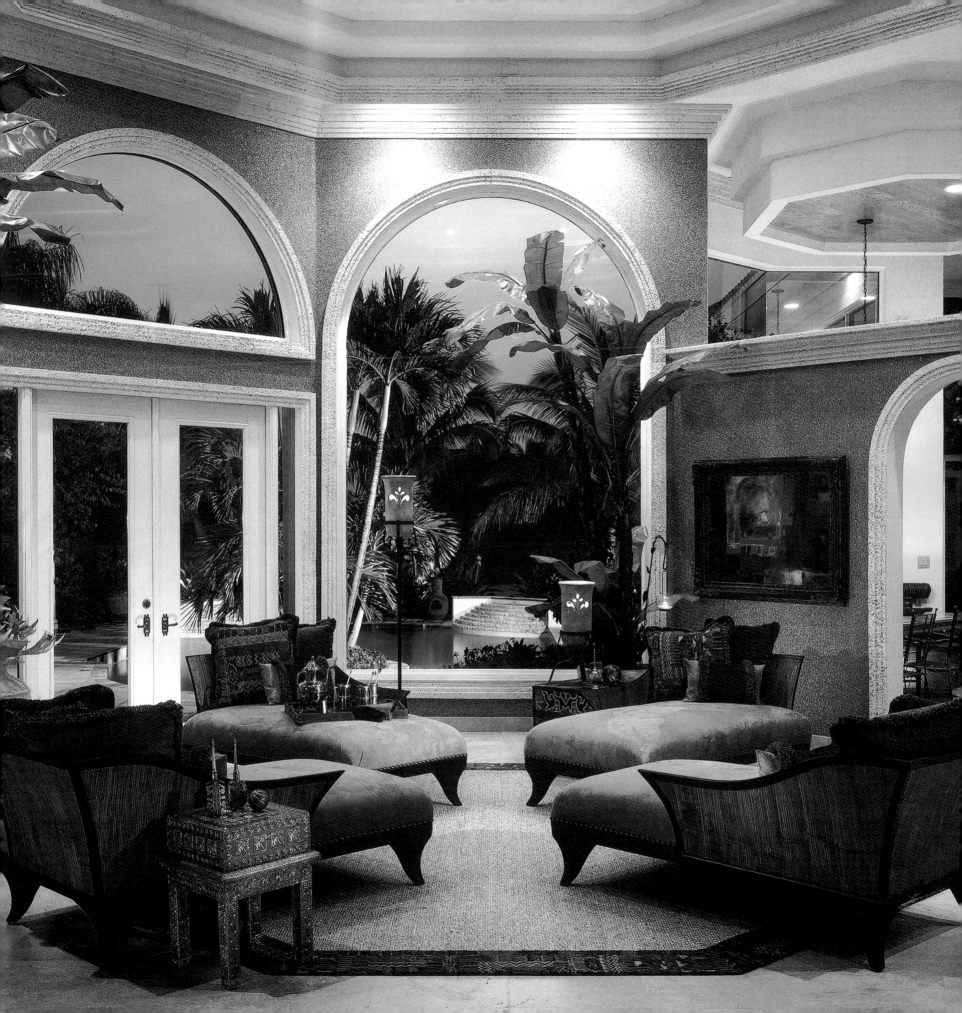

chip du pont and toni michal o'neil

Du Pont-O'Neil & Associates

Chip du Pont had been looking for a business partner for some time when he and Toni Michal O'Neil met while collaborating on a pro bono project for low-income housing. The housing development got a much-needed makeover, and Chip found his partner and formed DuPont-O'Neil & Associates. Fourteen years later, the award-winning duo offers comprehensive interior design and space planning services that have enriched the lives of discriminating clients worldwide, throughout South Florida, Latin America, the Caribbean, Chicago, Atlanta, San Francisco, Canada, and in Europe.

DuPont-O'Neil & Associates create personal spaces that express the personality and lifestyle of their clients, from raw loft spaces in high-rise condos to single-family homes that feature extensive outdoor living spaces, complete with fully equipped kitchens and fireplaces. They also collaborate with architects and builders on pre-construction and renovation projects.

DuPont-O'Neil handles all projects as a team, from conception to completion, giving clients the benefits of their vast combined experience. They are efficient and responsive to the client's needs and welcome the challenges of working with various styles. The partners excel at accessorizing, visiting furniture and accessory marts nationwide, and finding the perfect items according to the client's budget.

The design approach of DuPont-O'Neil & Associates has been honored with many awards, including the IFDA Diamante Award in Residential Design. They are also honored to be chosen as the design team for the Presidential train, "U.S. No. 1."

LEFT
DuPont – O'Neil creates a deep, richly textured space that is perfect for conversation and casual entertaining.

ABOVE
The warm cherry cabinetry and stone accent provide warmth to this family-oriented kitchen.

DuPont-O'Neil & Associates
Chip du Pont, FIIDA
Toni Michal O'Neil, ASID
1191 E. Newport Center Drive, PHC
Deerfield Beach, FL 33442
954-428-9200
www.dupont-oneil.com

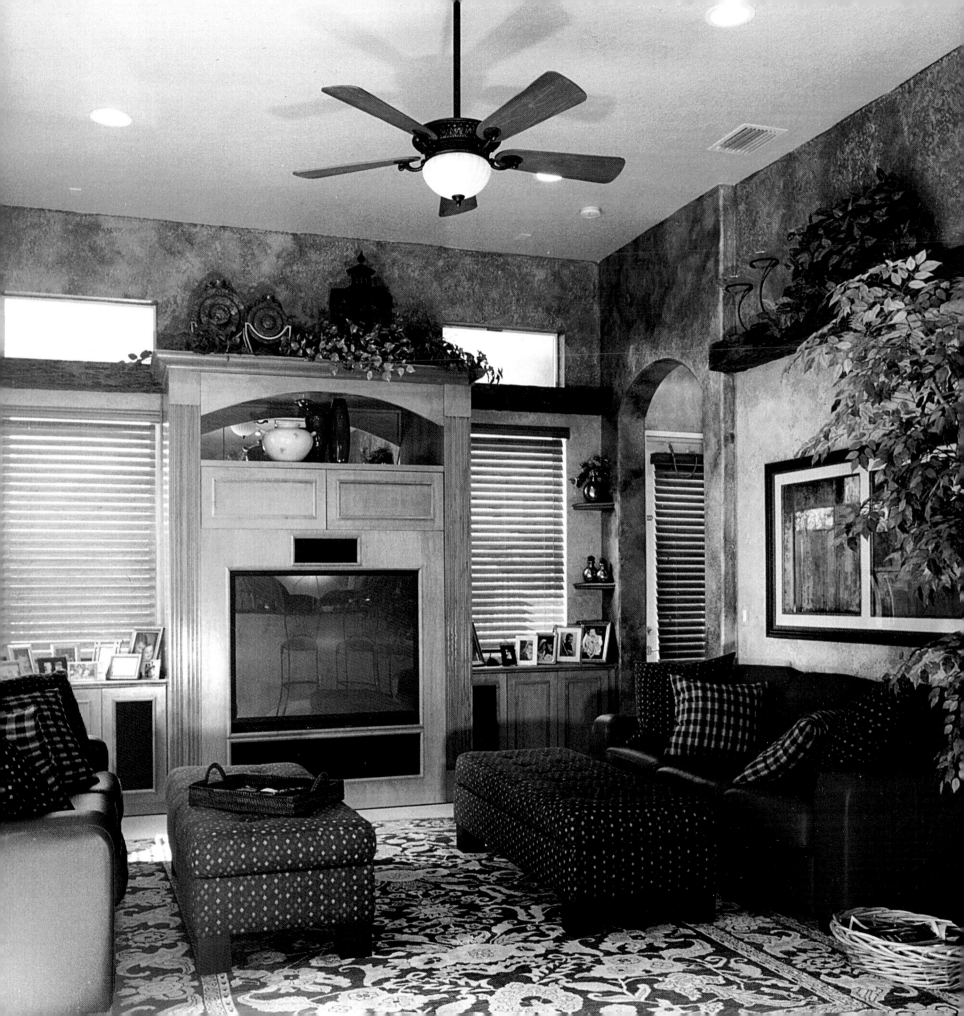

ken golen

Ken Golen Designs

LEFT

LEFT
This warm and cozy family room is accented with faux wooden beams, warm colors and comfy leather sofas with useful cocktail ottomans that also open for storage. The inspiration for this room was the hand-knotted Persian Rug.

ABOVE
This bathroom was designed using a Zen-like contemporary style. It is inviting and functional utilizing exquisite plumbing, hardware, stone and woodwork.

In his own words, Ken Golen's objective is to "turn someone's white box into a castle." From renovated condos to brand-new houses, he creates homes filled with personal touches that express the taste of his clients at its very best. A sole practitioner, Ken has nurtured relationships with a select group of local craftsmen; highly skilled carpenters, faux finishers, painters, and art experts, all of who approach their work with the same creativity and versatility that Ken himself does. Working together, they are able to transform his clients' dreams for their homes into reality.

A graduate of the University of Miami with a degree in business management and a minor in art and computers, Ken has been in the design business for six years. The Miami-born decorator works out of an office in Weston. With its own shops, restaurants, superb schools, and mayor, Weston is a community entirely separate from its neighboring big cities, providing Ken with ample opportunity to transform what often start out as beautifully maintained "basic white boxes" into singularly comfortable, welcoming homes.

While his own house is an eclectic mix of antique French and English pine furniture and contemporary elements such as black lacquered Chippendale chairs and modern art, he takes an open-minded approach to his work. In-depth meetings with his clients give him a thorough sense of their personality and color and style preferences, so he can take his cue from them as to whether they would prefer traditional, contemporary or eclectic decor. Regardless of the style, Ken delivers design that is, above all, classic and elegant.

He offers a highly personalized service of interior decorating. By knocking out walls to create airy, open spaces, he crafts luxurious kitchens and living spaces that capitalize 100 percent on the potential his clients' homes have to offer. His meticulous selection of color, artful furniture placement, and gift for showcasing a space with specialized lighting makes his interiors not only beautiful, but beautifully suited to his clients' taste and lifestyle.

Ken's innate ability to get into his clients' heads makes the decorating process exceptionally rewarding for him and them. As he reflects, "When you hear, 'This is exactly what I wanted,' it's a wonderful feeling."

FAR LEFT
This traditional bathroom is both inviting and functional, utilizing exquisite plumbing, hardware, stone and woodwork.

NEAR LEFT
Before, this dining room was a dull dark corner with no windows or lighting. Now the dining room shows depth by utilizing mirrors with beautiful coral stone trim and faux marble columns showcase the height of the ceiling adding architectural elegance to this new space.

TOP RIGHT
This kitchen is designed to be fully functional for the client's individual needs. All cabinetry and granite countertops were imported and custom-made to a high-end finish.

BOTTOM RIGHT
This formal living room with 16 foot ceilings and keystone crown molding was furnished to create a warm and inviting family room feel while maintaining its grand elegant appearance.

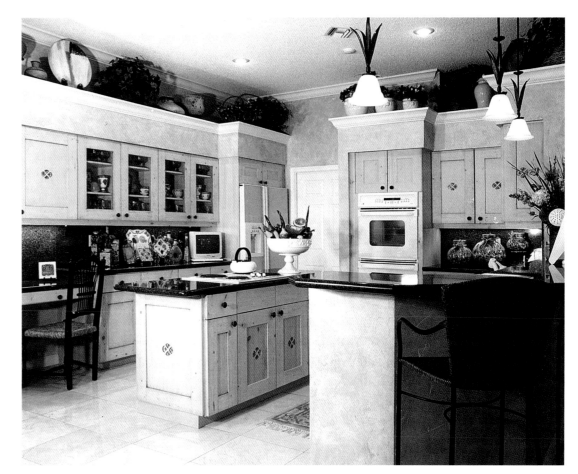

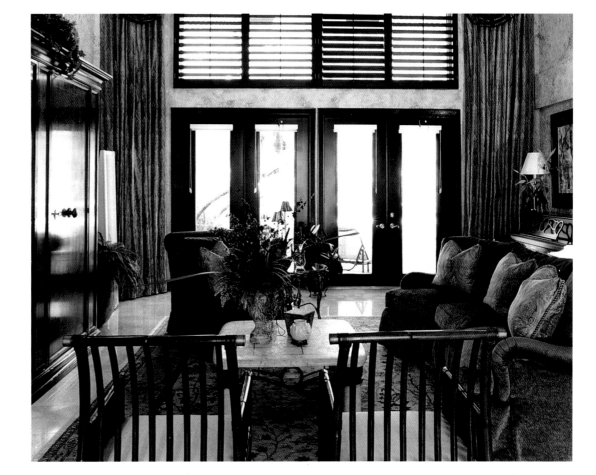

Ken Golen Designs
Ken Golen, Allied Member ASID,
Associate Member IDS
2712 Cypress Manor
Weston, Florida 33332
954-217-7388
FAX 954-217-0640
www.kengolendesigns.com

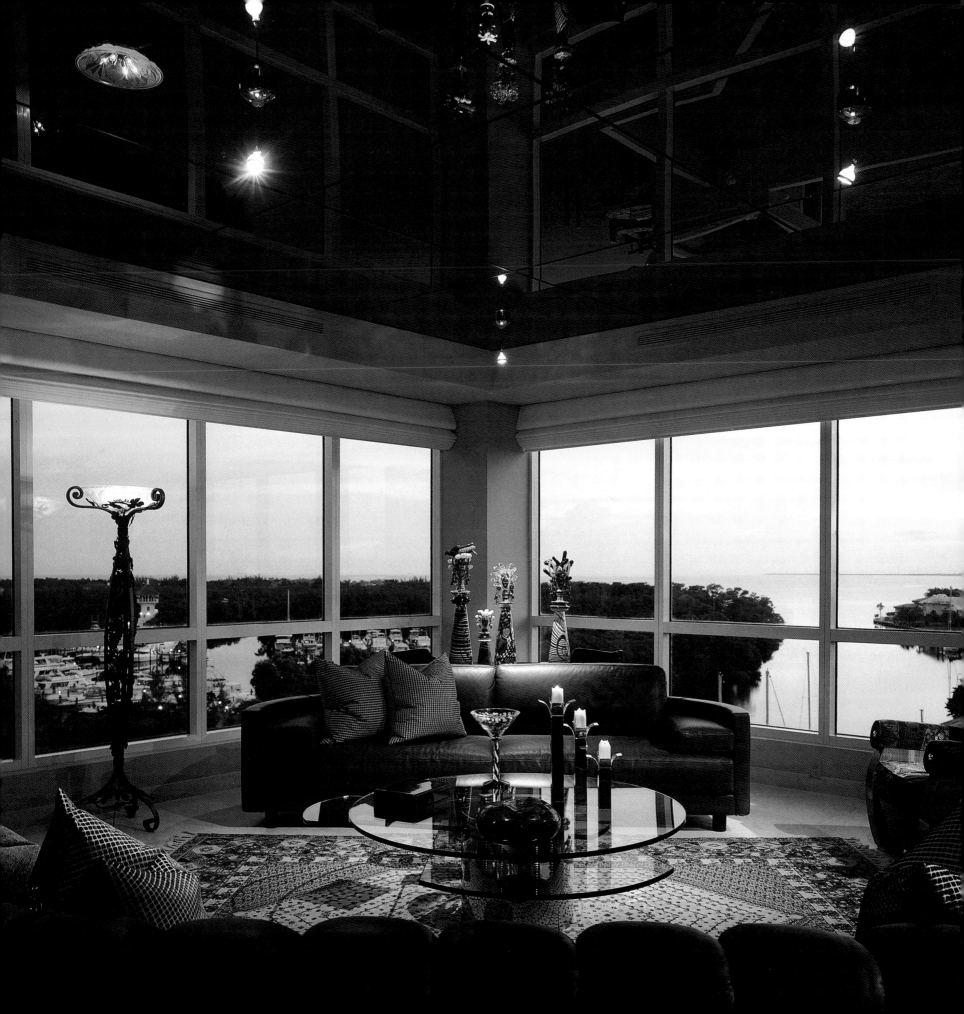

rodney harrison
Rodney Harrison Associates Inc.

Interior designer Rodney Harrison says that a "room is a backdrop for a great interior." It is like a blank canvas to an artist or a clean sheet of paper to a poet. However, while you can clutter a room with furniture and accessories, Rodney also says that without "those unique architectural details—the room is still just a box."

Since 1981, Rodney and the staff at his namesake firm, Rodney Harrison Associates Inc., has been offering the highest caliber of personalized service to residential, corporate and commercial clients worldwide

This eclectic, detail oriented designer earned a bachelor of arts degree in 1973 from the University of Florida. After working for larger design firms, he opted to open his own smaller, more specialized business, concentrating on an individualized, upscale market. "I have to have everything in my designs in a harmonious relationship," said Rodney, who designs in pleasing combinations of hues and interactions

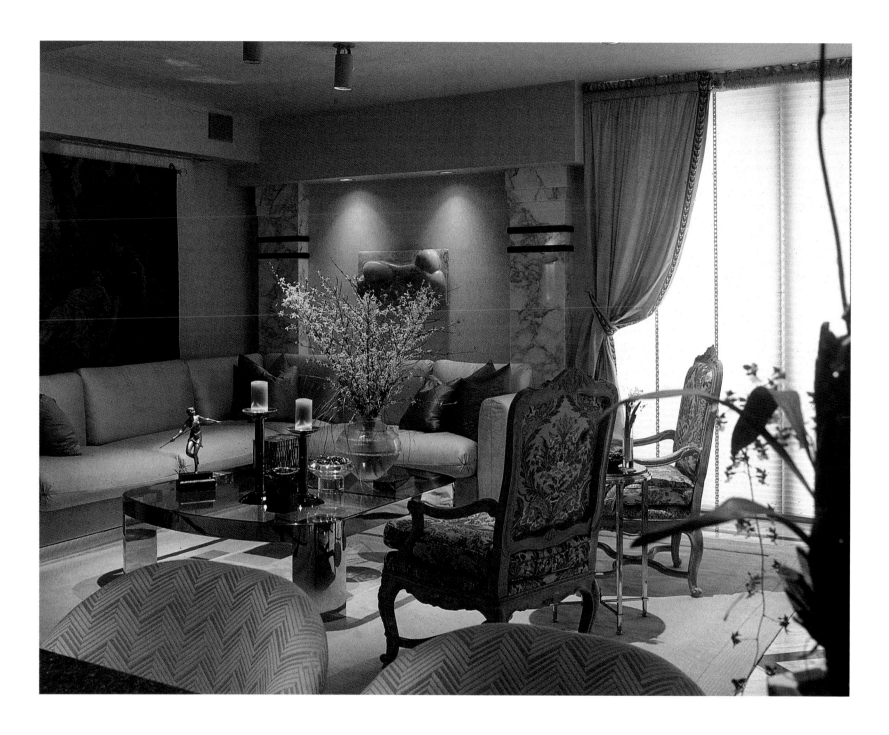

between accessories and pieces. The final results—clients who are living in comfortable, peaceful settings.

Since he opened his doors, Rodney maintains a small, tightly knit staff and provides personalized service to his global list of clientele from Florida to South Africa. His team works on major residential and commercial design and renovation projects and his designs have frequently been featured in leading publications. Rodney has also been listed in *Who's Who in Interior Design*.

LEFT
This eclectic living room combines contemporary and traditional decor showcasing marble, textured fabrics and warm lighting to provide an elegant but comfortable atmosphere.

RIGHT
Tailored warmth enhanced by bold color permeates this den. A contemporary stainless steel and glass table share this intimate space atop a hand crafted rug.

More about Rodney…

WHAT IS THE BEST PART OF BEING AN INTERIOR DESIGNER?

As an interior designer, Rodney enjoys the process of translating a client's desires into a living or working atmosphere that they really enjoy.

WHAT IS THE HIGHEST COMPLIMENT YOU'VE RECEIVED PROFESSIONALLY?

Rodney has received many accolades for his work, but his never-ending favorite is when a client is thrilled to see the original concept actually become a reality.

WHAT PERSONAL INDULGENCE DO YOU SPEND THE MOST MONEY ON?

One of Rodney's passions is raising rare orchids and palms.

WHAT ONE ELEMENT OF STYLE OR PHILOSOPHY HAVE YOU STUCK WITH FOR YEARS THAT STILL WORKS FOR YOU TODAY?

A true lover of architectural details, Rodney says that if a structure has great bones you're lucky; if not, you must create them.

IF YOU COULD ELIMINATE ONE DESIGN/ARCHITECTURAL/BUILDING TECHNIQUE OR STYLE FROM THE WORLD, WHAT WOULD IT BE?

He absolutely dislikes round structures.

NAME ONE THING THAT PEOPLE DON'T KNOW ABOUT YOU.

Rodney also owns South Florida's oldest and finest chocolate company, Jimmies Chocolates.

WHO HAS HAD THE BIGGEST INFLUENCE ON YOUR CAREER?

His second-year professor at the University of Florida taught him to dream big and never accept limitations from others.

Rodney Harrison Associates Inc.
Rodney Harrison
4865 SW 58th Avenue
Fort Lauderdale, FL 33314
954-792-2113

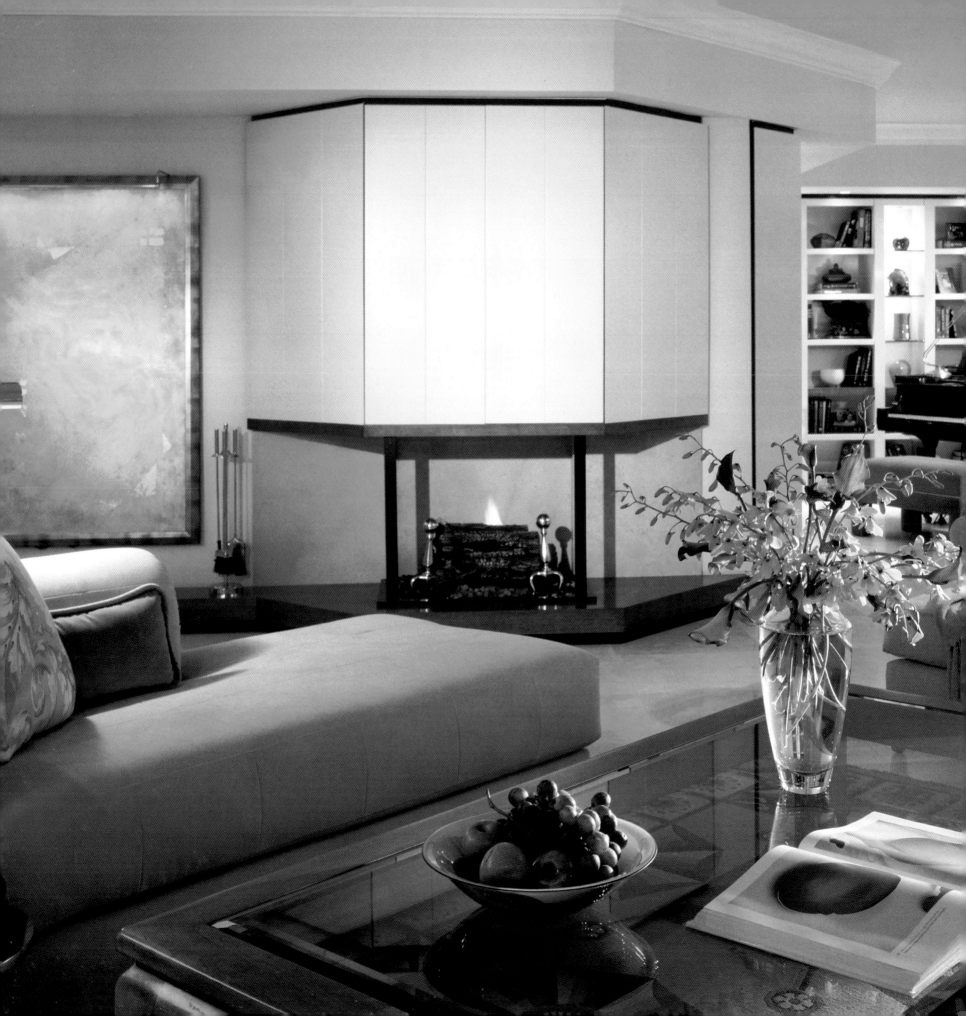

mac mcguinness
MCG Design, Inc.

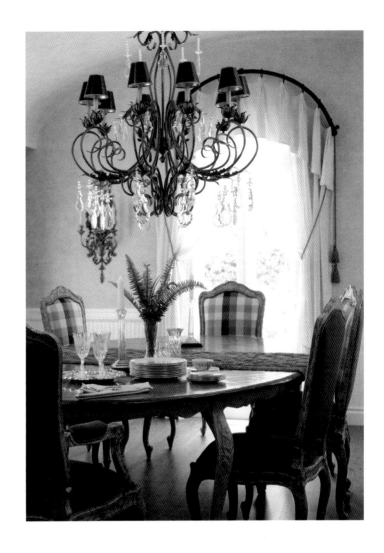

True artists know that the color blue, particularly a deep royal blue or azure, conveys a richness and depth that is not replicated in the rest of the color palette.

It's fitting, then, that Mac McGuinness, President and CEO of MCG Design, Inc., cites royal blue as the color that best describes him, given the richness of his own design experience. His journey has taken him all over the world, and his designs have enhanced residences throughout Europe, the Middle East and beyond.

But it's a mere coincidence that Mac works along Florida's blue waters in Dania Beach. Mac's company, MCG Design, Inc., specializes in high-end residential and yacht design, and in both cases, his company creates distinctive environments that exude what they term "easy-to-live elegance." The synonymous concept of "barefoot elegance" is quite popular in South Florida, as it allows homeowners and their guests to host lavish events in formal attire but also to kick off their shoes and relax—all in the same space.

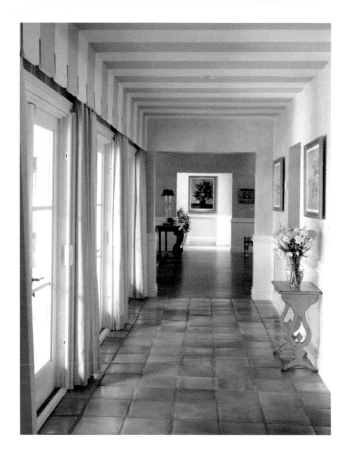

Clients come to Mac with a basic idea or thought, and he clarifies it and translates it into their vision. The end result? The finished product reflects the client's taste, whether they could articulate it at the outset or not. Under Mac's trained eye, for instance, a cookie-cutter vacation home becomes a client's personal dream house, and every detail down to the deck chairs says something about the home's owner.

Mac has never entertained thoughts of a career outside of design, and he's never wanted to. From the time he was a child growing up in London, and well before he even realized there was such a profession, he wanted to be a designer. Educational training in architecture has played a key role in the success he enjoys today, as has his commercial design experience, which he gained while heading up the interior design department

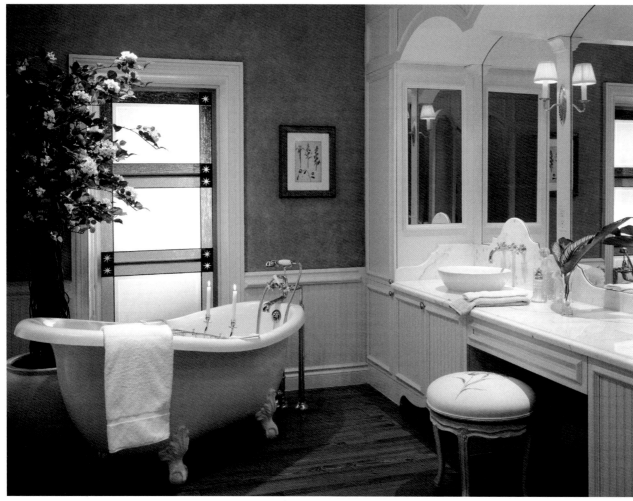

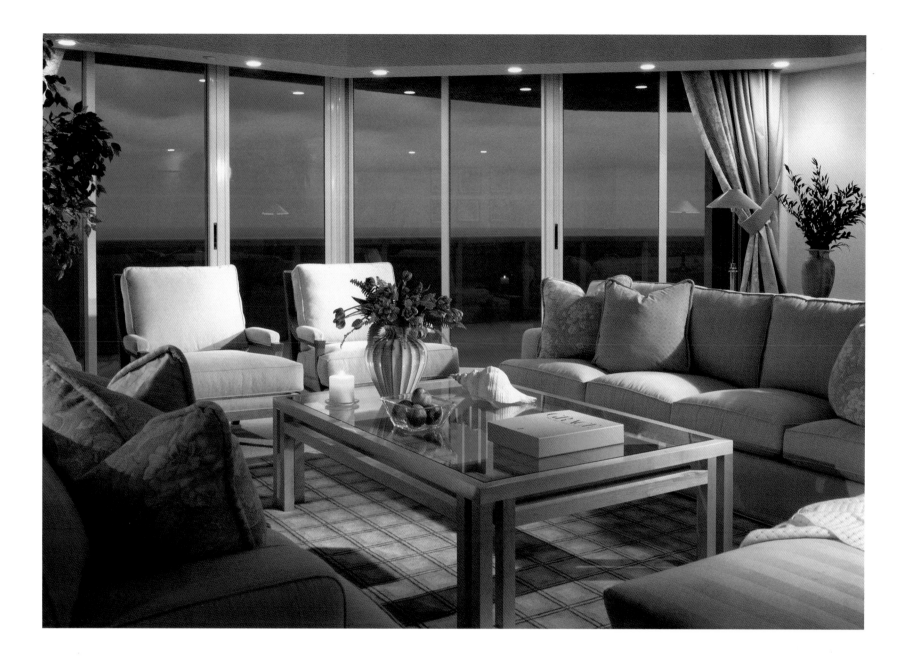

of one of Britain's most esteemed architectural firms. His aforementioned globe-trotting provides additional material for his design work today—Mac often generates new ideas based on design elements he observed in other countries years ago.

On the whole, though, Mac never looked back after arriving in America in 1989 and diving into residential work. On one of his most memorable projects, a client literally cried with joy upon seeing how Mac had remodeled and refurbished her living quarters.

Mac has learned to effectively read people, and he's able to merely sit with someone over coffee and learn a great deal about them and their design preferences in a short time. He maintains that it's just as important to determine what the client doesn't like as what they do.

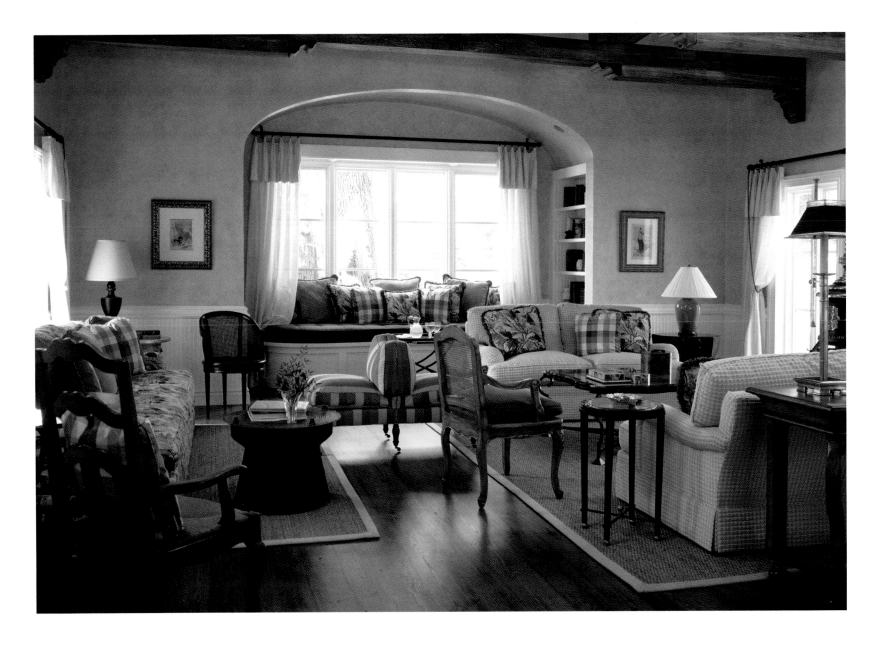

He uses that information to convert what he calls "dead, concrete boxes" into spectacular living environments. In another memorable project, Mac tackled a Fort Lauderdale condominium with a Manhattan apartment-meets-South Beach approach. He installed black-stained hardwood floors and intersected them with thin strips of silver to accompany the silver detailing throughout. A black and tan color scheme with accents of red dominated, and all of the furniture was classic contemporary and upholstered in luxurious black fabrics.

The client was thrilled. He had asked Mac to harmonize the sophistication of Manhattan

ABOVE
Aspects of European style and French Country meet in this sophisticated, yet comfortable living space.

with the festivity of South Beach, and Mac delivered. All told, Mac knows how to create settings that simultaneously exude comfort, elegance and pizzazz, and he does so time and time again with a richness and depth that only a true master could possess.

RIGHT
Blending plaids from Provence, luxurious chenilles and palm tree motifs, give this room a unique, eclectic style and quality of its own.

More about Mac…

WHAT PERSONAL INDULGENCE DO YOU SPEND THE MOST MONEY ON?

Books.

WHAT COLOR BEST DESCRIBES YOU AND WHY?

Royal Blue. It's richness, and depth.

YOU CAN TELL I LIVE IN SOUTH FLORIDA BECAUSE. . .

I do not have a tan.

YOU WOULDN'T KNOW IT, BUT MY FRIENDS WOULD TELL YOU I WAS…

Modest.

WHAT BOOK ARE YOU READING RIGHT NOW?

The Egyptologist and *Eats, Shoots & Leaves.*

WHAT ONE ELEMENT OF STYLE OR PHILOSOPHY HAVE YOU STUCK WITH FOR YEARS THAT STILL WORKS FOR YOU TODAY?

"Easy to live elegance."

IF YOU COULD ELIMINATE ONE DESIGN/ARCHITECTURAL/BUILDING TECHNIQUE OR STYLE FROM THE WORLD, WHAT WOULD IT BE?

They all have their merits.

WHAT IS THE MOST UNUSUAL/ EXPENSIVE/DIFFICULT DESIGN OR TECHNIQUE YOU'VE USED IN ONE OF YOUR PROJECTS

Gold leaf over "painted" with colored glazes.

WHAT IS THE HIGHEST COMPLIMENT YOU HAVE RECEIVED PROFESSIONALLY?

Client cried with joy!

WHAT IS THE SINGLE THING YOU WOULD DO TO BRING A DULL HOUSE TO LIFE?

Color (Paint).

MCG Design, Inc.
Mac McGuinness
Design Center of the
Americas
1855 Griffin Road
Suite. B-480
Dania Beach, FL 33004
954-921-9843
FAX 954-921-1720
www.mcgdesigninc.com

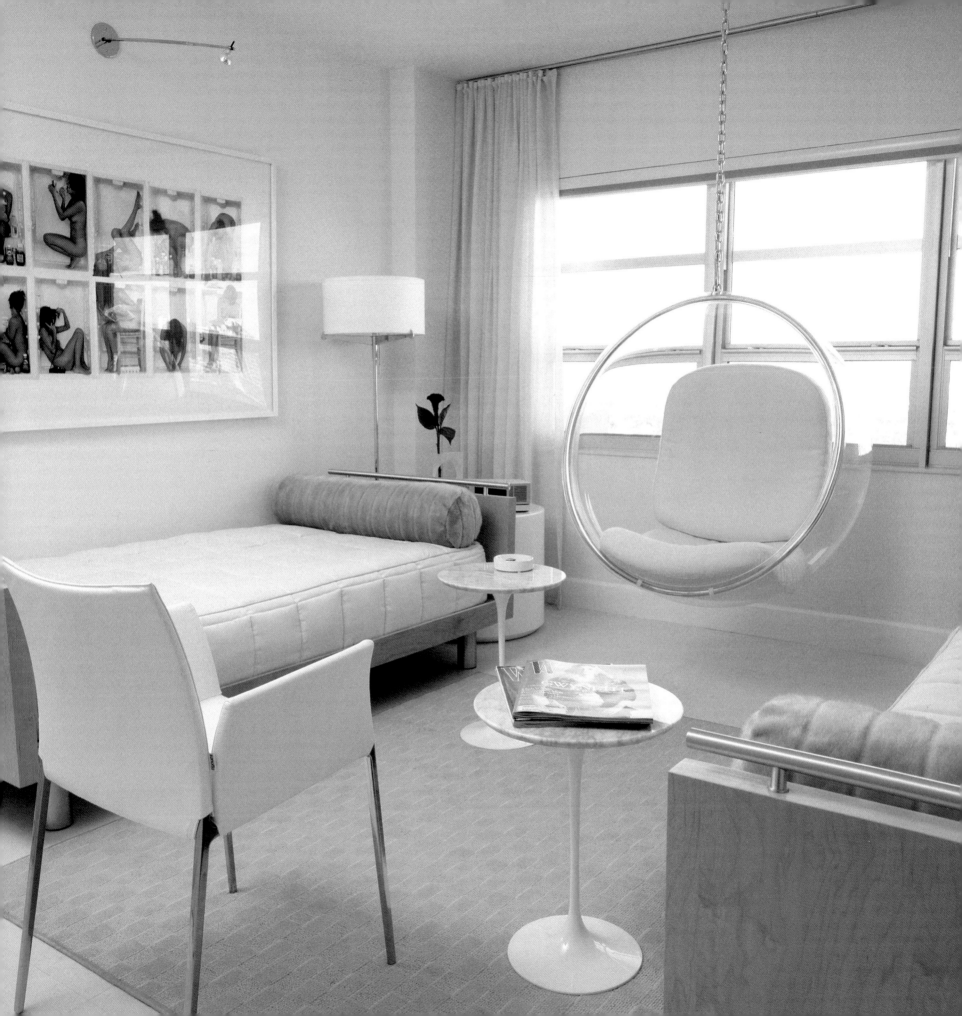

lorenzo b. mollicone
and tony ferchak
William Bernard Design Group

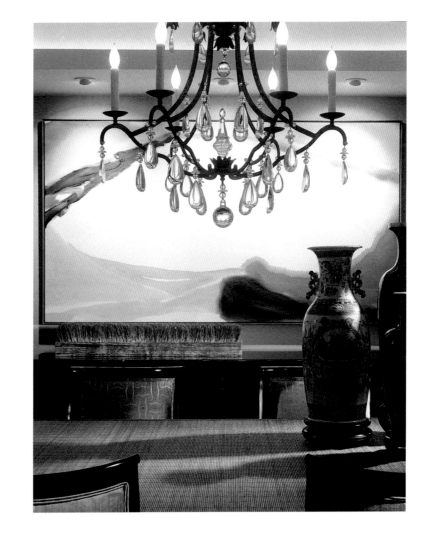

The design philosophy of partners Lorenzo B. Mollicone and Tony Ferchak is simple: "Deliver what the client wants." So when a client who had a vast art collection told the pair that she loves the way they designed her apartment so much that she often gets up in the middle of the night just to walk around in it, they knew they had delivered.

The duo met at a Fort Lauderdale design firm five years ago and merged their talents to create the William Bernard Design Group. This award-winning team has combined experience of over 25 years designing timeless and classic interiors ranging from the classic/traditional to the contemporary.

Tony was born in Washington, D.C., graduated from the University of Maryland and relocated to South Florida in 1990, graduating from the Art Institute of Fort Lauderdale. Tony is fluent in the process of working with contractors and owners from the blueprints and conceptualization stage, overseeing installations and finishing touches, right up until it is time to move in.

Lorenzo focuses on interior accents and scours the world for the perfect details. Born in Rome, Italy, and raised in New York, Lorenzo began his schooling at the Fashion Institute of Technology, and graduated from the Art Institute of Fort Lauderdale. Lorenzo prefers working with clients who bring personal items into a job.

Tony's hands-on involvement with contractors and artisans combined with Lorenzo's vision and design equal an unparalleled balance and harmony to their client's projects. Tony and Lorenzo do not boast a signature look and their interiors are neither trendy nor stylistic. Instead, the client's taste, style, personality and vision guide the finished product.

This solid business partnership and talented duo have been recognized for their designs, as recipients of a 2005 "DCOTA Rising Star Awards" for a premier living room/dining room. The awards celebrate the exceptional creativity of Florida's design professionals. Their designs have also been featured in *Architectural Digest, Florida Design, Interior Design* and *Condo Living* magazines.

BOTTOM LEFT
Velvet upholstered panels soften the clean lines of the wenge wood bed. Miami Beach artist Mira Lehr's #9 Moonflower imparts an Asian feel.

BOTTOM RIGHT
2 glass topped wenge wood shelves display the owners' collection of Baccarat glassware and African masks. A sculpture by Sorel Etrog, "Knotted Figure," stands on the bar.

FACING PAGE
The red, green, cream and gold hues of the oriental rug were carried throughout the home. Dale Nally's painting, Realm #9," pops against a wainscoted, antique-white wall."

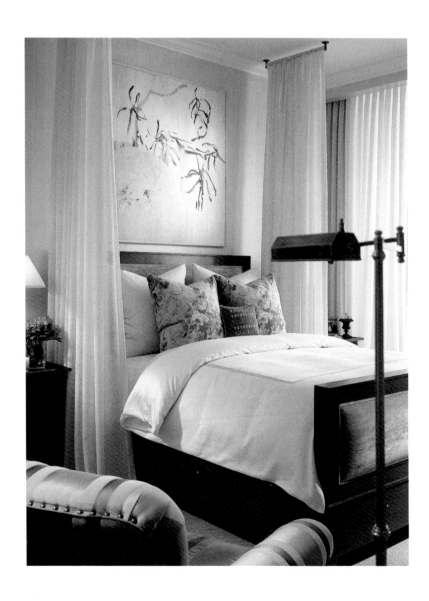

More about Lorenzo and Tony...

LORENZO, WHAT ONE ELEMENT OF STYLE OR PHILOSOPHY HAVE YOU STUCK WITH FOR YEARS THAT STILL WORKS FOR YOU TODAY?

What's "in" is "out."

WHAT'S THE HIGHEST COMPLIMENT YOU'VE EVER RECEIVED?

When faced with many obstacles on a particular project, the client expressed to a prospective client that he was always confident that our design firm would see things through to the completion of the project and not leave any loose ends.

DESCRIBE YOUR STYLE OR DESIGN PREFERENCES.

Simple, clean, eclectic and personal.

TONY, WHAT IS THE BEST PART OF BEING AN INTERIOR DESIGNER?

Every day is different.

William Bernard Design Group
Lorenzo B. Mollicone
Tony Ferchak
821 N Federal Hwy
Fort Lauderdale, FL 33304
954-7633900
FAX 954-769-4940
www.williambernarddesigngroup.com

dennis pelfrey
Dennis Pelfrey Interior Designs, Inc.

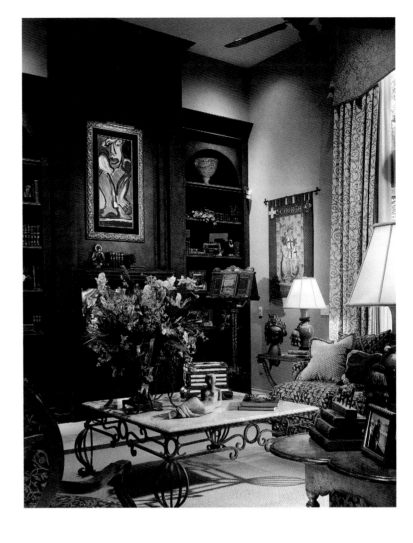

For more than 25 years Dennis Pelfrey, president of Dennis Pelfrey Interior Designs, Inc., in Fort Lauderdale, has shown a rare sensitivity and an artful hand, combining contemporary and classical style infused with sumptuous color to create a unique design that meets the needs and desires of each client —innovative but with a nod to the classic.

Whether designing exquisite vacation homes, luxurious private residences, or prestigious corporate offices from New York to the Caribbean, Dennis' client roster runs the gamut from first-time home buyers to celebrities and corporate CEOs, but he never loses sight of the individual attention each client deserves, bringing a fresh contemporary vision to each project he undertakes.

When asked to describe his personal taste, Dennis replied, "a polished style that is strong and sophisticated." Depending on his vision and personal interaction with his client, Dennis might draw upon the Gothic and the Arts & Crafts periods, introducing a strong color palette and a careful mix of ancient relics with

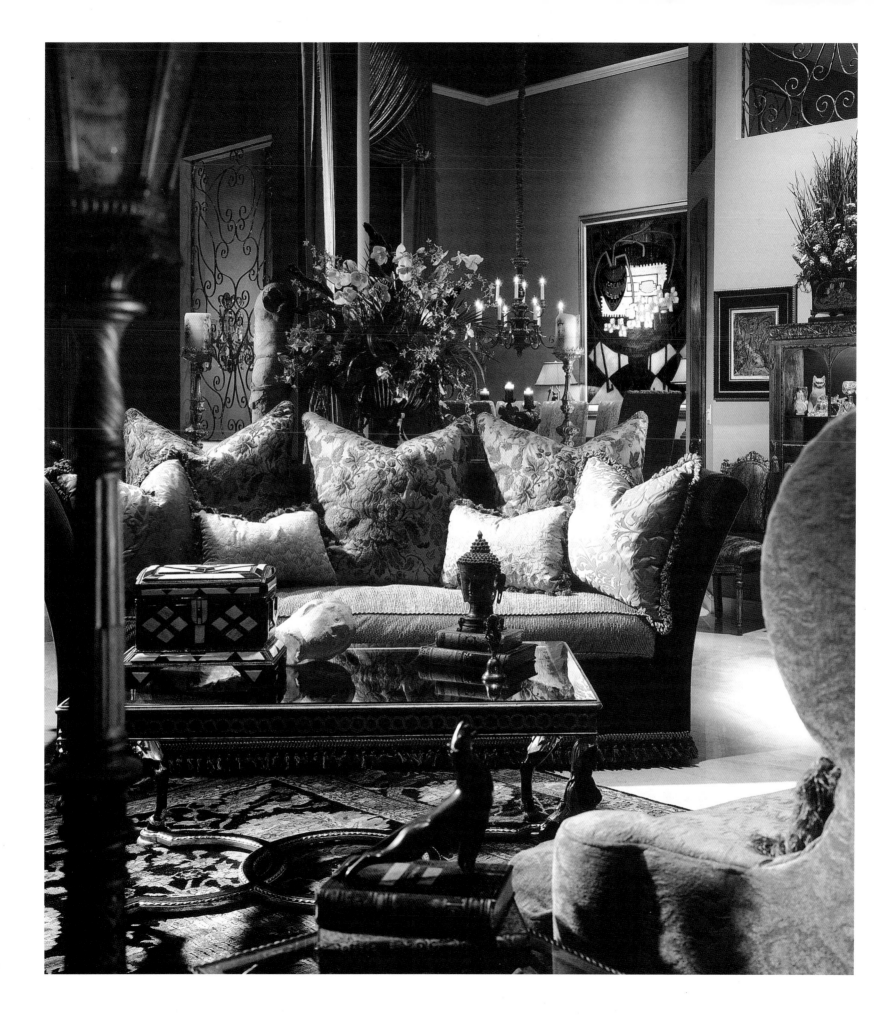

14th to 17th century Greek or Roman artifacts. Or he might opt for a more Spanish-Mediterranean Revival style reminiscent of Addison Mizner.

Whatever the style, rest assured it will be striking and a wonderful combination of elegance, substance, rich colors and comfort.

The many accolades Dennis has received include "South Florida Best Award for 1999" by the Builders Association of South Florida, and "Designer of the Year" by The Design Center of the Americas. He has appeared numerous times in prestigious design magazines and is often chosen to feature his designs for showcase homes. The Discovery Home Channel has featured his designs in the 2005 edition of "Picture This."

It is no wonder he has garnered such praise for his interiors. With an emphasis on comfort and timelessness, the beautifully scaled rooms are cleanly composed and whether they feature accents and colors that are dynamic and dramatic or classic and soothing, they will always be approachable, inviting and, above all, livable.

LEFT
Oriental rugs anchor the sumptuous downfilled living room sofa, which is customized with over a dozen textured fabrics and trimmings to set a soft tone. Artifacts carefully collected, such as the Circa 200 B.C., marble head fragment casually accessorized the French empire cocktail table.

ABOVE RIGHT
A Conquistador statue heralds the dining room, where Danielle Lauteigne's, "Citrons tet Raisins" adds a contemporary note to the old world setting. The designers custom skirted guest chairs with tapestry band overlay add a romantic elegance.

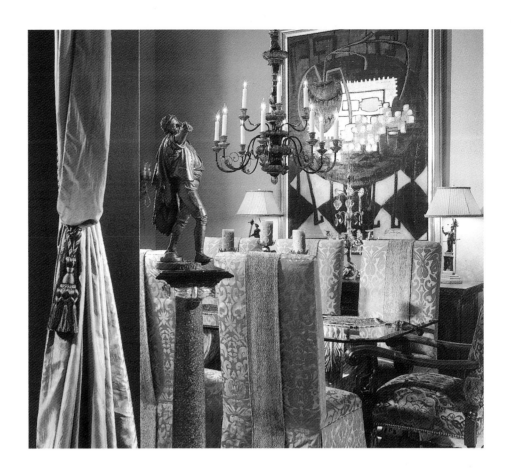

More about Dennis…

WHAT TYPES OF COLLECTIONS DOES DENNIS OWN?

He collects Gothic church architectural elements and artifacts, including metal crosses from trips to Amsterdam and Germany, a six-foot stone angel and other religious icons. He finds these religious items soothing.

WHAT DOES DENNIS DO FOR FUN?

He just bought a new home and spends much of his spare time outdoors, compulsively watering his yard and plants. He also owns a chocolate lab— his best buddy.

WHO INSPIRES DENNIS?

He loves the work of renowned architect Addison Mizner. "He had his own sources in the 1920s who would do things his way and if he couldn't buy it, he would make it," said Dennis. "His timeless designs are very desirable and people are still striving for his look."

Dennis Pelfrey Interior Designs, Inc.
Dennis Pelfrey
2816 NE 14th Ave
Fort Lauderdale, FL 33334
954-565-7179

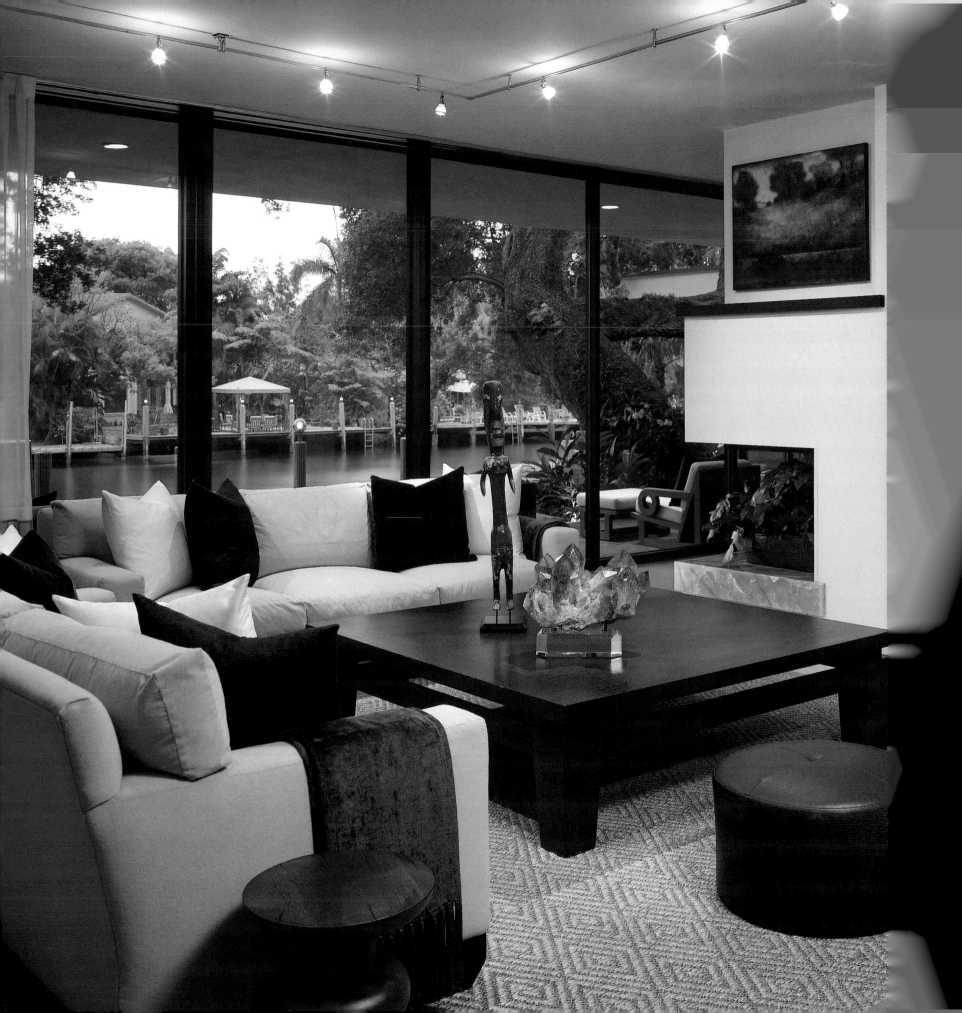

cheree roberts
SW3 Designs

For interior designers, inspiration comes in many forms. For Cheree Roberts, inspiration comes from the perfect balance of contrasted colors and textures found in nature. While hiking in Telluride, Cheree came upon a rocky area where a brilliant fuschia flowering plant was contrasted against sheets of dark gray, taupe rock. "It struck me; I had the perfect mix of color and texture for a job I was working on." This talented designer incorporates these experiences and more into her own personal design style.

For the past decade, Cheree Roberts of SW3 Designs, has created spaces that her clients can connect with. "Before I begin, I spend time with my clients. I need to know how they live and what will fit into their lifestyle. Then I get an image in my mind." To Cheree, her clients' homes should also reflect where

ABOVE
Cheree creates a serene environment through calming colors and textures
for her clients, whose hectic daily lives often contrast the serenity achieved here.

BELOW
This bathroom showcases one of Cheree's custom designs for the vanity,
against a glass tile wall.

they are in life. "My designs are about luxury, but not in the conventional meaning. Today, luxury is more about how your home makes you feel and the mood surrounding it. I believe calming colors will calm the soul. Luxury is having the time to use every part of your home surrounded by your family and the things that bring you joy. I call it simple luxury."

Cheree also uses minimal but striking elements to keep the focus on her clients' personality within the home.

Fortunately for Cheree, her proclivity for design and business is in the genes. "My mother has the most incredible sense of style and scale of any designer

BELOW LEFT
The wall unit in this elegant living room opens to reveal an entertainment center, transforming the room into an enjoyable and usable space for the whole family.

BELOW RIGHT
These original paintings, purchased in Santa Fe, are part of Cheree's personal collection. The artist said the paintings were her interpretation of "life in eternity."

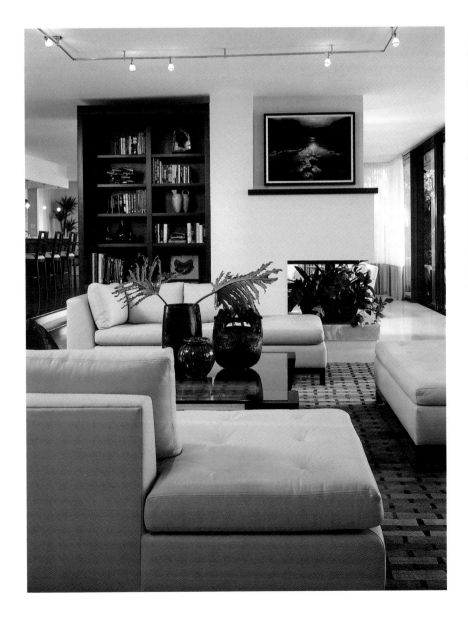

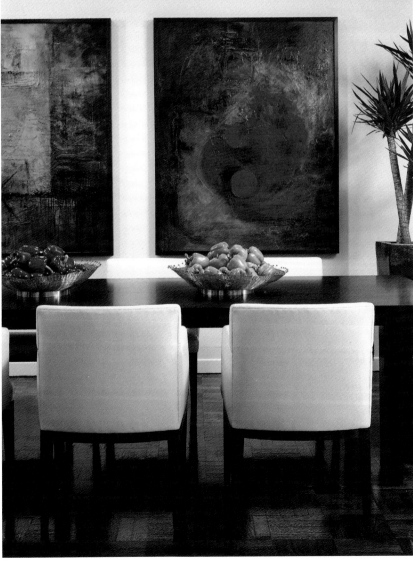

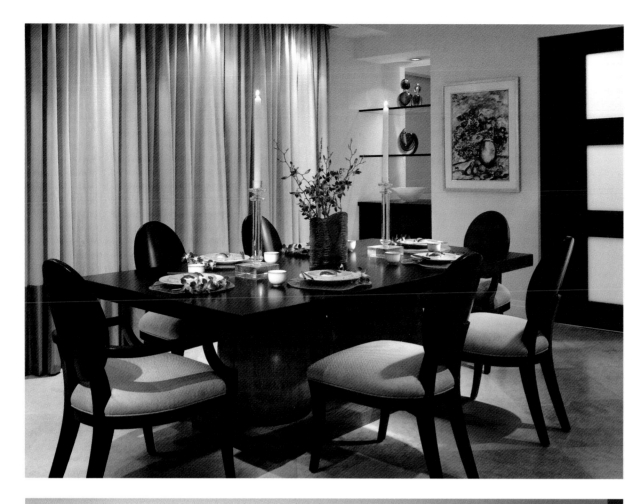

I know. My father has great business sense and has influenced me immensely in my business." She also credits her very competent and multitalented staff for contributing to her success. While awards, accolades and magazine covers abound SW3, above all else, Cheree's passion has always been in making her clients happy. When her vision materializes, thrilling her clients, only then is she truly satisfied.

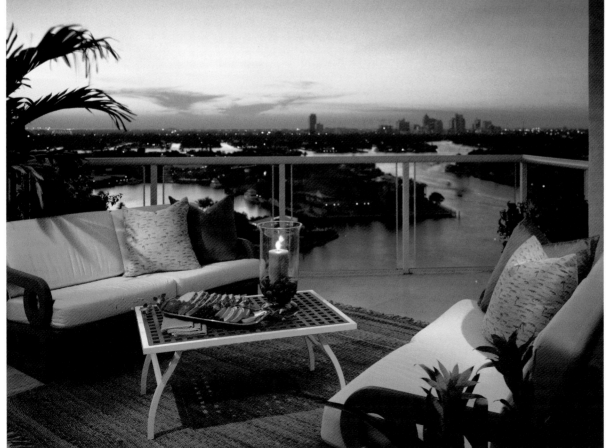

ABOVE
This Zen dining room table was chosen by Cheree because of its designer. "Peter Alexander does the most amazing dining room tables. This is one of favorite pieces."

NEAR LEFT
Because Ft. Lauderdale has such beautiful sunsets, many of Cheree's clients desire outdoor living spaces in which to enjoy those views and much more.

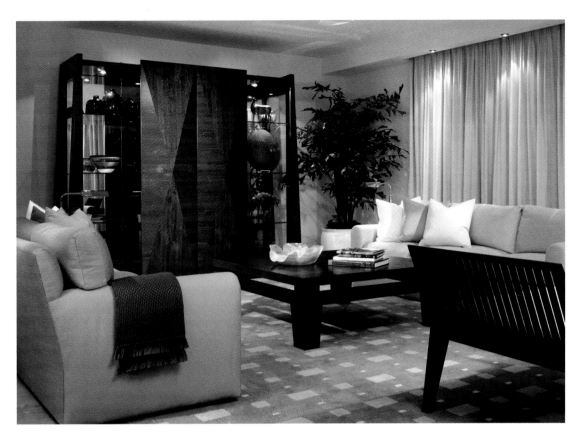

More about Cheree…

WHAT PERSONAL INDULGENCE DO YOU SPEND THE MOST MONEY ON?

Cheree indulges in a personal chef. With such a busy schedule, she says that not having to worry about cooking has allowed her more free time with her family. She also counts handbags and buying and selling real estate among her favorite indulgences.

IF YOU COULD ELIMINATE ONE DESIGN/ARCHITECTURAL/BUILDING TECHNIQUE OR STYLE FROM THE WORLD, WHAT WOULD IT BE?

Faux coral columns.

WHAT BOOK ARE YOU READING NOW?

In preparation for an upcoming trip to Greece, Cheree is reading several books on Greek culture and customs.

WHAT IS THE BEST PART OF BEING AN INTERIOR DESIGNER?

Her clients are Cheree's favorite part of being an interior designer. "They are the most amazing people that I get to know." She also says that being an interior designer has given her a free ticket to be creative. "I love creating spaces for people to live in, it gives me great pleasure."

WHAT ONE ELEMENT OF STYLE OR PHILOSOPHY HAVE YOU STUCK WITH FOR YEARS, THAT STILL WORKS FOR YOU TODAY?

Cheree sticks with what she terms as "simple luxury. It applies to every type of interior, whether you are designing in Key West, Mediterranean, or Rocky Mountain, my clients want to live comfortably, without a lot of excessive stuff."

WHAT IS THE HIGHEST COMPLIMENT THAT YOU HAVE RECEIVED PROFESSIONALLY?

Cheree's designs have made the cover of magazines, which she calls, "a compliment because that means someone likes your work and it's good enough for the cover."

WHAT IS THE MOST UNIQUE/ IMPRESSIVE/BEAUTIFUL HOME YOU'VE SEEN IN SOUTH FLORIDA?

"Of course, I have to say mine, because I have a wonderful 200-year old oak tree that canopies my pool. It's just such a beautiful view, it's my most favorite place to be."

SW3 DESIGNS
Cheree Roberts
420 South East 17th Avenue
Fort Lauderdale, FL 33301
954-760-7199
FAX 954-760-4133
www.sw3designs.com

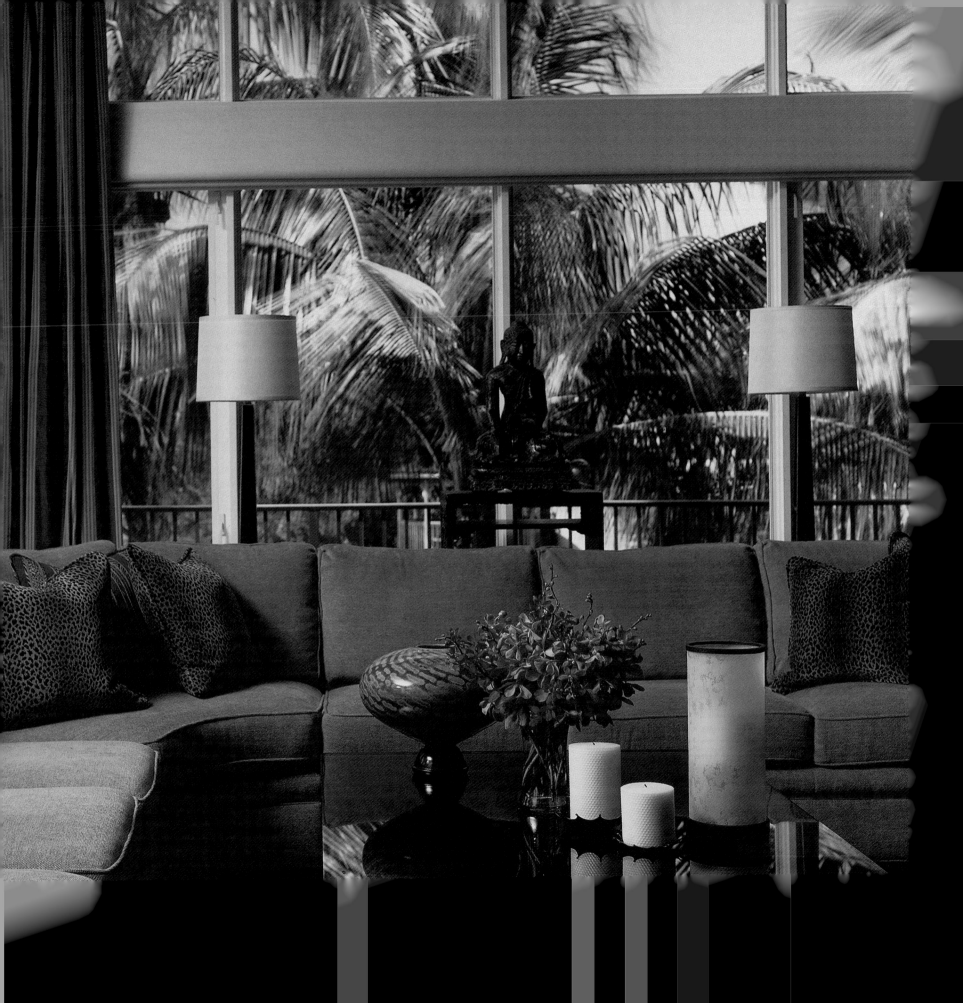

tamara tennant

Tamara Tennant Interior Design, Inc.

Most people would savor living in a luxurious setting, but they also cherish comfort and livability. Fortunately, people can turn to Tamara Tennant Interior Design, Inc. Tamara creates elegant spaces that are livable and comfortable. Her clients are inspired and proud of their exquisite surroundings; yet they can really relax and enjoy every space in their home.

Throughout her twenty-five years in the design business, Tamara has refined her style to one that blends superior design with undivided attention to detail. Bright, easygoing and creative, Tamara has spent a great deal of time in Europe, which has contributed to her love for beautiful old moldings, original artwork, and the many intricate details that render a home exceptional.

Although Tamara currently divides her time between Florida and New York City, and her clients span the globe, her award-winning design firm has a boutique feel. Her philosophy is to offer each client personal attention.

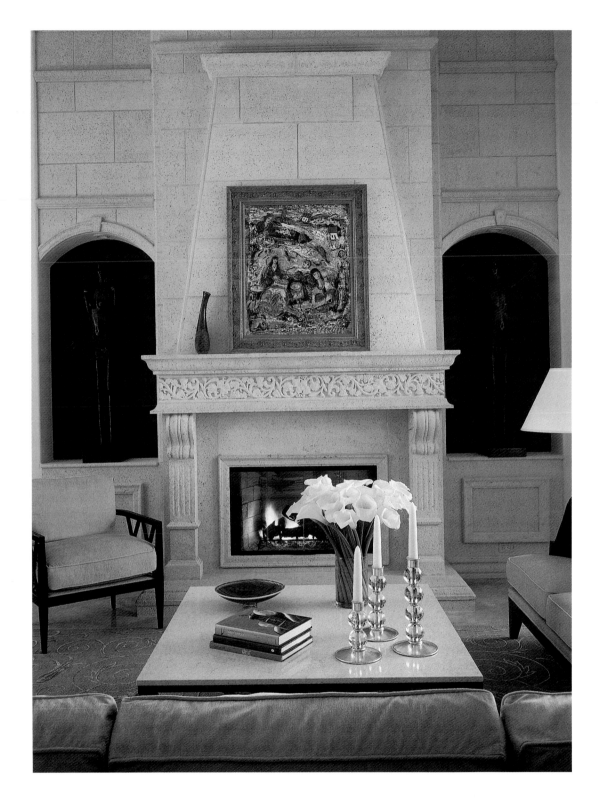

Recently, Tamara completed a design endeavor that she describes as 'Manhattan-meets-Florida.' The finished residence is filled with a beautiful art collection, including original paintings and magnificent sculptures, luxurious furnishings, fabrics and rich colors—as well as palm trees and water. Tamara says, "I love it and so do my clients. It exudes the classic Florida lifestyle with touches of the Big Apple."

Tamara has a passion for her work. She truly enjoys her clients and wants to please them. She spends a lot of time getting to know each and every one personally, learning their lifestyles, tastes and desires in order to create an environment that fits a particular family's needs.

It is no surprise that her accolades are abundant—she has won numerous local and national awards and has been featured in countless publications—or that her projects and styles run the gamut: everything from traditional European to classic contemporary and Country French.

"Most of my clients have good taste and their own unique style," Tamara explains. "I just help them refine it and translate it into a spectacular, luxurious environment that is neither stuffy nor overdone."

ABOVE
In the living room, royal blue sink pillows accent cream chenille on classic contemporary furniture. An Albric Soly oil painting tops the mantle, and Asher bronze sculptures occupy niches beside the fireplace.

FACING PAGE
Different textures of ivory silk, animal prints and subtle lighting combine to create a seductive master bedroom. The original Aromi-Mariera painting above the bed reflects the owners' passion for art.

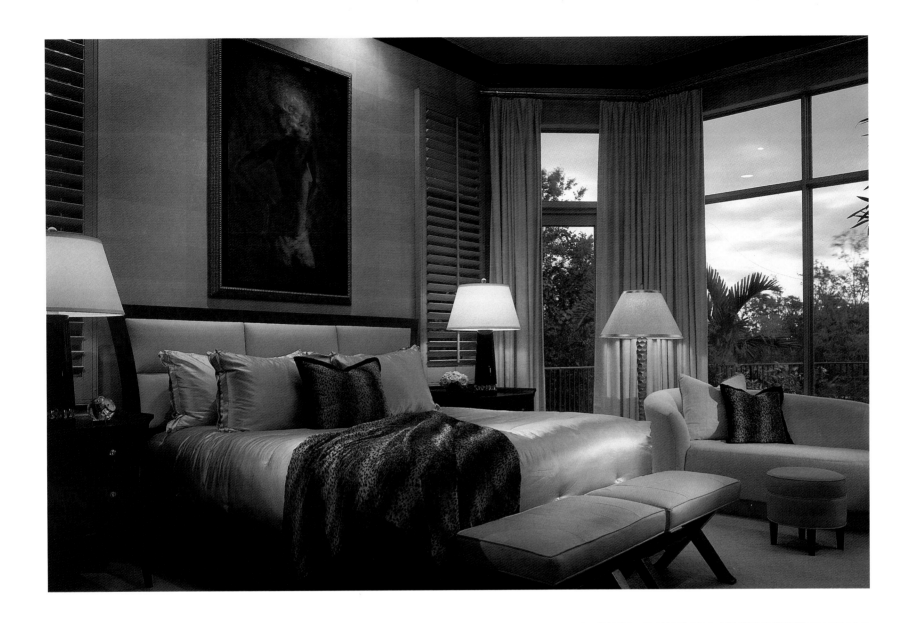

More about Tamara...

WHAT PEOPLE DON'T KNOW ABOUT ME?

In addition to my home on the water in Fort Lauderdale that I share with the love of my life, we have a wonderful chalet in a little village in the Alps of Switzerland.

MY FIRM'S FIRST PROJECT

I devoted an entire year to the design of a 35,000-square-foot estate in Palm Beach.

MY FAVORITE COLOR

Is Red. It emits energy and stirs passion, but I only wear it occasionally. I prefer to wear shades of straw or black that do not compete with what I am designing.

THE ULTIMATE COMPLIMENT

To see a client's face light up when they walk into their completed home, and to hear them say that they absolutely love it!

Tamara Tennant Interior Design, Inc.
Tamara Tennant
2400 East Las Olas Blvd.
Suite 192
Ft. Lauderdale, FL 33301
954-763-1763
FAX 954-763-1757
www.tamaratennant.com

toby zack
Toby Zack Designs

When she first started designing homes 30 years ago, award-winning designer Toby Zack was a pioneer of contemporary style. Refusing to follow the trends of the times, she created a look that was clean, classic, and simple. There were no swags on her windows, no overdecorated living rooms, no inhospitable formal dining rooms. Instead, there were tailored comfort and elegant style entirely in harmony with the Florida setting of the homes she designed and the lifestyle of her clients. Her minimalism is executed with natural materials—wood, stone, linens, and wool. Her designs are the highest quality of originality and distinction. Today, Toby's timeless style is just as sought after as ever, if not more.

Toby sums up her design philosophy by describing her approach to window treatments. "You're buying the view, when you live in Florida. Why cover it up?" she explains in a manner that is as refreshingly direct and unpretentious as her designs. Eschewing elaborate window treatments, Toby instead favors motorized sun shades, a streamlined solution that exemplifies her partiality to simple, versatile design elements that never go out of style.

109

What she can't order from a manufacturer to suit her purposes, she designs herself. Rather than being forced to conform to a supplier's stock, Toby creates furniture that gives her more flexibility and allows her to accommodate her clients' wishes. Among the pieces she has developed are an elongated nightstand for bedrooms with long walls and an extension table that starts as a sofa backing console table, extends partially to serve as a desk, and when both leaves are opened, serves as a buffet table—on wheels, no less.

Florida Design recently featured Toby's glass-topped Parson's table with white lacquer legs—an essential item, it seemed to her, but one so hard to find that she simply created her own. She has also designed a similar dark Parson's table that works particularly well with leather chairs. The Toby Collection features her own pieces as well as fine contemporary furniture and accessories she imports from some of the world's foremost designers.

Her six-person firm, Toby Zack Designs, is a small, custom firm that provides personal attention to every job and every client. A licensed Florida designer, Toby initially meets with clients in her office so they can see samples of her furniture and more than 30 years worth of work. She interviews clients as much as they interview her, finding out the minute details of their lives that will make a difference in her approach to designing their home. By asking such in-depth questions, she not only forges a comfortable and comforting bond with her clients, but she obtains information that will enable her to create a home that is entirely tailored to her clients' needs.

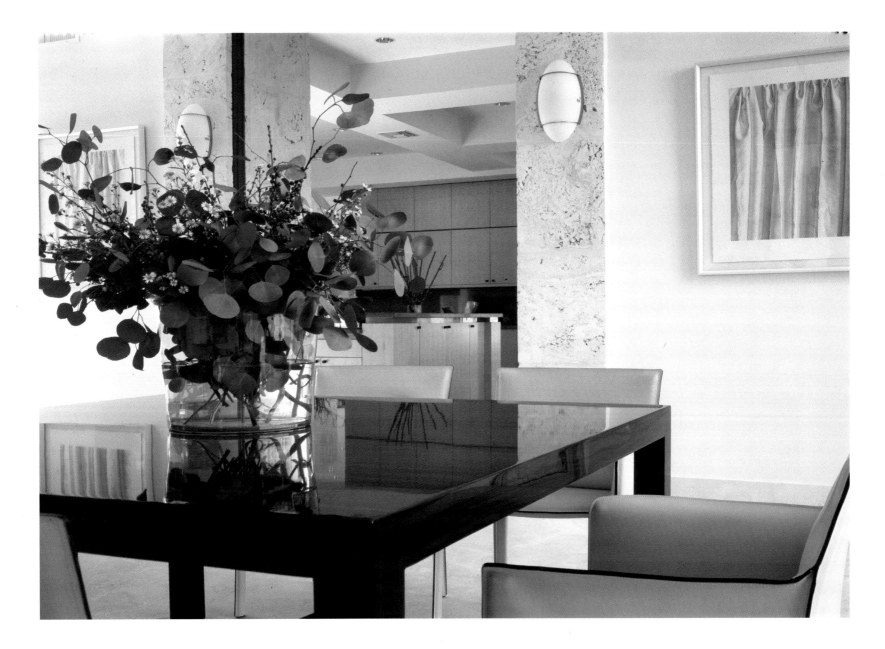

The recipient of the IDG Award, Fame Award, and Williams Island Award, Toby loves 20th century modern pieces. She has two Barcelona chaises in her own home, as well as a collection of contemporary art from around the world that includes work by Alan Jones, Jim Dine, and Bernard Venet. She enjoys the unexpected juxtaposition of primitive art and exotic artifacts, such as sticky rice baskets from Thailand, Australian burial poles, and Ashanti stools, with the clean lines of contemporary furniture. As an accomplished photographer, Toby is able to visualize how vastly different styles can be blended to create timeless compositions that reflect her clients' personal taste—and that will continue to do so, beautifully, for years to come.

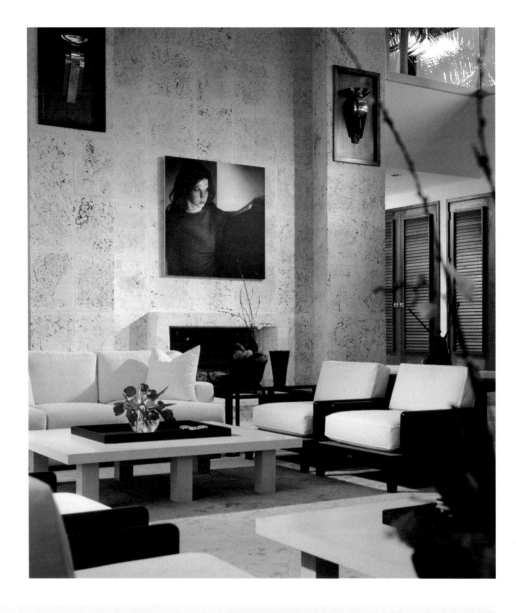

RIGHT
Toby Collection sofa with chairs from Holly Hunt and coffee table from Christian Liagre.

FACING PAGE
Macassar ebony dining table with all leather Pasqualina chairs.

More about Toby…

WHAT IS ONE OF THE MORE UNUSUAL REQUESTS FROM A CLIENT?

Toby had to come up with a privacy solution for a client who had her bathtub in a greenhouse window, since there was nowhere to put up a curtain rod. She had a system installed that, with the flick of a switch, turned the window entirely opaque.

WHO HAVE BEEN SOME OF THE MAJOR INFLUENCES IN TOBY'S WORK?

Toby loves contemporary architecture and particularly admires the work of architects Richard Meyer and Philip Johnson.

IF TOBY COULD ELIMINATE ONE DESIGN STYLE FROM THE WORLD, WHAT WOULD IT BE?

She would do away with overdesign and overdecoration, in general.

WHAT DOES TOBY ZACK ENJOY READING?

Her favorite author is Proust. She also loves art books. Her husband calls her a magazine freak—she reads them all!

Toby Zack Designs
Toby Zack, ASID/Allied, IIDA
3316 Griffin Road
Fort Lauderdale, FL 33312
954-967-8629
www.tobyzackdesigns.com

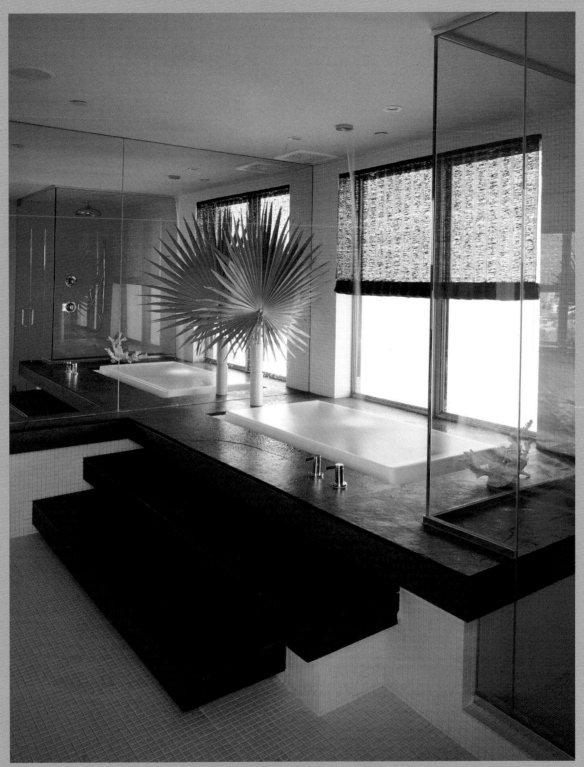

SOFIA JOELSSON, SOJO DESIGN, page 145

Miami-Dade

CHAPTER THREE

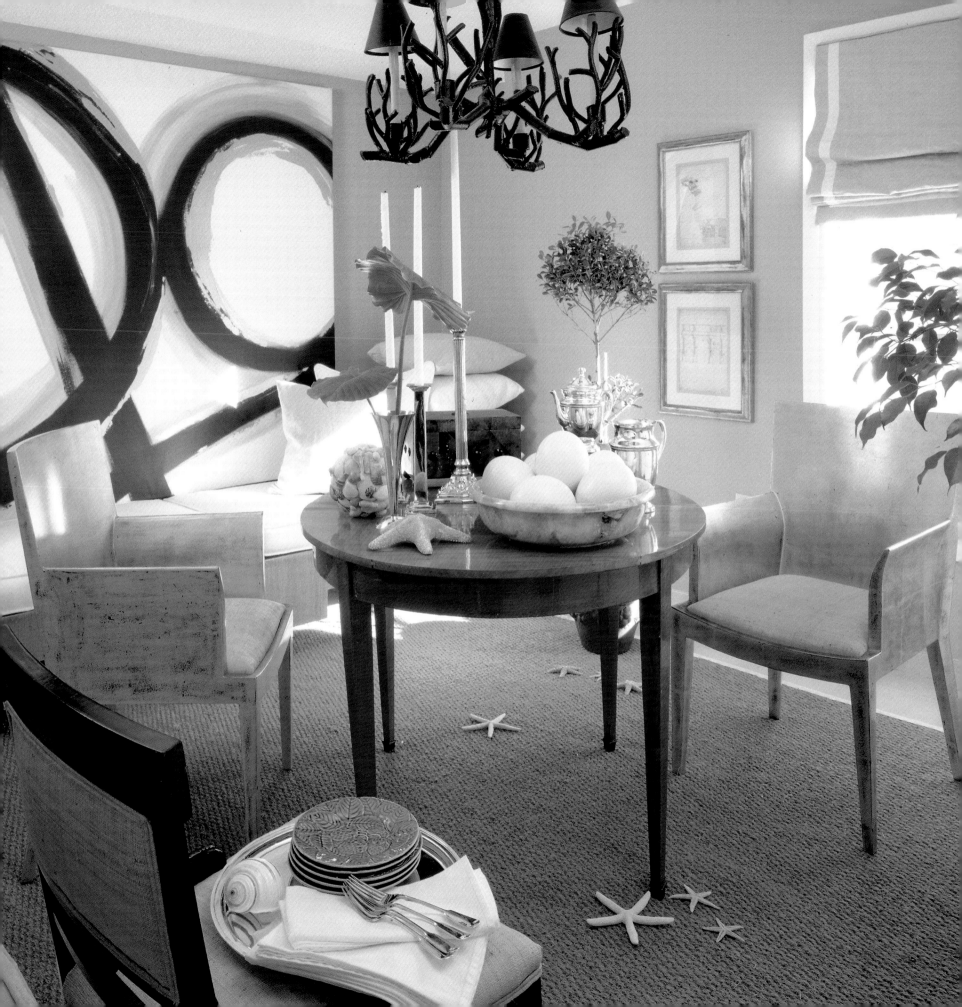

charles aber

Charles R. Aber

When you listen to the story of Charles Aber's life, it is just as awe-inspiring as the interior designs that he creates for his clients. A native of Pittsburgh, Charles had a passion for design since he was a young boy, ever since he watched his talented grandmother design and build nine homes.

Not wanting to become a starving artist, he focused his talents on interior design and attended the Art Institute of Pittsburgh. During his collegiate years, the 19-year-old up-and-comer was recruited to become an associate store designer for Kaufmann Stores, responsible for their in-store look.

Then after working under the tutelage of Arthur Dimling and Charles Cable for two years, Charles packed up his belongings and his industry knowledge and decided to move on. Encouraged to take his design dreams to the Big Apple, he opted to relocate to Miami, a family vacation spot, with no more than the clothes on his back and just a few dollars in his pocket.

LEFT
This bold sophisticated design showcases clever use of a small space. Charles Aber's artwork hangs on the wall.

ABOVE
An Empire chest lends formality to a modest space. Charles' calligraphy artwork is prominently displayed.

Donning his best suit—and in Miami that got the strangest looks from the fashion-relaxed designers—he pounded the pavement of Designers Row and was hired on the spot by Muriel Rudolph, a top-notch high-end interior designer. He spent an amazing 16 years with Rudolph, after which he was finally ready to strike out on his own.

Tragically, his entrepreneurial dreams fell short soon after he sustained a horrific debilitating neck injury that prevented him from working and ultimately cost him his company and his home. After several painful years, Charles faced a critical crossroad in his life. "It was time to do something about all of this," he said. His courage and passion for the business pushed him to restart his own firm again and in less than two years, he's already riding quickly back to the top.

Today, Charles focuses on residential and commercial projects, designing classic, yet contemporary spaces. He commonly uses antique pieces within his calm, serene designs to create a formal atmosphere. Charles' talents extend to designing fabrics, wallpaper, furniture and lamps. He is also currently in the midst of designing dog beds and accessories that he says are "Great American Sportswear for Man's Best Friend."

More about Charles…

WHAT PERSONAL INDULGENCE DO YOU SPEND THE MOST MONEY ON?

Without a doubt, Charles admits that his passion are animals, especially his Jack Russell terrier, Ned, that he says is "spoiled rotten," and the inspiration for his Nedware designs. His new passion is quarter horses pleasure riding.

WHAT IS ONE THING THAT PEOPLE DO NOT KNOW ABOUT YOU?

Very few people know that Charles has another love—gardening. "What's not to like?" he says. "Being outdoors; it's almost like interior design but of a much faster nature. I'm fascinated by landscape architecture and exterior space planning."

WHAT COLOR BEST DESCRIBES YOU AND WHY?

Charles is quick to describe himself as Celadon Green because, as he describes, " it's a serene color and at the same time, it's optimistic." After reading his story, one can see why it's a match to his personality!

WHAT BOOK ARE YOU READING RIGHT NOW?

Charles is reading *The Success Principles* by *Chicken Soup for the Soul* co-author Jack Canfield, and Patty Davis', *The Long Goodbye*.

Charles R. Aber
127 Ponte Vedra Colony Circle
Ponte Vedra Beach, FL 32082
904-280-1933

carlos terence adharsingh

Chambray Avenue Design Studio, Inc.

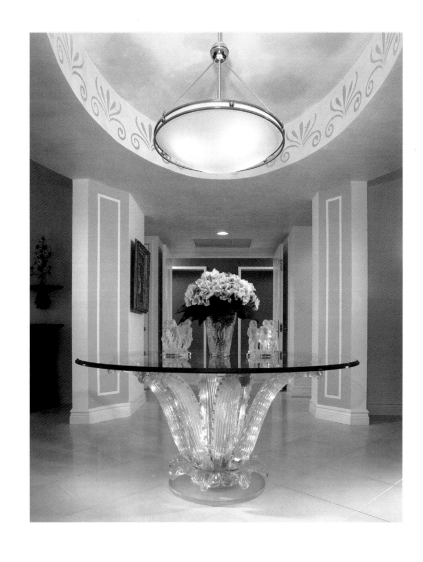

LEFT
This bold brick red foyer leads past etched glass doors into an art filled gallery.

ABOVE
Our client's elegant Lalique table was the inspiration for this multicolored residence.

From an early age, Carlos Adharsingh excelled at drawing and painting. He studied architectural drawing and drafting in his native Trinidad, then relocated to Miami to study interior design at the International Fine Arts College and communication and media arts at St. Thomas University. Today, he is listed in *Who's Who in Interior Design,* and has been designer on call at Design Center of the Americas for the past year.

In 1998, Carlos established Chambray Avenue Design Studio, Inc. From Key Biscayne to Naples, he handles a mix of residential and commercial projects including condos, houses, offices and restaurants. He makes it a point to meet with his clients on site so he can determine how to make the most of what they already have. With a quick repositioning of a mirror or a change of light bulb for a crisper light, Carlos is able to demonstrate on the spot the difference

even the simplest changes can make. Suddenly, the process becomes more real to his clients; less abstract. They relax and become more involved, which Carlos prefers since it gives them a true sense of ownership of the project.

With his easygoing nature and ability to connect one-on-one, Carlos inspires trust in his clients. In one large-scale project, his clients were moving from a six-story brownstone in New York City to a five-bedroom house in

Key Biscayne. The challenge was to make the large, dark furniture that had been so well suited to a Manhattan brownstone equally effective in a Colonial Plantation-style house on the water in Miami. After Carlos met with them in New York City, his clients left the design of their Florida house up to him.

When they entered their new home three weeks later, their belongings had been entirely reinvented for Miami. Formerly imposing

furniture had been lightened up through reupholstering, and decorative accessories had been streamlined. Their antique furniture was given prominent position. The addition of sisal rugs, plants and flowers in the interior courtyard, and simple sheer silk panels at the windows enhanced the tropical effect.

Carlos' goal is to have clients tell him, "Now it feels like home." With his hands-on, positive approach to design, it's something he often hears.

More about Carlos…

WHAT DOES CARLOS MOST ENJOY ABOUT BEING A DESIGNER?

The design industry is always evolving—new products, new customers, new locations, and unlimited opportunities.

WHERE DOES CARLOS GET HIS ARTISTIC INSPIRATION?

Anything can provide inspiration—lectures, trade shows, movies, art shows, everyday experiences. Carlos is inspired by anything that goes beyond the obvious, whether it's an unusual color combination or innovative architecture.

IF HE COULD ELIMINATE ONE ARCHITECTURAL STYLE FROM THE WORLD, WHAT WOULD IT BE?

As Carlos says, "The McMansions that are invading the suburban landscape are the SUV of the single-family home—they're like a Hummer: all bulk, little style."

WHAT IS THE MOST IMPRESSIVE OR BEAUTIFUL HOME CARLOS HAS SEEN IN FLORIDA?

He believes Villa Vizcaya is a perfect example of the gilded age in design and architecture.

Chambray Avenue Design Studio, Inc.
Carlos Terence Adharsingh, ASID,
Interior Designer
1500 Brickell Avenue
Miami, FL 33129
305-446-0841
FAX 305-446-2842
www.chambray.com

nikki baron
and wendy st. laurent

Baron & St. Laurent Interior Design

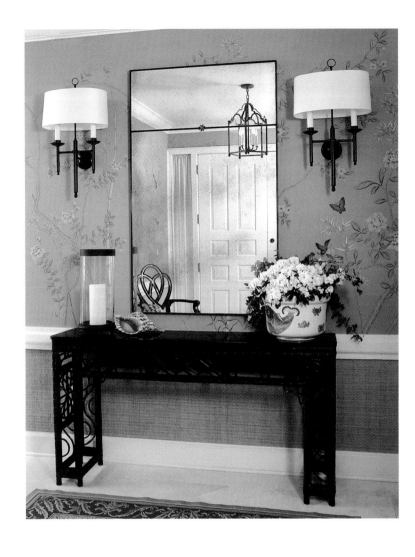

In an industry where firms are expanding and designers are less involved with the process, the Miami-based boutique firm of Baron & St. Laurent prides themselves on personalized interior design service and working hands-on with their clients.

Nikki Baron and Wendy St. Laurent listen, process and interpret the clients' wants and needs and then skillfully and creatively make it all happen—whether the style is traditional, contemporary or transitional. Thanks to their dedication and passion, the team of Baron &

St. Laurent works closely with their clients to create the most beautiful homes in South Florida.

The pair began their partnership in 1999 and have since become very successful, creating clean, luxurious and classic designs that reflect Florida's tropical environment. They work as a team with each other and their clients—exchanging ideas, challenging designs and making decisions—a process that originates from both their academic backgrounds.

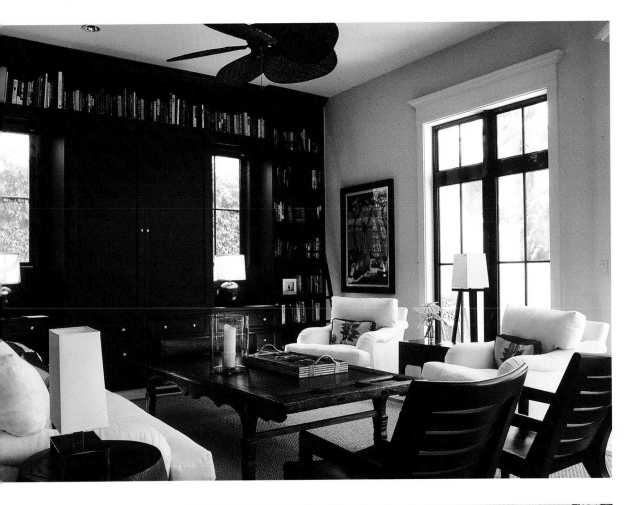

Nikki received a master's of fine arts from the University of Miami and began her career as an Associate Professor of Fine Arts at Barry University in Miami, where she taught for nine years. Wendy received her bachelor's of architecture from the University of Oregon and is a professional member of the American Society of Interior Designers (ASID) and she is NCIDQ certified.

Together this award-winning pair was recognized in the annual ASID National Residential Design Competition, bathroom category in 2003 in *Southern Accents* magazine. They have also been published in *Metropolitan Home, Southern Accents* and the *Miami Herald's Home & Design* magazine. These well-educated, talented designers develop long-lasting client relationships and deliver timeless quality with a classic tropical twist.

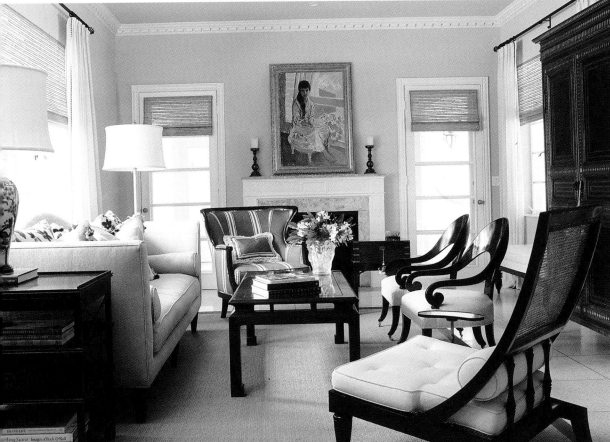

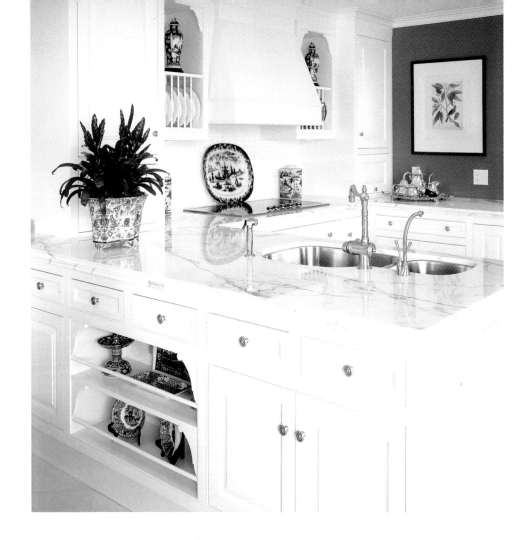

ABOVE LEFT
A newly constructed home features a great room opening to the Bay. Casual living expressed through traditional furnishings with a mix of antiques.

BELOW LEFT
A renovated 65-year-old Carribean Colonial home. The living room is traditional yet has a clean modern twist.

RIGHT
New custom kitchen in white lacquer features stainless steel with Calcutta Gold marble and a blue and white china collection.

More about Nikki and Wendy...

WHAT IS THE BEST PART OF BEING AN INTERIOR DESIGNER?

Wendy explains that the best part of being an interior designer is being in an industry that is fluid and constantly changing. She sees each day as intellectually challenging, and a new chance to be fresh and creative.

WHAT ONE ELEMENT OF STYLE OR PHILOSOPHY HAVE YOU STUCK WITH FOR YEARS THAT STILL WORKS FOR YOU TODAY?

Wendy believes in balance, symmetry and proportion—these are the guiding principles that she learned in architecture school and applies to every decision she makes.

WHO HAS HAD THE BIGGEST INFLUENCE ON YOUR CAREER?

Wendy gives her partner, Nikki, the credit for influencing her career. She says, "Nikki pushes me every day to be a better, more creative and sincere designer."

WHY DO YOU LIKE DOING BUSINESS IN FLORIDA?

Nikki loves Miami because she says it's a "young and vibrant city growing by the second with a diverse population very exciting for creative, serious professionals. The volume of new projects feels limitless and we're excited to be here at this very moment."

WHAT DO YOU LIKE ABOUT BEING PART OF *SPECTACULAR HOMES OF SOUTH FLORIDA*?

Nikki feels a book is a new vehicle for the pair; there is an interesting element of permanence and documentation.

Baron & St. Laurent Interior Design
Nikki Baron
& Wendy St. Laurent
4040 NE 2nd Avenue
Suite 405
Miami, FL 33137
305-573-5828
FAX 305-573-5825

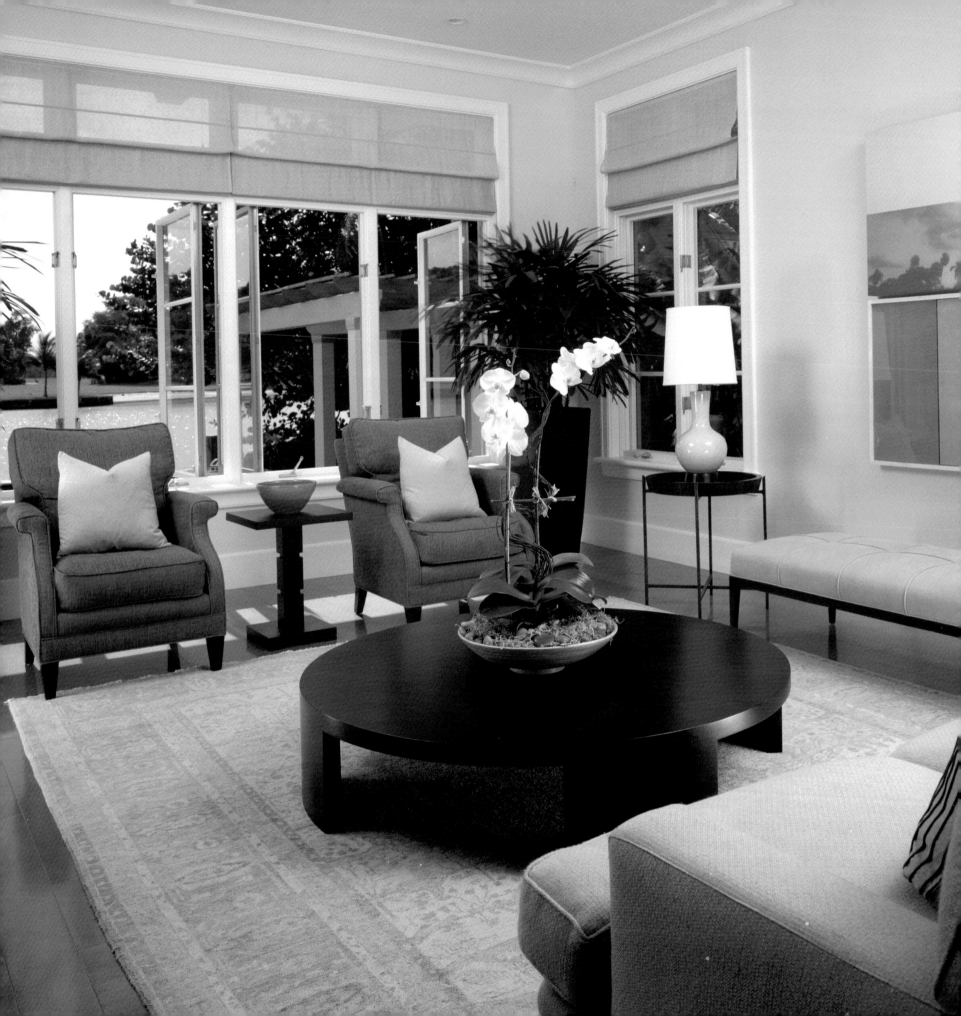

iggy olsson cuba
and robert zemnickis

Nuhouse Furniture Inc.

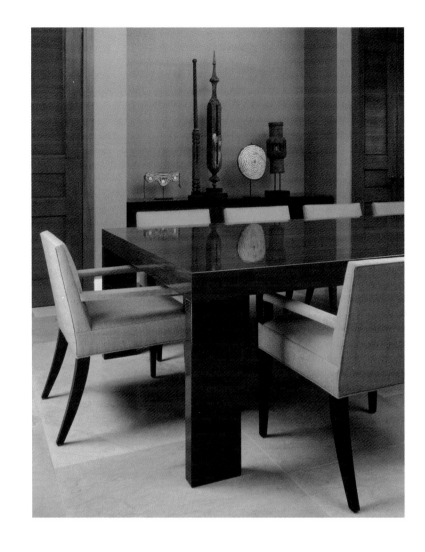

When Iggy Olsson Cuba and Robert Zemnickis started Nuhouse, they had one client, a tiny office, and a staff of two. Ten years later, Nuhouse has a seven-person staff, a spacious Miami office, and a jam-packed portfolio. From large-scale single-family houses in Dade Country to high profile restaurants in New York City, they have developed a flourishing business.

The success of their partnership is due, in part, to their differences. Where Robert is more intense, Iggy is relaxed and laid-back. Iggy's work has been informed by her upbringing in Sweden, where design tends toward the minimalist, emphasizing light and using bright colors. Robert, who was brought up in Montreal, finds the classic French aesthetic to be a major influence in how he interprets design. She admires the work of designer Vincente Wolfe; he is inspired by architect Carlos Scarpa and the French designers of the 1940s. These contrasts provide Nuhouse with a depth of knowledge and expertise that forms the foundation of a singularly effective collaboration.

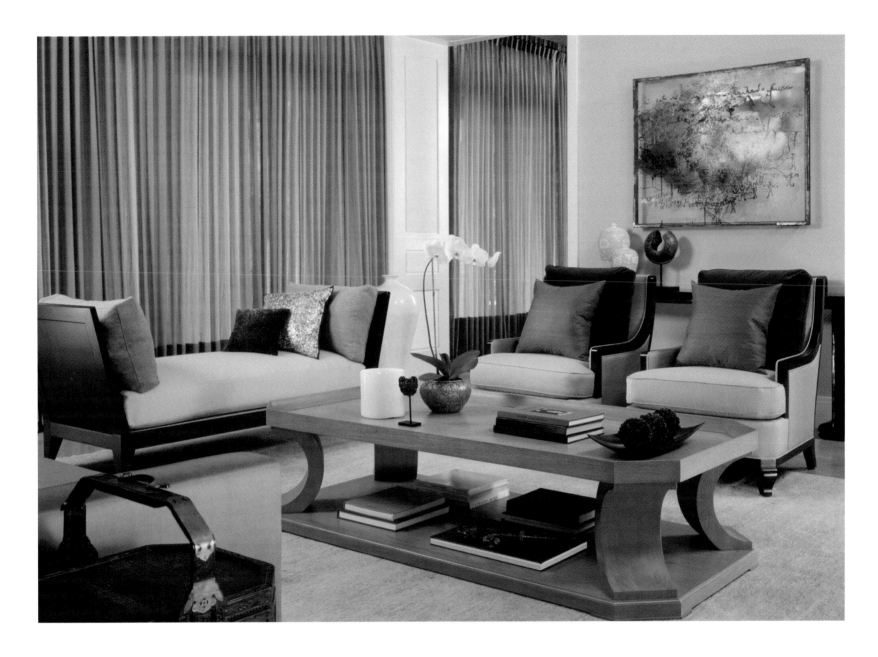

Nuhouse takes a unique problem-solving approach to their projects. Working intensively with their clients, they clearly assess the clients' needs and guide them through each stage of the design process. While they each manage their own projects, Iggy and Robert often create the concept together in the office as a group, getting input from several Nuhouse designers. Their clients get the best of both worlds—personalized attention from one of the partners, and the collective talents of the Nuhouse staff behind the scenes that help refine each project.

Specializing primarily in new custom residential construction, Nuhouse's current projects range from a 146-room luxury condominium on Sunny Isles to a 6,000-square-foot condominium residence in Aventura to a

17,000-square-foot Oceanside custom residence in Golden Beach. They get involved at the architectural level of most of their projects, working with the project architect on such decisions as placement of staircases, lighting, moldings, finishes, kitchen and bathroom fixtures, and much more.

While they tailor the design style to their client's needs and tastes, their interiors share a sense of depth, richness, and informal elegance in keeping with Florida's casual lifestyle. Traditional Mediterranean remains popular, but in recent years, they have been creating a more modern style, with an emphasis on cleaner lines and classic design elements such as lighter woods and a subtle, soothing color

BELOW
A clean-lined breakfast area. Buffet cabinet from Room and Board. Wenge table through Contemporaneo. Glass pendant by Prandina. "The Bismark" lounge chair is designed by Nuhouse Furniture Inc. Area rug from Odegard. Maple paneling and limestone floors. Architecture by Jaya Zebede.

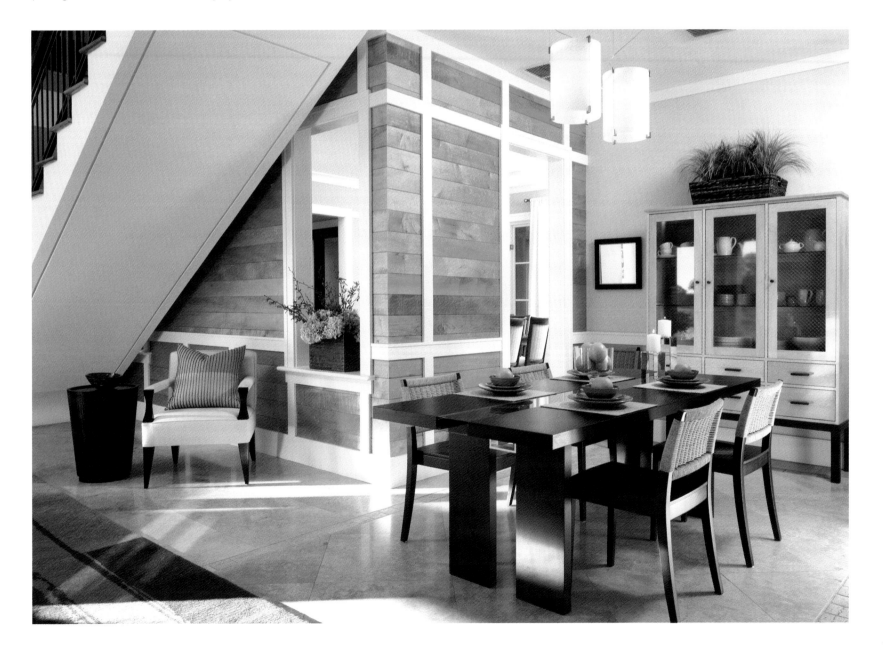

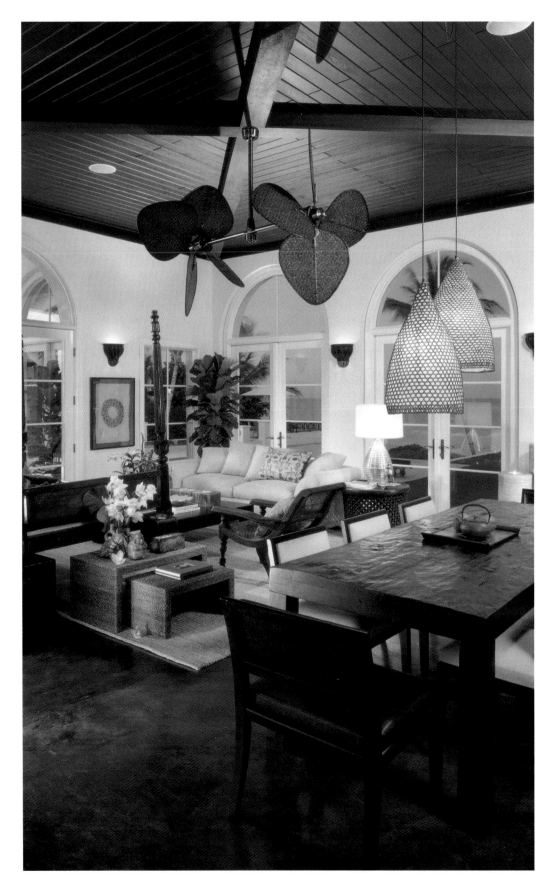

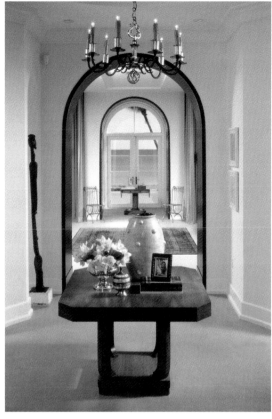

LEFT
A family room with an African dining table and hanging lamps through Tucker Robbins, NYC. Dining chairs and cord nesting tables by Richard Mishan, NYC. Indonesian four poster bed and plantation chair from World Resources, Miami. Bronze "helmet" sconces, by Nuhouse Inc. African bark art piece through Havelli, Miami. Fan by Fanimation.

ABOVE
Pouillerat inspired iron gilt chandelier and an antique walnut center table, both Paris flea market finds. African wooden fertility statue. Peruvian silver and horn inlayed sphere in the background. Biedermeier drop leaf table. Glass nickel hurricanes from Ralph Lauren Home.

FAR RIGHT
A master bathroom with custom his/hers vanity table in wenge and polished nickel accents by Nuhouse Furniture Inc.. Aero faucets in nickel by Waterworks. French limestone through Piedras. Sanders glass wainscott trim and towel warmer by Waterworks. Black & white art piece through Raoul Currasco, Miami.

palette. A relaxed indoor-outdoor aesthetic is beginning to emerge, similar to the casual feeling of California.

As Miami matures as a city, Nuhouse continues to evolve as well, accommodating the requests of knowledgeable, sophisticated clients for complex customization and technology in their homes. With their mutual passion for design, Iggy and Robert and the entire Nuhouse studio thrive on new challenges and consistently present their clients with homes that are dynamic, expressive, and personal.

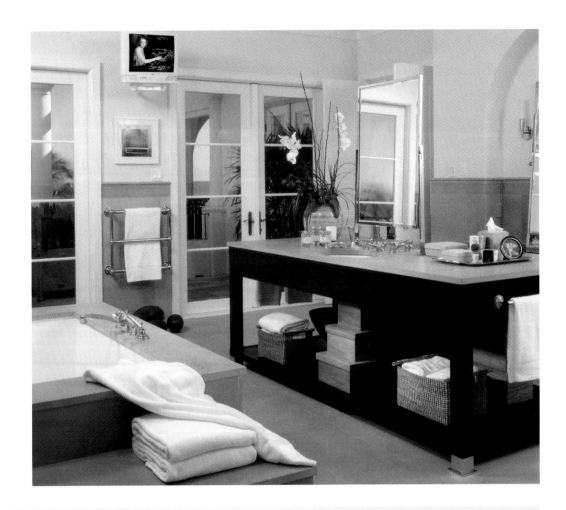

More about Iggy and Robert…

WHY DO IGGY AND ROBERT ESPECIALLY ENJOY DOING BUSINESS IN FLORIDA?

They like the size and scope of the projects available in the area, and the opportunity to participate at the conceptual level. They are also inspired by the international clientele and exceptional mix of local culture.

WHAT IS THE SINGLE THING IGGY AND ROBERT WOULD DO TO ENLIVEN A DULL HOUSE?

The first thing Iggy would do is repaint. Robert would put in a great floor—a good choice in flooring will set the tone for the rest of the design.

WHAT IS THE MOST IMPRESSIVE OR BEAUTIFUL HOME IN FLORIDA?

Iggy is very drawn to the architecture of the old Key West homes. She finds the mix of bright colors, wood siding, zinc roofs and intricate carpentry to be unique, genuine, and very interesting.

WHAT IS THE MOST UNIQUE PROJECT NUHOUSE HAS BEEN COMMISSIONED TO DESIGN?

Nuhouse designed a 20-foot-tall castle room for a little girl, complete with balcony, courtyard, and murals of rolling hills in the background. The project was a chance to let their imagination run wild, and to have a great deal of fun.

WHAT IS THE BEST PART OF BEING AN INTERIOR DESIGNER?

Robert finds being an interior designer to be constantly challenging and never boring. As he says, "Combining art, style, and creativity—what's not to love?"

Nuhouse Furniture Inc.
Iggy Olsson Cuba
Robert Zemnickis
4100 Northeast 2nd Avenue
Suite 209
Miami, FL 33137
305-572-9505
nuhouse@nuhousefurniture.com

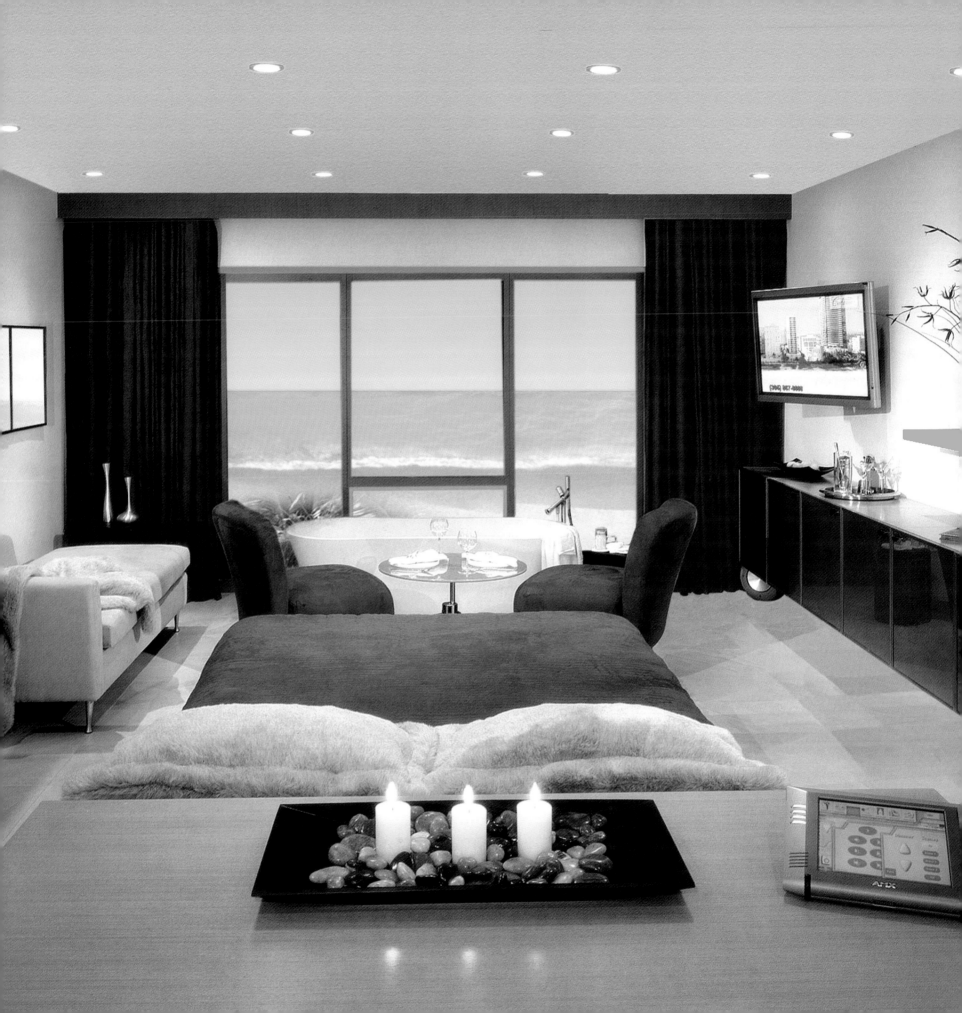

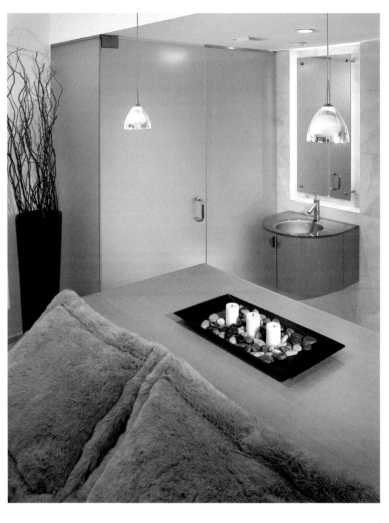

teri d'amico
D'Amico Design Associates

D'Amico Design Associates, known as DADA, is best known for designing extraordinary South Florida and Caribbean resorts, including an exquisite Miami Beach award-winning "Cabana" project shown on these pages. This well-designed oceanfront retreat showcases DADA's exceptional design skills and meticulous attention to detail and exemplifies the ultimate tropical hideaway experience. It's a unique, modern and sleek space that encompasses tropical imagery and textures and provides a balance of the indoors and outdoors.

Teri's design career began in New York City. Her passion and advocacy for historical preservation led her to become founder of MiMo (short for Miami Modern), dedicated to preserving mid-century Miami-Dade architecture. She recently curated an architectural photo exhibit on MiMo for the New York City Municipal Art Society and the exhibit is currently traveling around the world. In addition, this labor of love lead to the now published book *Miami Modern Revealed*, in which Teri's own photography can be seen.

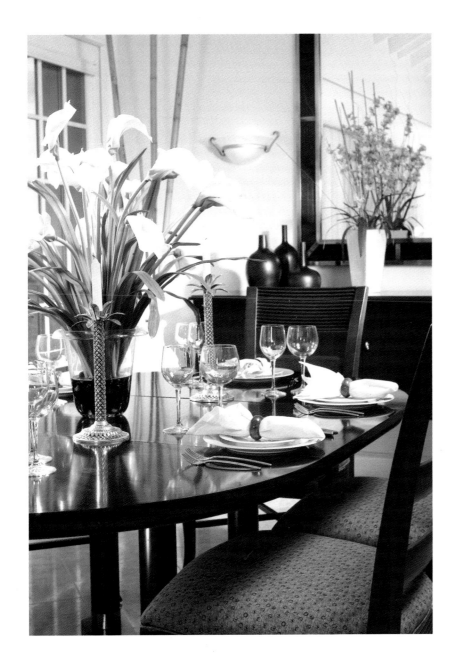

DADA, named after the European art movement from the 1920s, is a full-service interior design firm with President Teri D'Amico at its helm. DADA weaves color, texture and presence into spaces filled with possibility—they convert the mundane into the provocative. Their clients come from far ranging locales and bring with them an arsenal of unique needs. Each endeavor is a chance to offer enlightened spaces to inhabit at whatever level they so desire.

Teri is an NCIDQ certified interior designer and, to share her passion, an Adjunct Professor at Florida International University's School of Architecture,

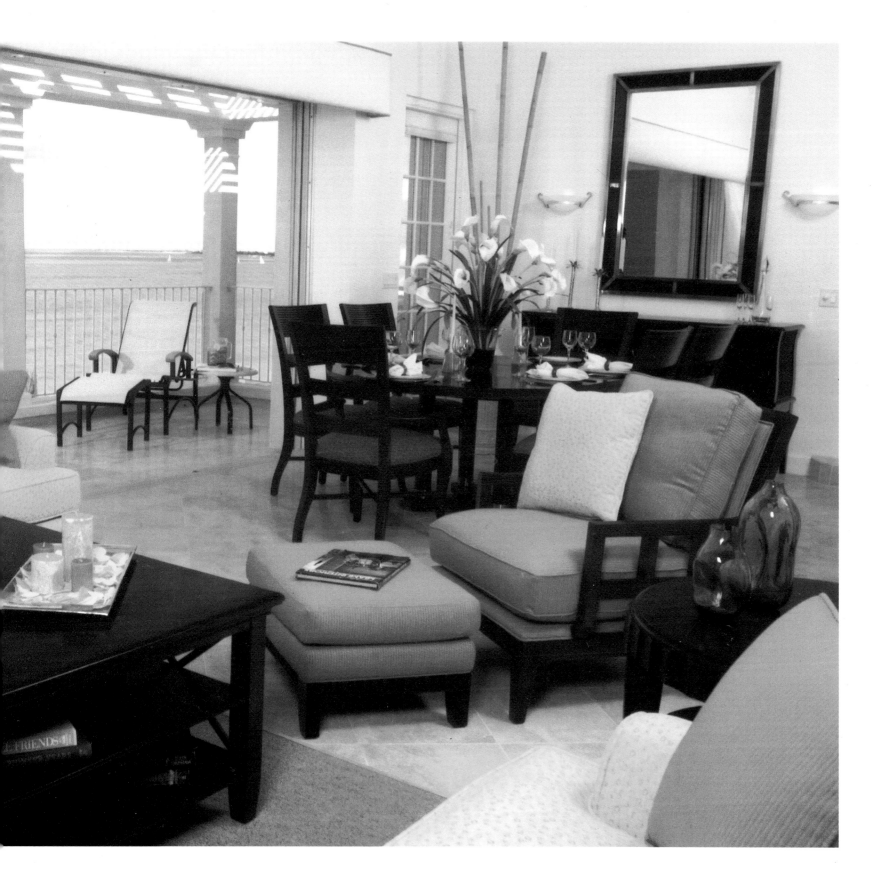

FACING PAGE
Dark wood furniture is contrasted by bright colored fabrics, to give a modern look to a tropical environment.

ABOVE
Casual fabrics with a formal place setting are a perfect blend for entertaining.

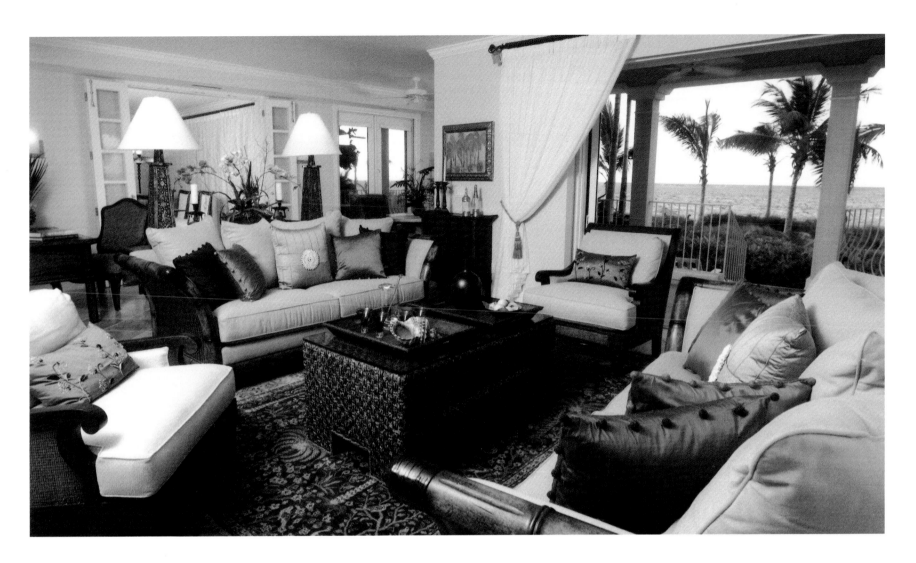

teaching hospitality design and computer-aided drafting. Teri is an expert consultant on tropical vernacular and historic architectural styles in Florida.

With considerable respect for the principles of architectural design, whatever interior style their clients prefer, DADA creates a living space that is comfortable, inspiring and refreshingly unique.

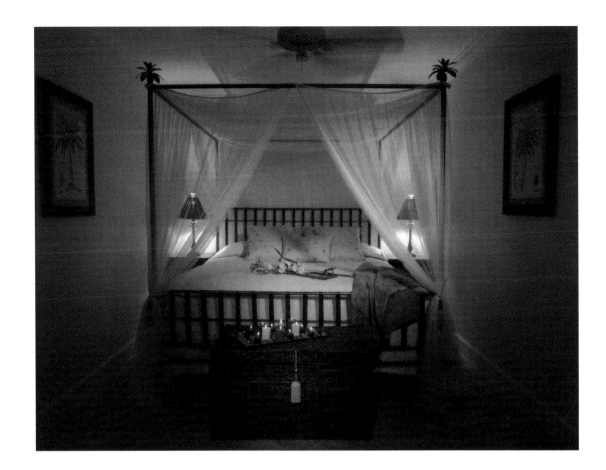

More about Teri…

WHAT IS THE HIGHEST COMPLIMENT YOU'VE RECEIVED PROFESSIONALLY?

Awarded "Best Vacation Ownership Property" from Hospitality Design 2005 Awards for her "Cabana" design in the Miami Beach's Historic North Beach (MiMo) Resort District.

WHO HAS HAD THE BIGGEST INFLUENCE ON YOUR CAREER?

Marcel DuChamp—founder of DADA.

WHAT IS THE SINGLE THING YOU WOULD DO TO BRING A DULL HOUSE TO LIFE?

Add color.

WHAT ONE PHILOSOPHY HAVE YOU STUCK WITH FOR YEARS THAT STILL WORKS FOR YOU TODAY?

The meaning of DADA—art for art's sake—a carefree notion that the trivial can convey an honesty of being.

WHY DO YOU LIKE DOING BUSINESS IN FLORIDA?

Able to wear sandals year-round.

DADA, D'Amico Design Associates
Teri D'Amico, NCIDQ
1941 NE 149th Street
North Miami, FL 33181
305-945-1770

t. keller donovan
T. Keller Donovan Inc.

LEFT
Bringing the best of past and present together.

ABOVE
Crisp white linen and seagrass carpet add up to a classic retreat.

"Good design speaks for itself," says renowned interior designer T. Keller Donovan. "Achieving good design requires creativity, innovation, and resourcefulness, good client relations, and a roster of talented craftspeople to execute our ideas."

Since founding his namesake firm 28 years ago, Keller has been successfully implementing these principles at his New York City and Miami Beach-based award-winning design firm. A love of traditional design started at Colonial Williamsburg when he was a teenager.

His current designs incorporate this classic traditional with an updated modern twist that his clients love.

The firm has designed residences from New York to San Francisco and Massachusetts to Miami. Worldwide design projects have included London, Tel Aviv, and Bermuda.

Avoiding the easy cookie-cutter approach, Keller works diligently to create original one-of-a-kind spaces that are the epitome of style and chic. "I try to reinvent the wheel with each

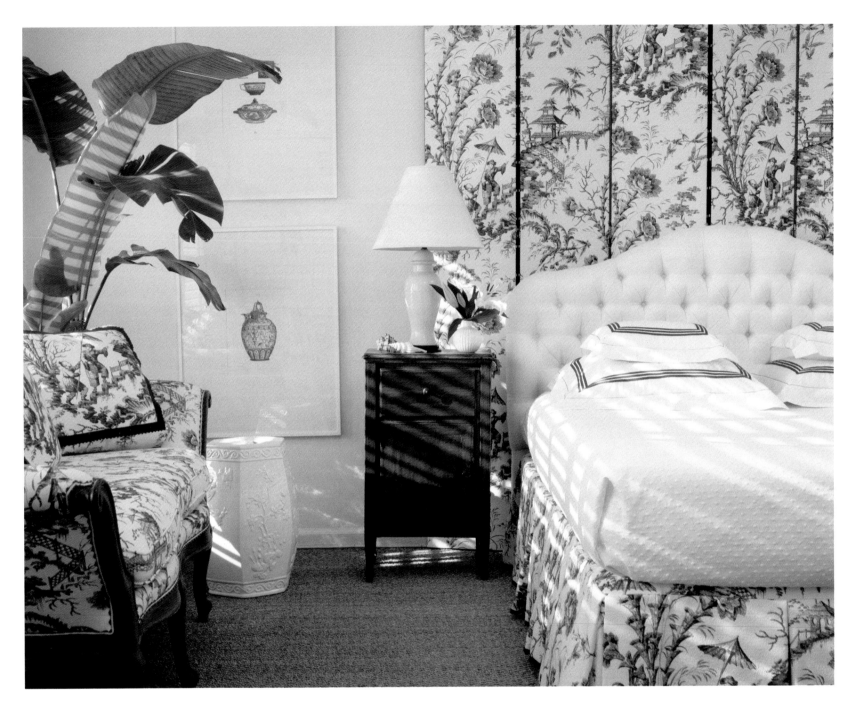

project," explains Keller. "I feel it's my responsibility to keep good taste and good design moving forward and not do the same old, same old."

A native of Short Hills, New Jersey, Keller attended Bethany College and Parsons School of Design before working at Bloomingdale's, Tom O'Toole Inc., and David Easton.

Keller has been named to *House Beautiful's* Top 100 Designers list each year since its inception in 1996. He twice won their Best Showhouse Room in 1986 and 1994. The firm

is listed in glowing terms in the *Franklin Report* (www.franklinreport.com) and was listed in the *New York Magazine*'s 2002 top designers list.

The firm has had design projects appear in *Architectural Digest, Country Living, Elle Decor, Home Magazine, House Beautiful, House & Garden, Interior Design, Metropolitan Home* and *Southern Accents*, among others.

Internationally the list is more far-flung with stories in *Elle Decor-Russia, House Beautiful-Turkey, House & Garden-South Africa*, and *Italian AD*, to name just a few.

Keller says that the conversations with clients are most vital to the design process. "It's like starting with a bank canvas—I listen to how they want to live in the space and

BOTTOM LEFT
A plaster mirror reflects and a pair of Chinese lamps illuminate this updated traditional setting.

BOTTOM RIGHT
An antique French bedside cabinet within easy reach of luxurious bedding.

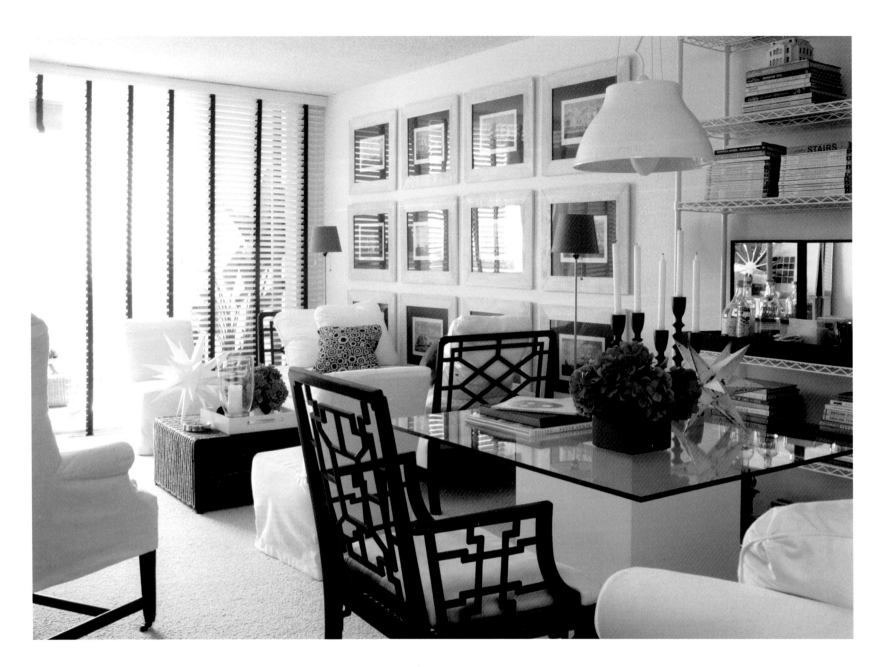

then go from there. We leave nothing undone—the project is completely planned and completely finished."

Like a painter, he makes sure his masterpieces are finished to the last detail. He masters the mix of colors, fabrics, and textures that make for great design and grateful clients.

LEFT
A lanai in chocolate brown, white and natural.

ABOVE
White on white punctuated with brown and a dash of blue keeps it cool.

T. Keller Donovan Inc.
T. Keller Donovan
P.O. Box 398434
Miami Beach, FL 33239
305-674-6922

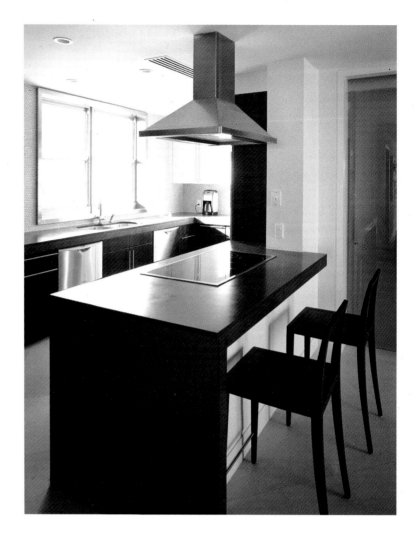

sofia joelsson
SoJo Design

Seven years ago, Sofia Joelsson, a Swedish native, came to America to pursue her passion for interior decorating. Today her company, SoJo Design LLC—headquartered in trendy South Beach Miami—has exclusive clientele in New York, Los Angeles, Chicago, Monte Carlo, and St. Tropez. SoJo Design's appeal has been so successful that it has become commonplace for the firm to design three or four homes around the world for the same client.

A boutique firm of seven people, they are passionately connected to every project from start to finish. The company is known for having a very unique approach to interior design. For this cutting-edge group of designers, music often becomes the eighth member of the team. Once the SoJo Design staff has met with a client and discussed their needs, a vision will evolve. It is then that the members of SoJo Design peruse their music collection and find inspiration for their design concept. One could compare their creations to a fine piece of music—timeless, harmonious, soul-inspiring. Through the music of creativity SoJo Design is able to "turn spaces into living places."

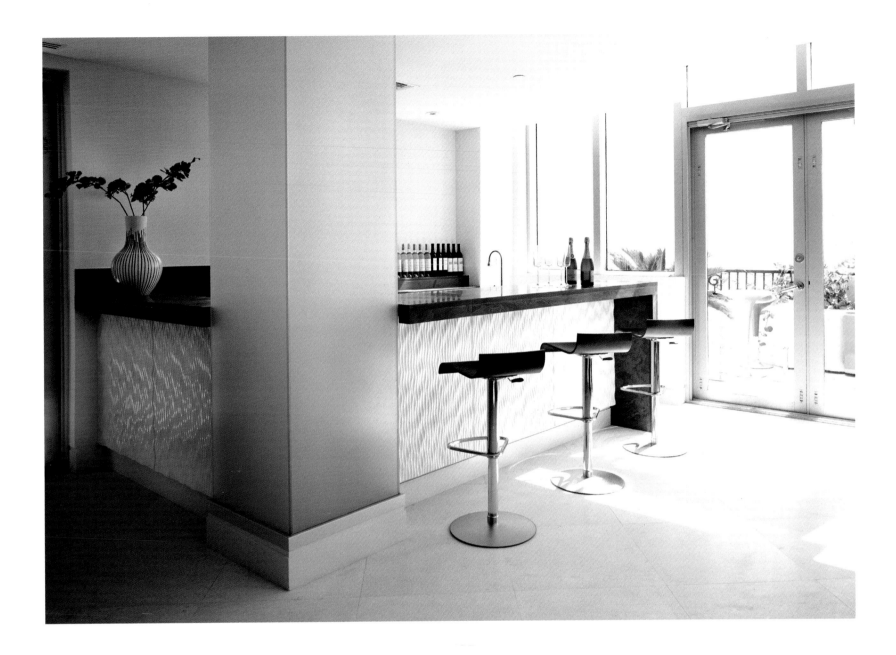

SoJo Design is a full-service interior design firm that specializes in high-end residential and commercial build-outs and renovations. Their portfolio includes everything from high-rise condos and office buildings to spectacular single-family homes. Having cultivated a superb working relationship with some of the industry's most talented architects and engineers, the firm is able to handle the most

complex of design challenges, all of which are self-imposed. From space planning to furniture and accessories selection, SoJo Design is there from conception to completion.

The palettes of the young and savvy designers at SoJo Design are ever changing. From modern elegance to sophisticated glamour, color is a key component in their design as every room is given its own life. By carefully

ABOVE
Bar with honed slate top, light column that changes colors according to mood.

NEAR RIGHT
This state-of-the-art staircase features a rock garden and a stainless steel structure with Brazilian teak-clad steps. In the middle, a custom-designed light fixture climbs up to the second floor of the penthouse.

FAR RIGHT
Master bath with Kohler Infinity Jacuzzi that fills from the ceiling. Slate-clad steps and glass enclosed double steam shower.

listening to a client's personal vision, and what the space itself has to say, SoJo Design is able to implement a plan that is a harmonious balance of both.

The members of the SoJo Design team are all self-proclaimed "new product junkies," constantly combing design markets worldwide for new state-of-the-art materials and design elements. By offering clients lighting and audio-visual consultations, in addition to highly personalized layout and design, SoJo Design is able to tailor specifically to everyone's needs. The goal ultimately is for clients to feel as comfortable and pampered in their homes as they would in a fine hotel.

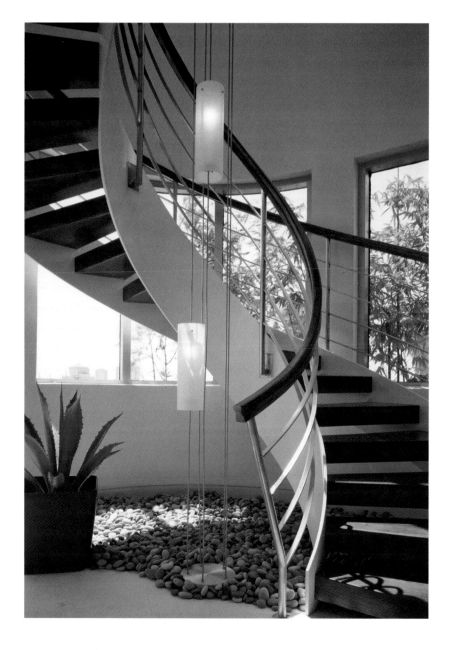

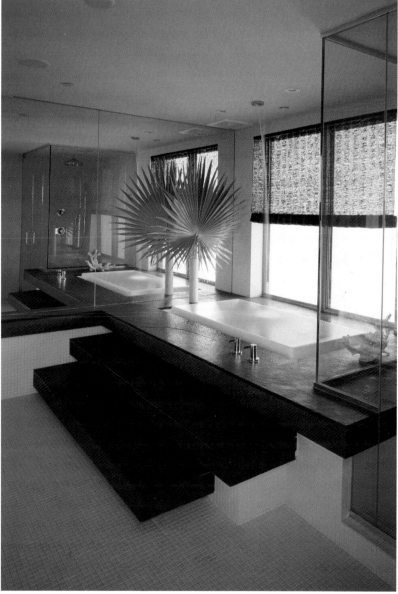

BELOW
Living room at an Ocean Drive Penthouse. Two light columns speak to each other in the open room. Retro wood curtain. American Leather sofa in caramel. Bar in slate with carved wood panel.

NEAR RIGHT
Outdoor relaxation is provided by teak furniture and day beds surrounded by tropical landscaping.

FAR RIGHT
Ocean Drive hideaway up in this Moroccan inspired terrace with custom carved furniture and hand-painted murals.

More about Sofia…

WHERE DOES SOFIA GET HER INSPIRATION?

Travel is an endless source of inspiration for Sofia, and an invaluable opportunity to keep up-to-date on what's happening in the design world. Staying in hotels and villas around the world inspires her to create the same feeling of comfort in her client's own homes. Notwithstanding, her passion and love for what she does is perhaps her greatest source of inspiration. After she views a space for the first time, she'll often dream about it that night and awaken the following morning with all the details planned out.

WHAT IS ONE OF THE MOST UNUSUAL PROJECTS SOFIA HAS WORKED ON?

She has done design consulting on airplanes. In addition to crafting the interior layout, selecting fabrics, finishes, and aviation furnishings, she has overseen the installation of surround-sound theater systems, designed custom galleys, and created exterior color schemes for each plane. As in a home, she feels the exterior speaks to the interior, and strives to ensure a harmonious balance between both.

WHAT DOES SOFIA LIKE BEST ABOUT WORKING IN SOUTH MIAMI BEACH?

She believes the light in Florida is magical and strives to make the most of the natural light in all her projects.

WHAT IS THE HIGHEST COMPLIMENT SOFIA HAS RECEIVED PROFESSIONALLY?

A client once told her, "You have created a home with a soul."

SoJo Design
Sofia Joelsson
Principal / Creative Director
1451 Ocean Drive, Suite 204
Miami Beach, FL 33139
305-695-9121
www.sojodesign.com
info@sojodesign.com

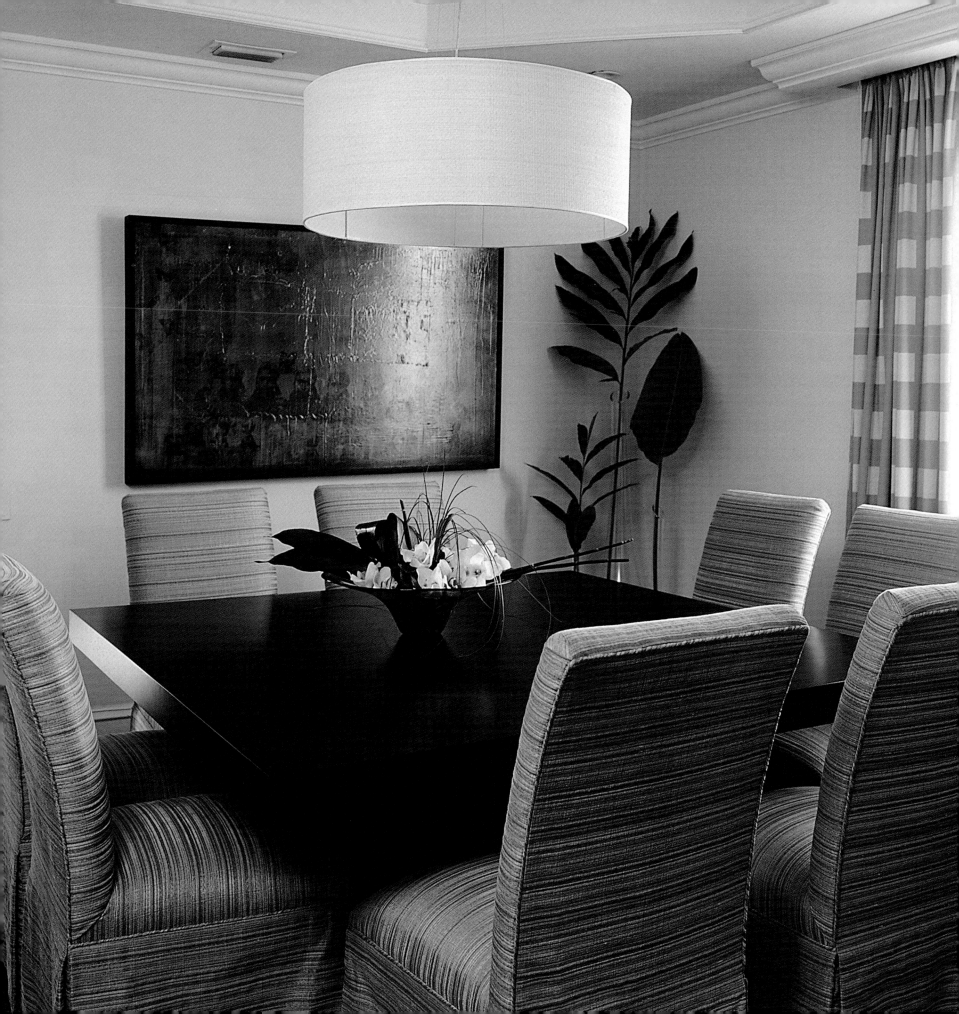

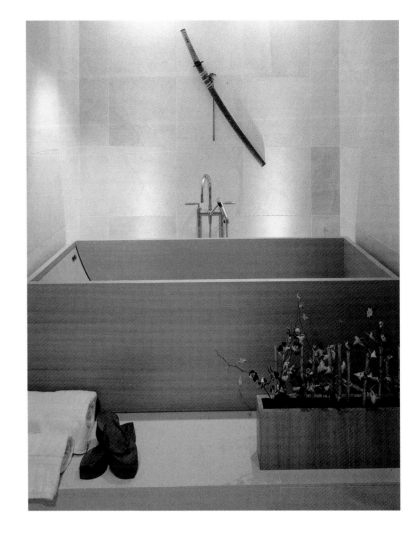

denise lavey

Denise LaVey Interior Design, Inc.

LEFT
Dining room – Asian simplicity with Osborne & Little curtains and larsen dining chair fabric.

ABOVE RIGHT
Creama pearl limestone on floors and walls. Free-standing wood agape tub and complement Dornporacht faucets. Antique Japanese sword hangs over tub.

Denise LaVey aspires to be one of the world's top interior designers and after being named one of *House Beautiful*'s Top 20 Young Designers, she's well on her way.

"It's a wonderful feeling; I never thought I would get to where I am now," said the 35-year-old soft-spoken interior designer who specializes in high-end residential design. Undecided about a career choice early on, Denise waited to attend design school, but "once I did, I was completely focused and knew this was for me."

Denise earned a bachelors of science degree in interior design from the Art Institute of Fort Lauderdale. For more than six years, her unique creative ability and her global resources for unusual furniture and custom designs have kept her in demand for projects throughout South Florida, as well as in New York, Europe and The Bahamas.

Before establishing her own design firm two years ago, Denise was an interior designer with Tutt Interiors, Inc. of Miami Beach, Florida, and previously served as an interior design

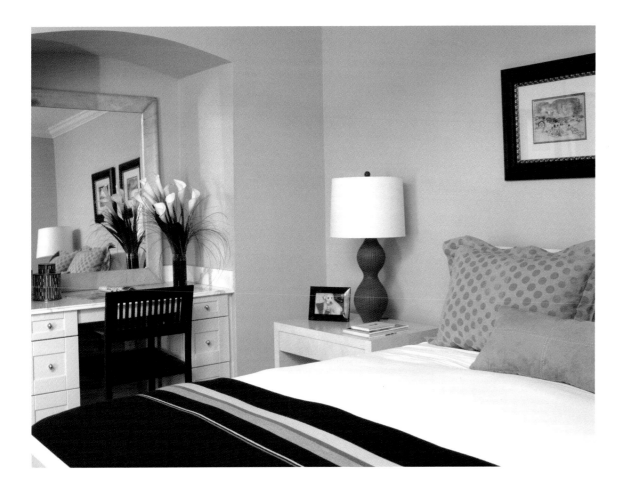

assistant with MacDonald Design Associates, Inc. of Miami, Florida. Now a solo designer, Denise enjoys the freedom and independence and often travels in search of that perfect decor or accessory that will complete the design.

A self-described eclectic designer, Denise is known for her exceptional ability to work in partnership with homeowners and she admits that she never says no to a client's ideas. Having the courage to start her own business has also given Denise the confidence and strength to know that her designs are right for her clients. "Clients get from me what I truly feel is right for the project," said Denise. "It has nothing to do with how much money it is. I have to have faith in what ideas I'm designing or I won't sell them on the idea." As a result, the final product is a smart, creative design that fulfills their desires, meets their needs and is a true reflection of the client's taste and lifestyle.

Denise's designs have been applauded and recognized in such publications as *Florida Architecture* and *Florida Design*.

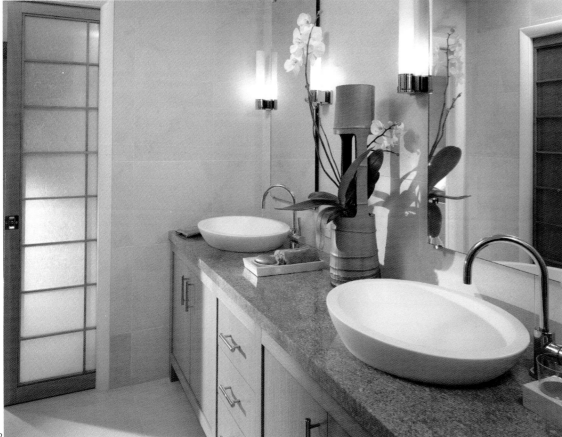

ABOVE LEFT
Guest bedroom with parchment bed and night stands from the Philippines. Larsen polka dot fabric on bed.

LEFT
Vanity – Japanese influenced bath with custom doors, agape semi-recessed sinks. Green tea granite was used to give a spa like feel.

FACING PAGE
Master bath with custom mahogany paneling, white thassos marble and bamboo blinds.

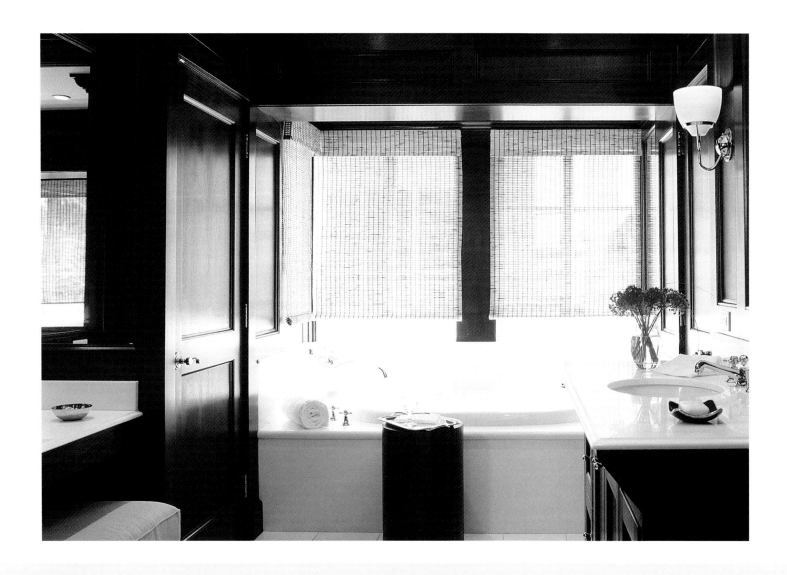

More about Denise…

OUTSIDE OF WORK, WHAT IS DENISE'S PASSION?

From slingbacks to retro, shoes are Denise's love!

WHAT'S THE BEST PART OF BEING AN INTERIOR DESIGNER?

Denise loves working with people and fulfilling their dreams.

WHAT IS THE MOST UNUSUAL DESIGN TECHNIQUE DENISE HAS USED IN HER PROJECTS?

One client asked for an unusual freestanding Italian wood tub!

WHO HAS HAD THE BIGGEST INFLUENCE ON YOUR CAREER?

Taking something from every job she's had, the biggest influence on Denise's career has been her past employers. She says she has learned valuable techniques from each one of them.

Denise LaVey Interior Design, Inc.
Denise LaVey
2 NE 40th Street, Suite 404
Miami, FL 33137
305-573-9400
FAX 305-573-9410
www.deniselavey.com

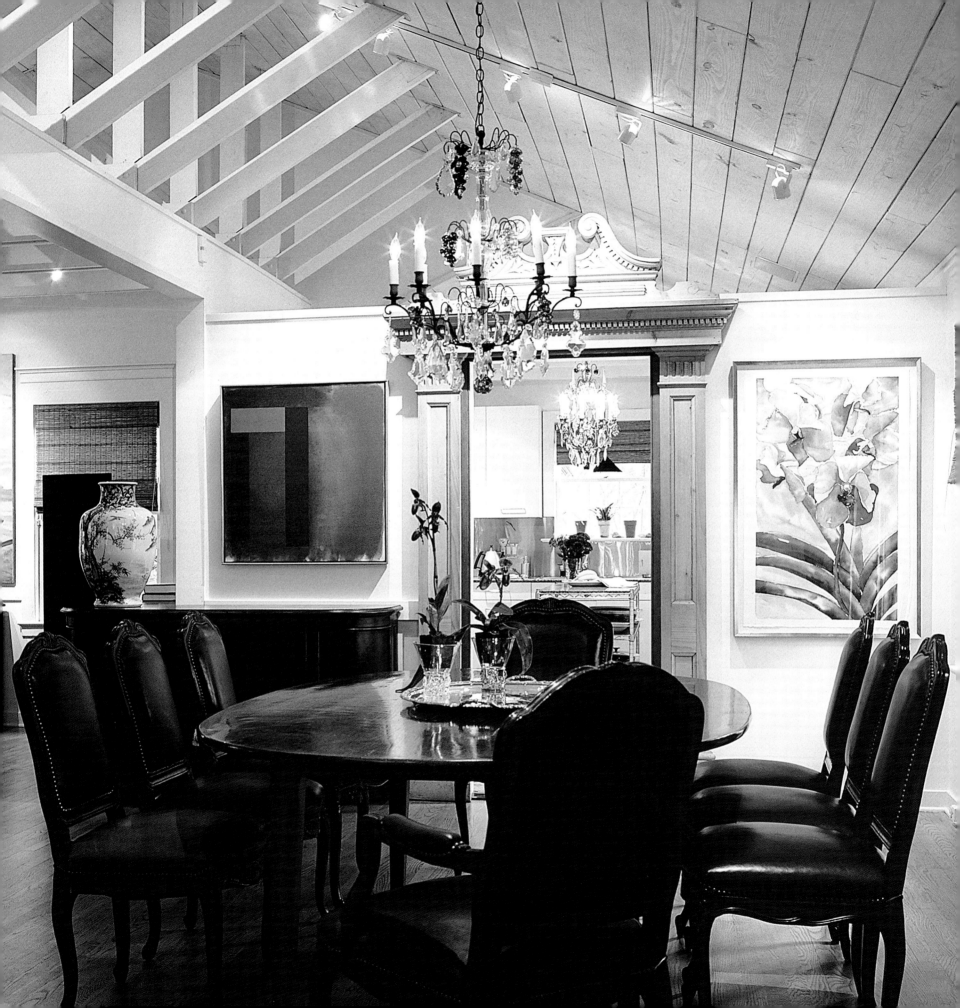

marilyn lazarus

Marilyn Lazarus Interior Design

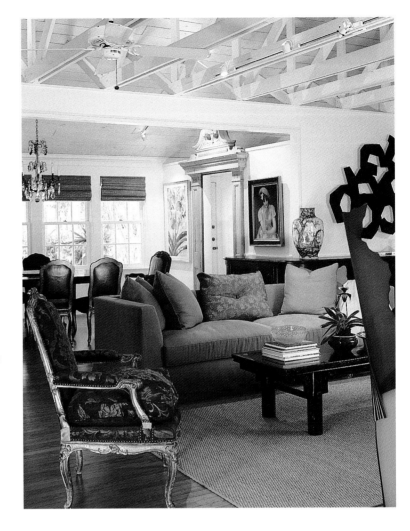

The success of designer Marilyn Lazarus lies in her remarkable ability to bring into concert the needs of the client, the integrity of the design and an intelligent use of art and antiquities.

Marilyn launched her career more than 25 years ago, designing developers' model homes. Clients were so impressed that she soon expanded into the private sector. Today, she is a renowned solo designer with a continual thirst for knowledge that keeps a creative edge between tradition and ingenuity.

Never one to remain static in her life or design, she has studied technique and style by continuously reaching out to artisans and craftspeople here and abroad that share her vision of symbiotic relationships amongst client, designer and the desired goal.

Extensive travel augment's Marilyn's work, as well as the privileged opportunities she has to visit architecturally important cities in Europe and the United States with such renowned educators as the late Professor Manuel Leon Ponce.

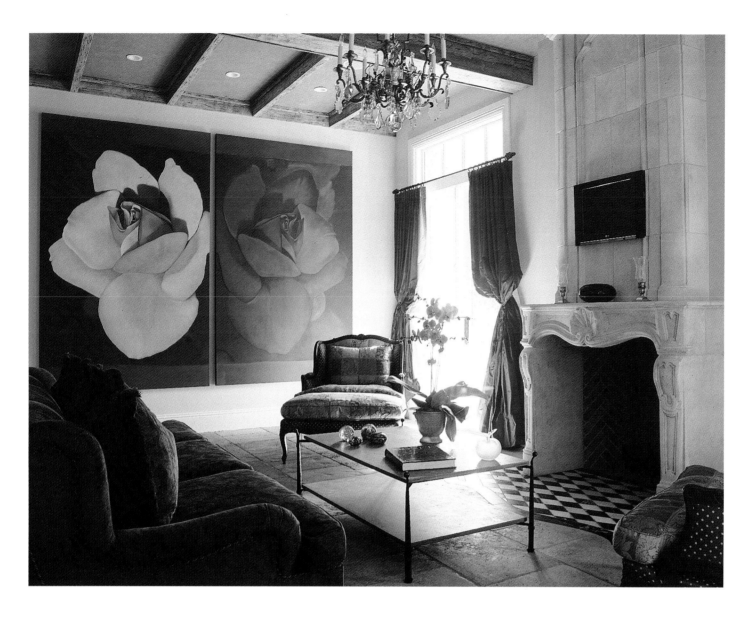

She listens carefully to what her clients need from their environment for function, restorative space, and design fantasies, and the archetypes that inspire and bring life to their homes. Marilyn believes "translating those desires into functional yet aesthetic reality is the true art of the profession. The key to each element of design are the details and are of the utmost of importance."

ABOVE
"Rose Room" features intricate stonework utilizing reclaimed Andalusian black and white marble and French limestone.

RIGHT
Butterfly kiss red chair floats above an oak and walnut inlaid floor.

Marilyn is well aware that it takes courage to incorporate atypical elements into design projects. To appear spontaneous but never frivolous and to be the most serious person on-site is quite a balancing act.

Each project is a labor of love. "I am blessed with the best possible clients a person could have. They make what I do fulfilling and exciting, and enable me to push myself to the limit for each of them."

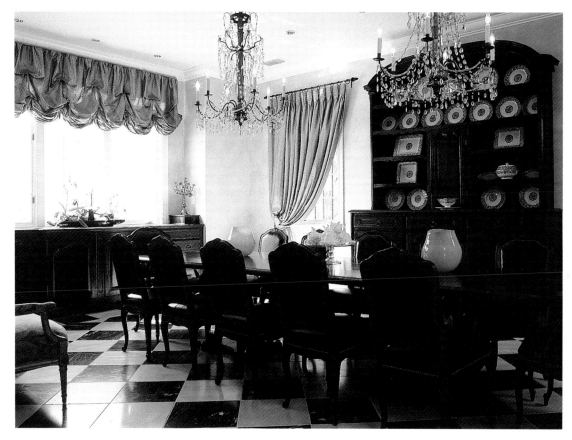

FACING PAGE
Re-created 18th century Parisian salon in historic "French Village."

ABOVE RIGHT
Formal dining room becomes accessible with the introduction of an 18th century Provencial Room. Vaisselier displaying a superb collection of French faience.

BELOW RIGHT
Dining within glass walls; exotic woods inside and out.

Marilyn Lazarus Interior Design
Marilyn Lazarus
Cell 305-775-6478

Miami
10090 SW 67th Ave
Pinecrest, FL 33156
305-661-3689

West Palm Beach
210 Sunset Road
West Palm Beach, FL 33401
305-775-6478

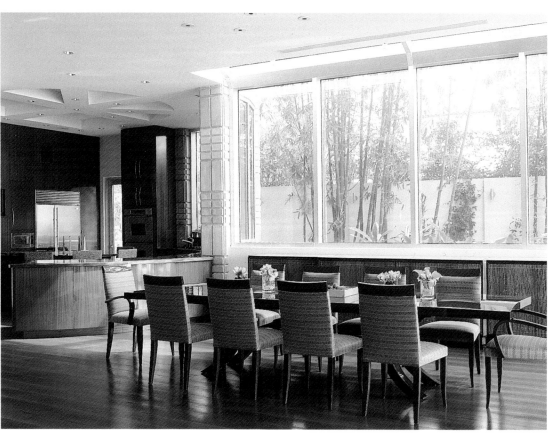

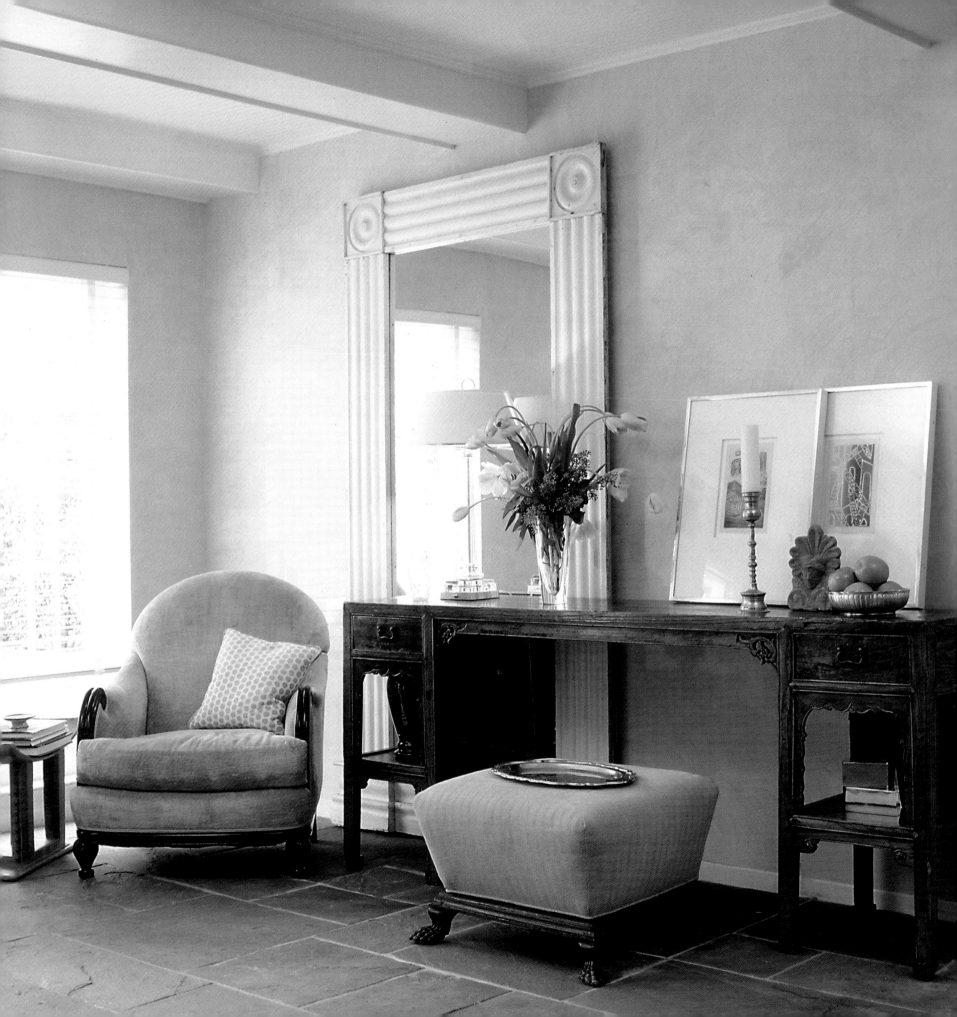

matt macdonald

MacDonald Design Associates, Inc.

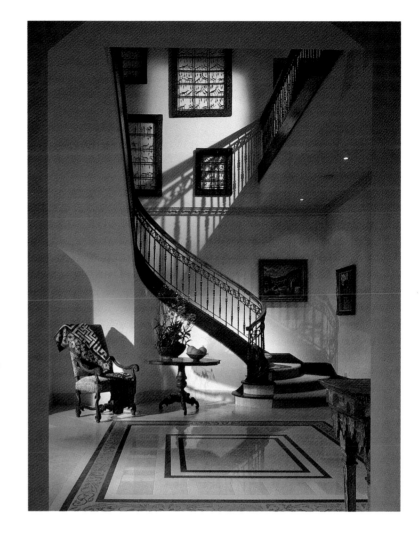

As a young boy, Matt MacDonald's career path seemed to be written for him. Several family members already had dental practices and it only seemed natural that Matt would follow suit. However, while home for the summer in his third year of college, Matt became engrossed in his mother's kitchen renovation and uncovered his natural design talents. This "light bulb moment" prompted the talented young man to change career paths, graduate from the Art Institute of Fort Lauderdale and enthusiastically pursue his dream to become an interior designer.

Matt is now the principal of MacDonald Design Associates, Inc., a prestigious and prolific design firm specializing in high-end residential design and creating highly personal residences in varied design styles.

Prior to opening the doors to his own design firm, which is located in the bustling Miami design district, Matt worked with Michael Brochet and Associates, and on such diversified commercial projects as a Christmas Store in Naples, Florida, the Executive meeting rooms at the

Headquarters for Colonial Bank, as well as projects for Sony, Columbia and TriStar Pictures in Los Angeles on the movie studio lot. He relocated to Miami Beach in 1994 and started MacDonald Design Associates.

His extensive list of residential projects reads like a Who's Who in Hollywood, including such notable projects with Cher, Jennifer Lopez, major league baseball player Jose Cruz, Latin recording artist Ricky Martin and Barry Diller, President and CEO of USA Network. He has designed homes for clients nationwide in Miami, Palm Beach and Naples, Florida; Beverly Hills, California; Missouri; Texas; Massachusetts; and New York City.

BOTTOM LEFT
Djawid C. Borower's painting, "Picture of a Poem," hangs above the living room sofa. "I love the color, the abstractness of it."

BOTTOM RIGHT
Art deco cabinet and antique tufted club chairs and leather covered Parsons coffee tables embellish the forty's theme.

FACING PAGE
This charming window seat designed around the arched windows which is an extension of the foyer, and reflects the successful mix of fabrics, styles and different time periods. As well as a custom bamboo curtain rod with spaghetti strape drapery.

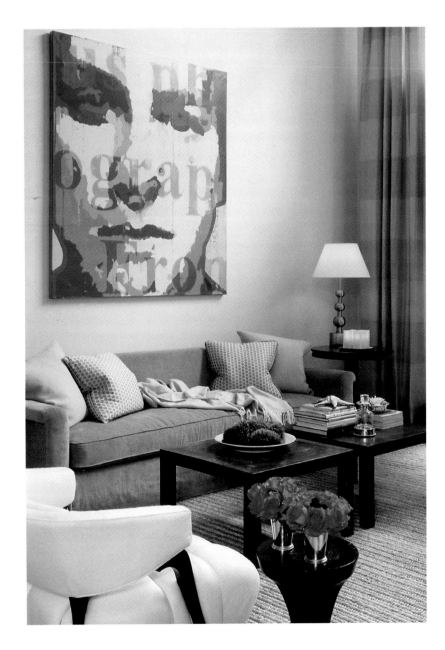

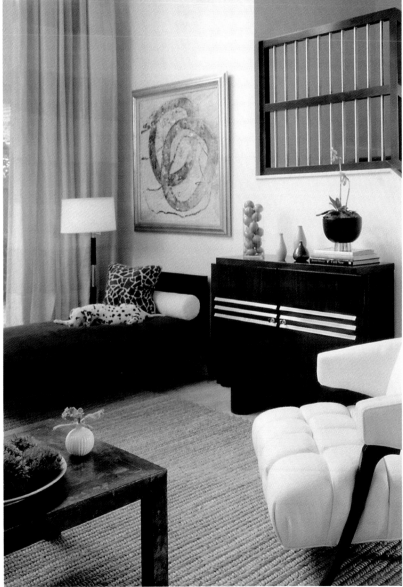

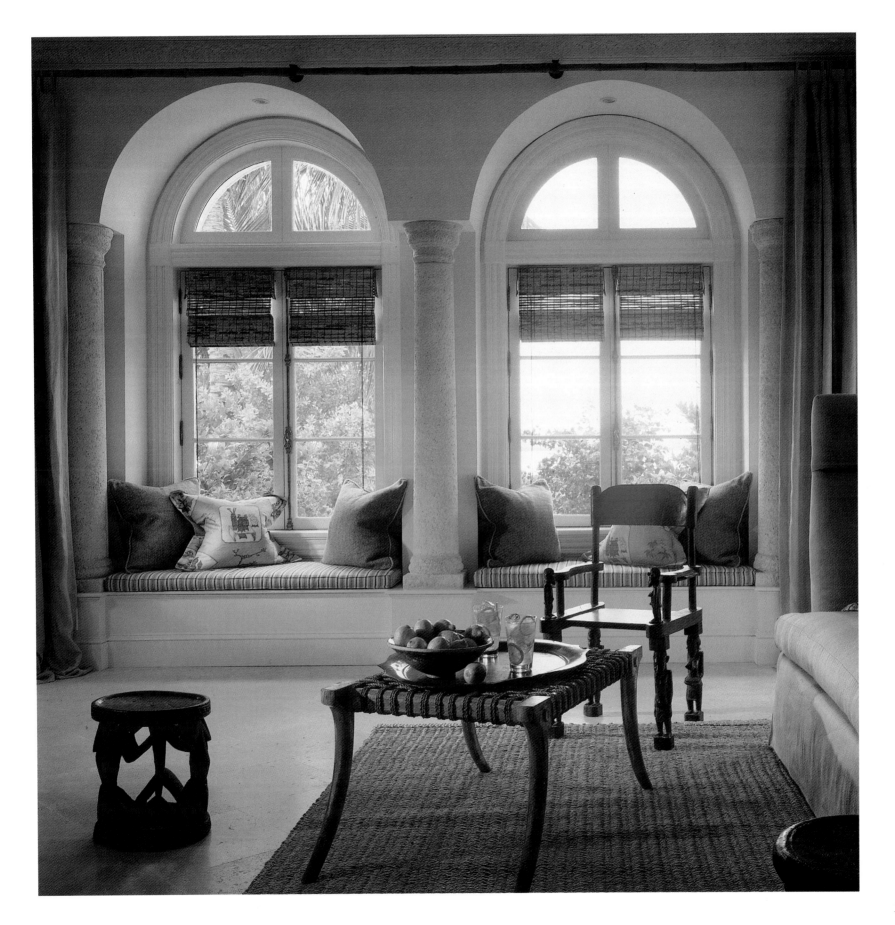

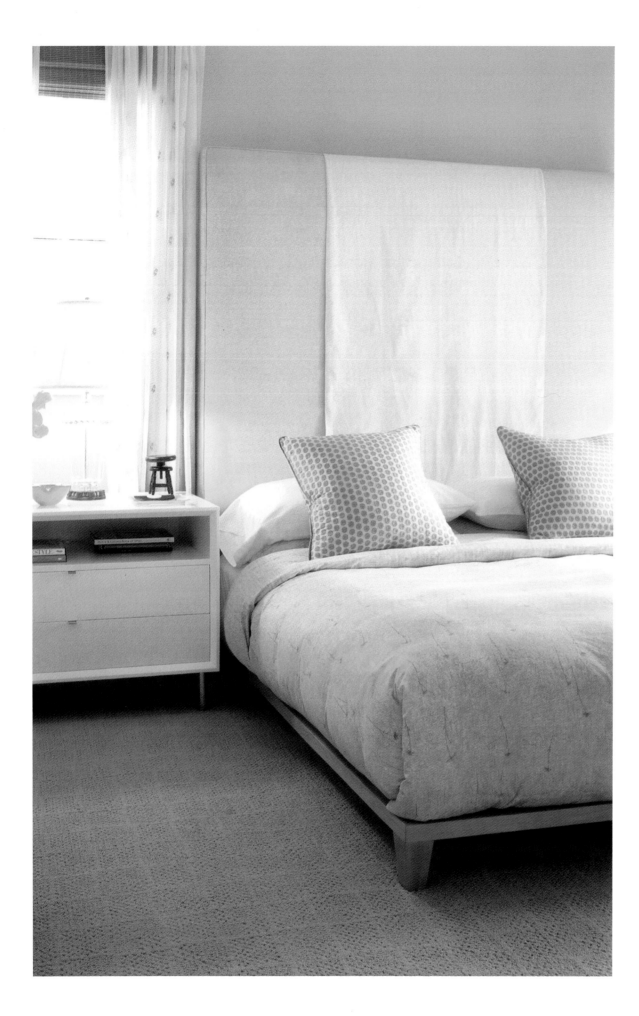

Matt describes his style as modern, yet classic with a twist of tropical and he is fully committed to the space, making sure objects, such as an antique piece, stands on their own to reflect this distinct flavor in a room. He appreciates the relationship with his clients, understanding that designing a person's living space is such an intimate process. When clients work with Matt, they receive hands-on attention and personalized service for each and every project. Matt takes his work very personally, exploring his passion for design and guided by the principles of integrity and simplicity.

Today, Matt is designing his own home, a 1930s Colonial that echoes the very principles of his commitment to space. His work has been featured in such publications as *Home & Garden, House & Garden, Miami Design, Traditional Home's, Decorator Show House, Florida Architecture, Florida Design, Design Times*, and on several episodes of HGTV's "Interiors by Design."

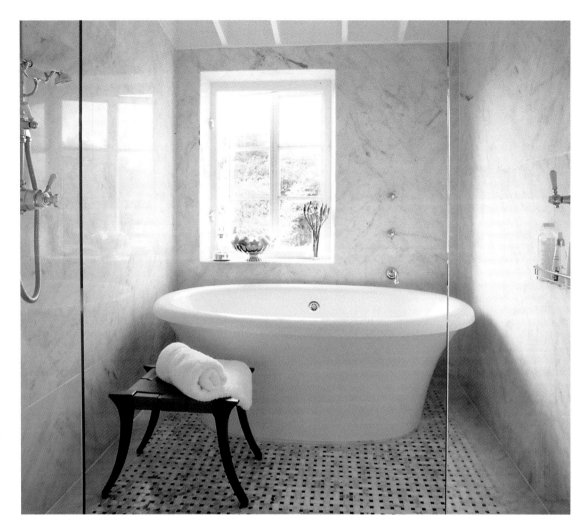

More about Matt...

WHAT PERSONAL INDULGENCE DO YOU SPEND THE MOST MONEY ON?

Matt fondly remembers when he was young and would spend time with his father, who introduced him to his passion for cars. Matt would help his dad prepare the cars for shows. Today, Matt's love of cars continues and he collects antique convertible muscle cars.

WHAT IS THE BEST PART OF BEING AN INTERIOR DESIGNER?

Matt enjoys looking for that diamond-in-the-rough piece for a home in an antique or thrift store. "I enjoy finding something old and making it new again, that's part of my interest in my car collection, too."

WHAT ONE ELEMENT OF STYLE OR PHILOSOPHY HAVE YOU STUCK WITH FOR YEARS THAT STILL WORKS FOR YOU TODAY?

Most importantly, Matt tries not to reinvent the wheel. He keeps it simple, avoiding the fussy and overembellished. He says he also makes sure the project's architecture coheres with the interiors.

MacDonald Design Associates, Inc.
Matt MacDonald
5701 Biscayne Blvd.
Miami, FL 33138
305-571-7170
FAX 305-571-7173

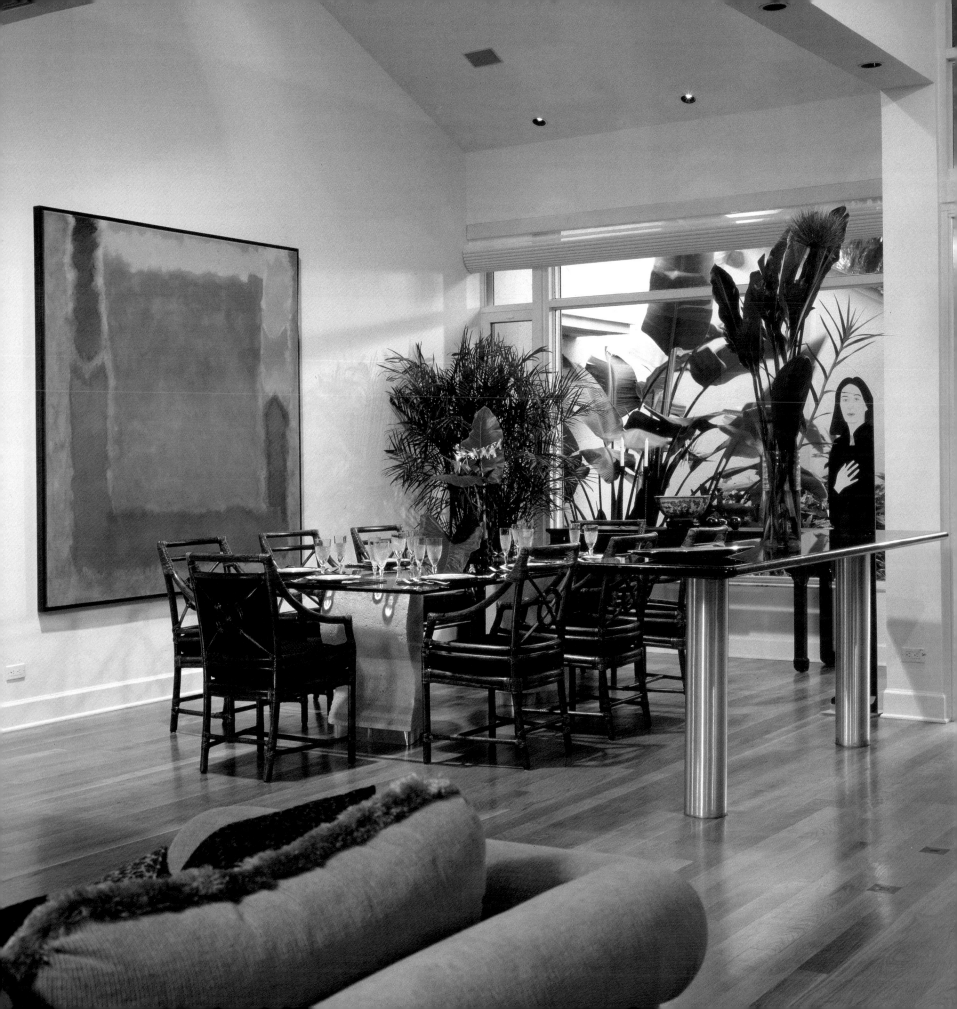

anita margolis
Anita Margolis Interior Design Inc.

Growing up in the cultural hotbed of New York City, Anita Margolis spent much of her time in the city's finest art museums and galleries learning about scale, proportion and color. Her original career path as a painter was where Anita learned to weave these elements of fine art onto beautiful canvases reflecting her taste for Abstract Expressionism. A transition to interior design enabled her to combine these artistic elements to create elegant residential spaces. Now an internationally-recognized, award-winning interior designer, Anita specializes in designing comfortable, yet stylish homes for her clients.

A graduate of Parsons School of Design, Anita attended Syracuse University School of Fine Arts and the New York School of Interior Design. She began her distinguished career more than 30 years ago when she founded her own business, Anita Margolis Interior Design. Her diverse projects have included everything from country cottages to Mediterranean villas and contemporary homes for many of South Florida's prominent CEOs, doctors, lawyers,

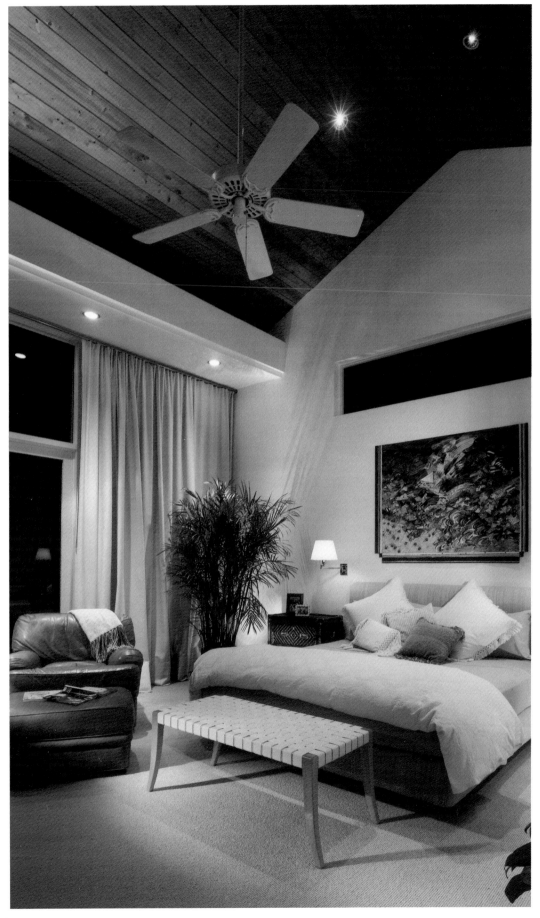

developers and other professionals living in the area's exclusive residential communities.

Anita is a color specialist whose extensive list of services includes space planning, furniture and art selection and a variety of design and architectural services. According to Anita, "Color is a critical element that can enhance a living environment, but it is the marriage of style and comfort that can transform a space from mere ordinary to the extraordinary." This passionate designer firmly believes that a home should be a restful, tranquil place and therefore avoids trendy styles.

Like framing a beautiful painting, Anita focuses first on her client's needs and communicates with them, beginning with a thorough consultation, to gain a complete understanding of their lifestyle and needs. "Every good design requires a basic plan prior to dealing with the decorative aspects," said Anita. She then works directly with her clients on all phases of the design process, creating spaces that are both functional and beautiful.

As a member of the American Society of Interior Designers, Anita's work has been recognized in *Southern Living, Florida Design, South Florida Magazine, Metro Magazine* and *The Best of Florida Design*.

In her personal life, Anita makes it a point to surround herself with both art and beauty and endeavors to do the same for her clients. Her fine arts background, combined with her expertise in the selection of furniture, textures, fabrics and color palettes, helps her to design exquisite spaces that are simple, classic and comfortable. "I provide a service to my clients and strive to make their lives more beautiful in the process."

LEFT
Anita designs this Florida master bedroom using a variety of neutral textures and materials—canvas, leather, wood and silk—that complement each other beautifully.

RIGHT
In this inviting library, Anita uses such rich elements as polished mahogany against grey flannel and lacquered wood bookshelves. She adds a playful leopard skin throw on the leather sofa to complete the look.

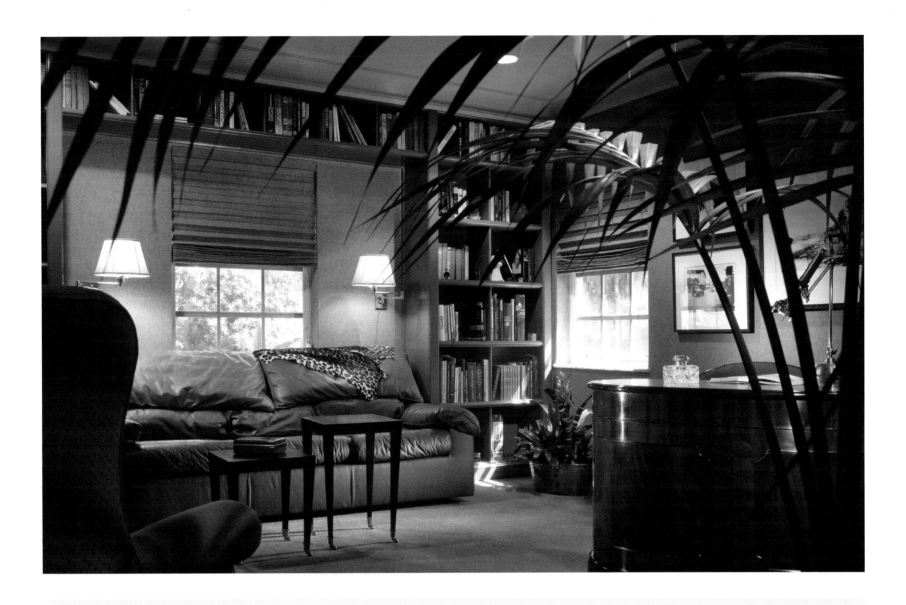

More about Anita…

NAME ONE THING PEOPLE DON'T KNOW ABOUT YOU.

Anita loves to play golf! She loves all aspects of the game—the need to be focused, the challenge, and the scenery.

WHAT COLOR BEST DESCRIBES YOU AND WHY?

Green is the color for Anita. She says it represents freshness, clarity and nature. She likes the hue so much she incorporates some aspect of it into all of her work.

WHAT IS THE BEST PART ABOUT BEING AN INTERIOR DESIGNER?

Reflecting on her industry, Anita says, "I can't imagine any other industry offering me the opportunity to work in the field of art and be surrounded by so many beautiful things."

WHAT STYLE OR PHILOSOPHY HAVE YOU STUCK WITH FOR YEARS THAT STILL WORKS FOR YOU TODAY?

Anita says that the need to simplify and make logical choices to create comfort, space and tranquility for her clients has worked throughout her career.

WHAT ONE PERSONAL INDULGENCE DO YOU SPEND THE MOST MONEY ON?

Anita loves to indulge on books and publications on her favorite topics—art, design, travel, food and fashion.

**Anita Margolis
Interior
Design Inc.**
Anita Margolis
1541 Brickell Avenue
Suite 2005
Miami, FL 33129
305-857-3500
FAX 305-858-3600
www.anitamargolis.com

osirys mendez
Mendez International & Assoc.

Miami's condominium real estate market is booming and interior designer Osirys Mendez is happily caught right in the middle—providing high-end interior design for clients who demand only the best, and then get it.

A Miami native, the Cuban-American designer has a bachelor's in business administration and has attended the Fort Lauderdale Institute Of Art. Celebrating her 10th anniversary in business this year, she primarily designs for ultra large and penthouse condominiums, but her residential installations include homes in such affluent communities as Key Biscayne and Miami Beach.

To Osirys, "condos are designer friendly, because they are very plain." But not for long—Osirys' exquisite modern decorating style incorporates specialty faux walls, precious stone countertops and flooring, and a soothing palatte of colors. A true romantic, Osirys is inspired by romantic design and often implements it into her fabulous decor, even modern designs are warmed up with romantic window treatments and sheer linens.

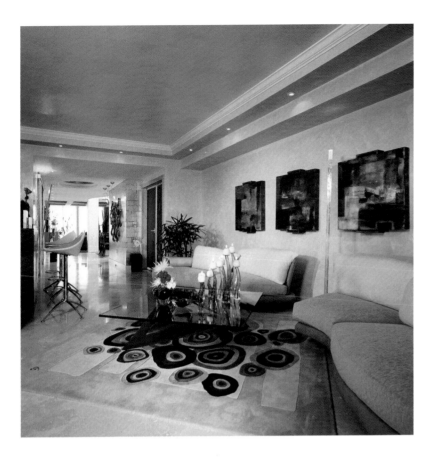

While some clients may be content with middle-of-the-road fixtures and finishes, her clients want cutting-edge, state-of-the art furniture and accessories. From inception to completion, Osirys works diligently to deliver beyond her clients' expectations.

A constant traveler, Osirys always mixes business and pleasure, searching for interesting accessories and hard-to-find items for her clients. For example, one client with a Modern Moroccan condo wanted a bar created with Lalique crystal pieces. Unfortunately, the pieces weren't available yet in the United States. While on vacation in St. Thomas and St. Bartz, the dedicated designer met with a Lalique crystal representative and bought the much-needed glass inserts for her client's bar. Then she went on with her vacation!

Osirys attributes her tremendous success to wonderful clients, a supportive family, and vendors with a can-do attitude, who accomplish her challenging requests. She prides herself on her creativity and flexibility in interchanging or completely redesigning rooms to fit any client's style and dreams and her clients appreciate her passion and dedication to carry out their wishes.

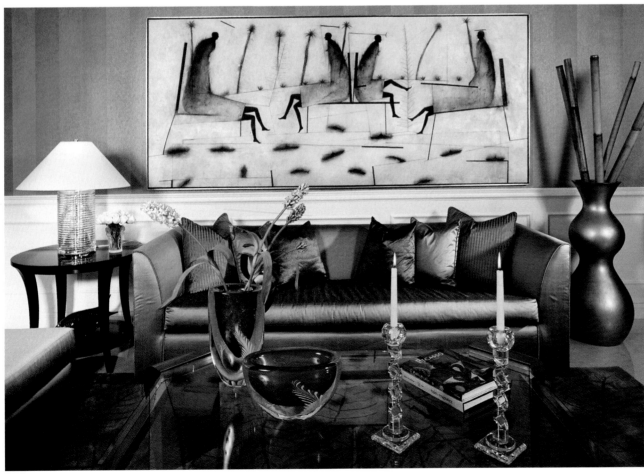

More about Osirys…

WHAT PERSONAL INDULGENCE DO YOU SPEND THE MOST MONEY ON?

Osirys loves to travel and spends money on shopping for rare items mostly art, jewelry and furniture.

WHAT COLOR BEST DESCRIBES YOU AND WHY?

Blue, because she admires the ocean and sky, which to her suggests openness.

WHAT IS THE HIGHEST COMPLIMENT YOU'VE RECIVED PROFESSIONALLY?

The highest compliment she receives is when she is told that her designs are not only aesthetically pleasing, but also liveable. "One tough customer, who I respect tremendously, said, 'I can definitely live here, it's better than I expected.'"

IF YOU COULD ELIMINATE ONE DESIGN/ARCHITECTURAL/BUILDING TECHNIQUE OR STYLE FROM THE WORLD, WHAT WOULD IT BE?

Osirys admits that it's a hard question. Since she can pretty much create around anything, she would prefer to eliminate any rules.

WHO HAS HAD THE BIGGEST INFLUENCE ON YOUR CAREER?

Vicente Wolf, a Cuban-born designer. Osirys relates to his culture and design and she respects his professional accomplishments.

WHAT IS THE MOST UNIQUE/ IMPRESSIVE/BEAUTIFUL HOME YOU'VE SEEN IN FLORIDA? WHY?

"There are many beautiful homes in Florida," said Osirys. "Too many to mention just one. Florida has very competent designers and we are blessed with views that serve as the perfect setting for any project."

WHY DO YOU LIKE DOING BUSINESS IN FLORIDA?

Osirys describes Florida as a very challenging market in constant evolution and reinvention. She says it's a melting pot of many cultures with endless opportunities and options.

WHAT BOOK ARE YOU READING RIGHT NOW?

The Historian by Elizabeth Kostova, which I highly recommend.

Mendez International & Assoc.
Osirys Mendez
15841 Pines Blvd.
Suite 254
Pembroke Pines, FL 33027
954-433-5974
Fax 954-704-1435

holmes newman

Holmes Newman & Partners, Inc.

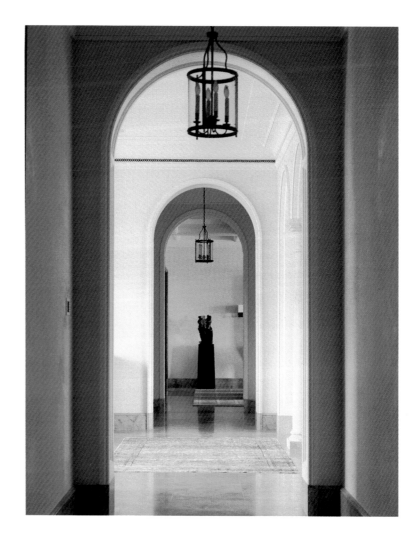

Holmes Newman has always been inspired by the architectural details that define the character and add visual interest to a room. In his travels, he often visits older hotels and when intrigued by a detail he will sketch it and bring it back to his office. This passion for architectural detailing and designing "from the inside out" has led to a succesful 40-year career designing high-end residences for clients nationwide.

Growing up in Manhattan, Holmes relocated to Miami, Florida, while still in high school and later attended and graduated from the University of Florida. He was inspired early in his career by the work of Mies van der Rohe and started his own firm 30 years ago. Today, he has 11 employees and an entire building that he had gutted and designed to meet the creative needs of his team.

He is well-known for his clean, classic and contemporary styles and integrates a subdued

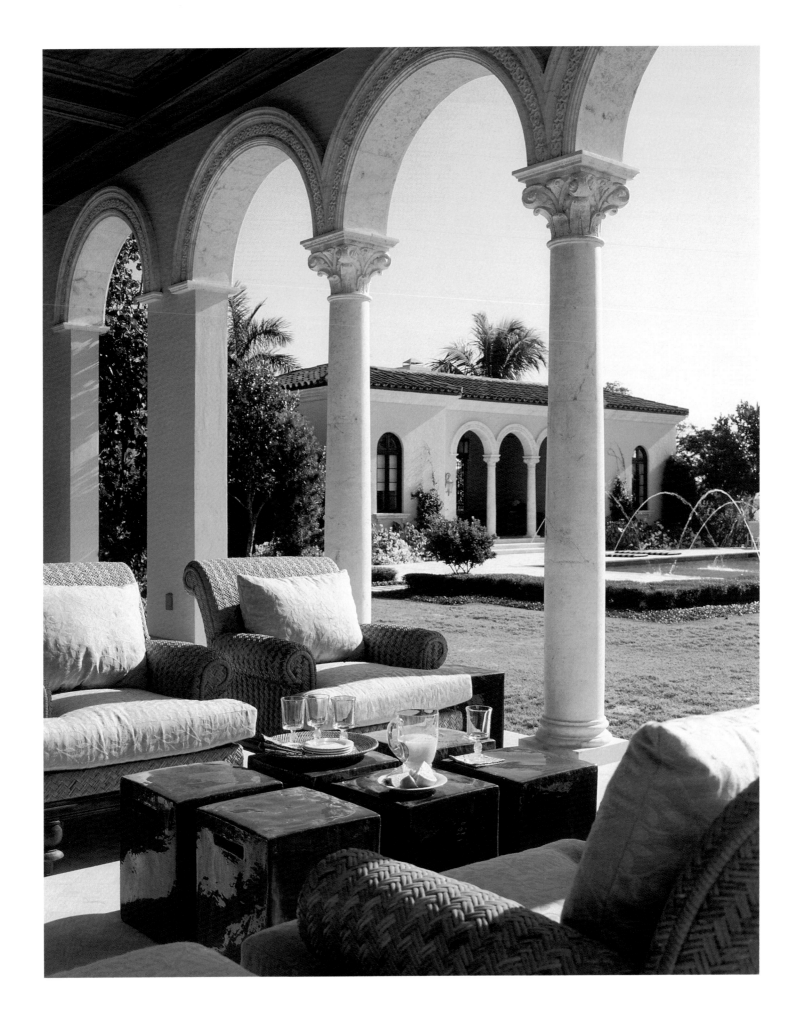

palette of beiges, greys, greens and blues. Holmes avoids trendy or
gimmicky design solutions but will collaborate with clients who have
a valid request. One residence was designed around a glass staircase,
several around art collections.

"The greatest challenge of a designer is to find the essence of a style—
whether it's Chippendale or neo-classical,—and reinterpret it into
something appropriate for today," said Holmes.

Holmes partners with architects and builders to bring his client's
vision to life from the ground up. By meeting a client in their current
home, Holmes examines the couple's surroundings and undertands

the dynamics of their relationship, and believes that having a chemistry with the client and having them enjoy the design process is just as important as the end result.

"It's a huge compliment for a client to say, 'I look at the world differently now; I really feel I've grown in the process,'" said Holmes.

In addition to his design work, and to address the concerns about interior design school licensing, Holmes was very active with The Foundation for Interior Design Education Research (FIDER), an international not-for-profit organization that accredits interior design at institutions of higher learning in the United States and Canada. He has served on the accreditation committee and the board of trustees.

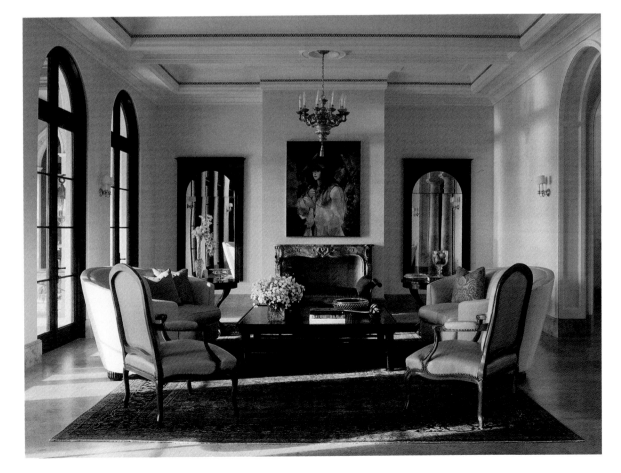

ABOVE LEFT
Four matching side-boards and mirrors flank the walls of this elegant dining room. The walls are covered with padded custom-woven silk panels.

BELOW LEFT
An antique mantel and silver-plated Caldwell chandelier are strong elements in establishing the character of the living room.

FACING PAGE
The book-matched red onyx floor of the master bathroom is juxtaposed with painted raised panel millwork which tempers the boldness of the onyx.

More about Holmes…

WHAT IS THE MOST ESSENTIAL DESIGN ELEMENT IN A HOME?

Lighting is absolutely paramount. Holmes always strives to create the right visual cues by integrating the proper use of light sources, natural light and decorative fixtures. The careful attention to every detail guarantees that each architectural space becomes a very personal and unique environment.

WHAT ONE ELEMENT OF STYLE OR PHILOSOPHY HAVE YOU STUCK WITH FOR YEARS THAT STILL WORKS FOR YOU TODAY?

Open space is a luxury. Don't crowd a room with furniture.

WHY IS YOUR FIRM SUCCESSFUL?

The firm attributes its success to their "team" approach to design. Each member of our experienced staff, under the leadership of the principal, works to maximize the potential of a project. Their objective is to create exciting, quality living spaces that meet the individual needs of their clients. They strive to make each project a unique design statement.

Holmes Newman & Partners, Inc.
Holmes Newman
4039 NE 1st Avenue
Miami, FL 33137
305-576-4372
FAX 305-576-4373

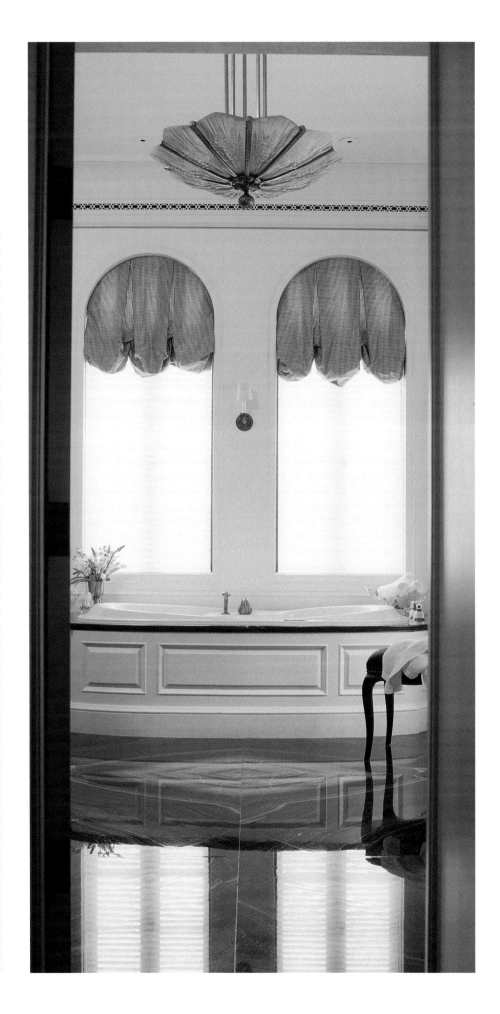

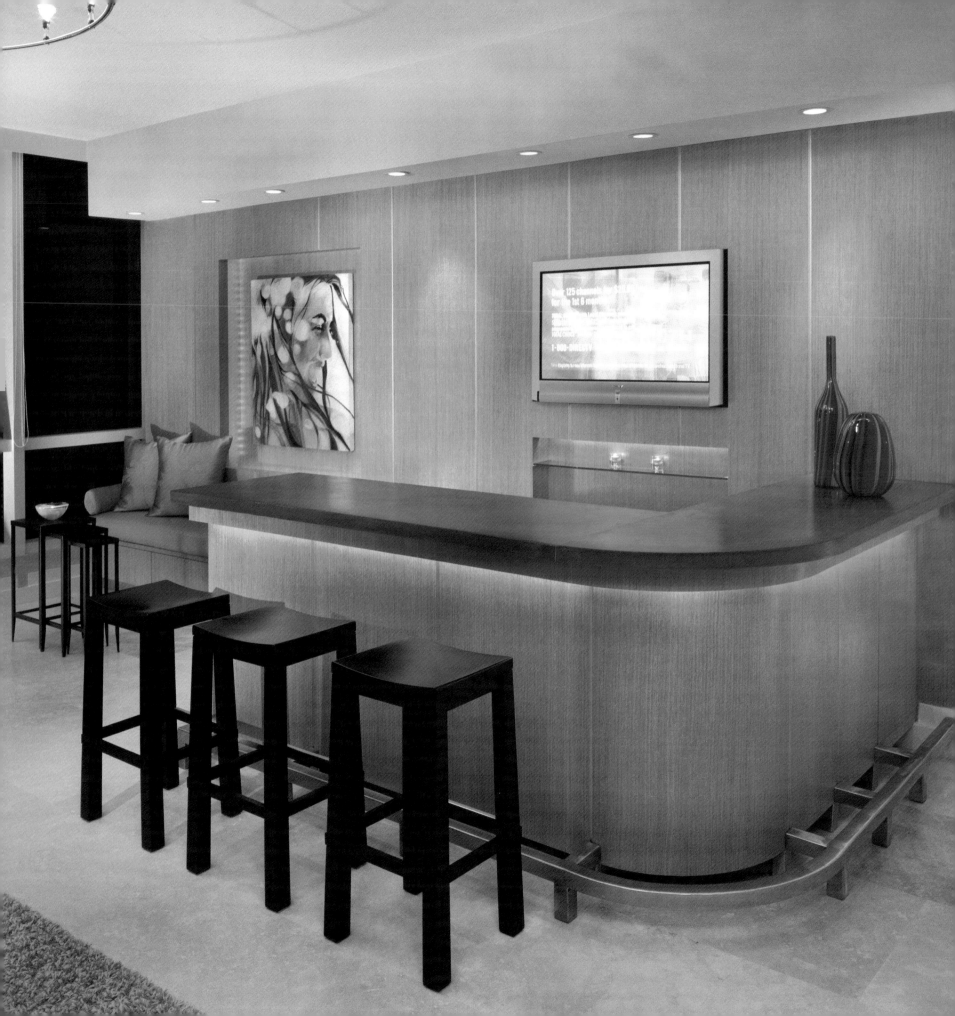

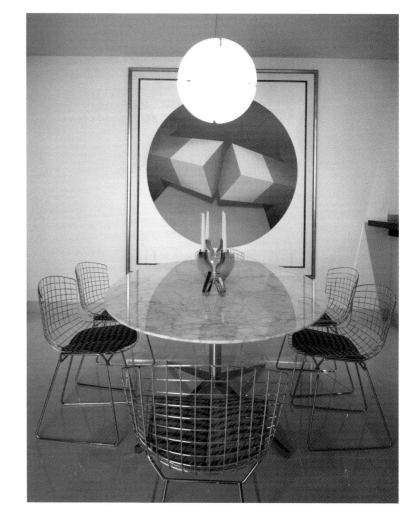

christopher raessler
South Beach Design Group

When it comes to fine interiors, Christopher Raessler has many design philosophies. "Interiors should be sensitive to the environment and the architecture they are in. With passion for great textures and intense hues, we design for the senses. Small spaces can be grand and opulent; submerge your clients in fabric and color."

These philosophies are evident in the unique and exclusive interior "environments," not just rooms, that he creates for his clients. From the traditional to the contemporary and everything in between, he designs a high-quality package that is a pure expression of the client's style and personality.

A Florida native, Christopher graduated from the Miami International University of Art and Design and the University of Miami School of Business before beginning his award-winning interior design career. He was influenced by the minimalist approach of Eileen Grey and designer Jean Michael Frank, sculptor Noguchi and Venetian architect Carlos Scarpa.

181

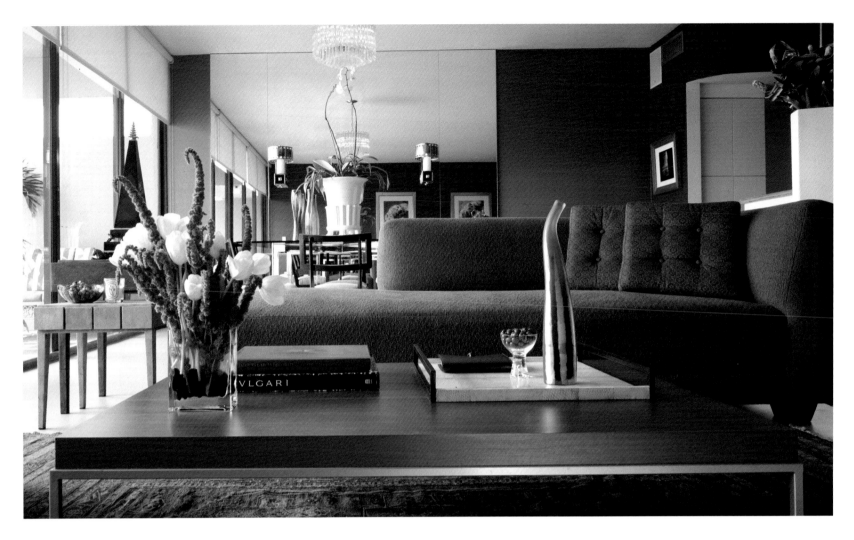

In 1993, he opened South Beach Design Group and now has a team of 18 with an upscale clientele that stretches from the United States to Hong Kong, Europe and Latin America. To complement their designs, his firm has a sophisticated 3,200-square-foot retail showroom containing a varied and eclectic range of furniture, lighting and accessories.

The South Beach team designs private residences, yacht interiors and commercial spaces but specializes in custom design work for high-end condos. "Smaller spaces raise design challenges," said Christopher. "Many clients buy high-end 'decorator-ready' condos that come with no light fixtures, flooring, baseboards or molding, lending themselves to adding great architectural details and lighting."

The South Beach Design Group is not about a "signature" look. Instead, the team works at making the client's dreams come true with a hands-on approach and assisting them in selecting the accessories and fine details to help create an individual expression of style.

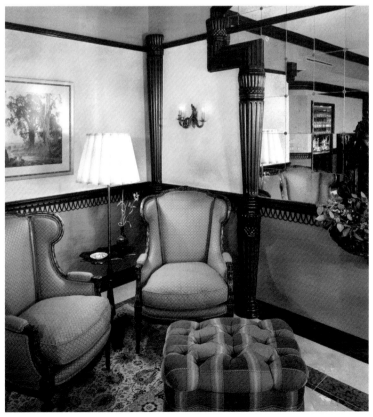

Well-known for his high emphasis on interior architecture and lighting, Christopher and the South Beach Design Group has been featured in *Elle Decor, Architectural Digest, Florida International Magazine, Robb Report, Ocean Drive, House & Garden, Florida Design* and more. They also have been the recipient of multiple design awards, including several awards from the Florida Chapter of The International Design Association (IIDA), and the Design Center of the Americas (DCOTA). This year Christopher was also inducted into the Designer Hall of Fame.

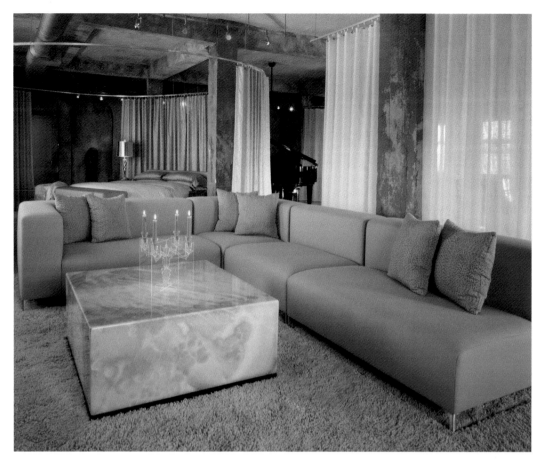

LEFT ABOVE
Reflected on the mirrored wall and console, the city's skyline becomes a backdrop for the eclectic mix of furnishings. This living room is a brilliant mixture of eras, colors and textures.

LEFT BELOW
This traditional sitting area is only a small corner of this 7000 square foot penthouse that began as a raw shell. Applied moldings, hand-painted finishes and custom carved columns were created throughout the space to establish an old-world style with an Asian flair.

RIGHT ABOVE
This raw loft space is perfect for entertaining. The media area is softened by the Italian clean-lined sofa in a Kvadrat wool fabric, the custom shag area rug and the custom lit onyx cocktail table.

RIGHT BELOW
An unforgettable guest bedroom was created for this Palm Springs home that was designed in the retro style that made this desert famous. Original classic furniture pieces along with the Brueton radiator bed and fabrics by Maharam and Jack Larsen were used to create this statement.

South Beach Design Group
Christopher Raessler
Interior Design Lic # 0001068
701 Lincoln Road
Miami Beach, FL 33139
305-672-8800
www.southbeachdesigngroup.com

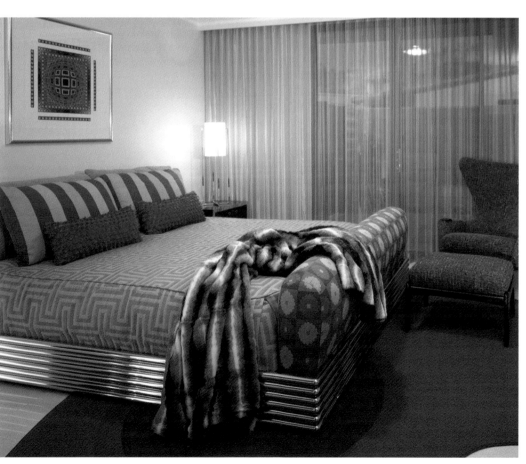

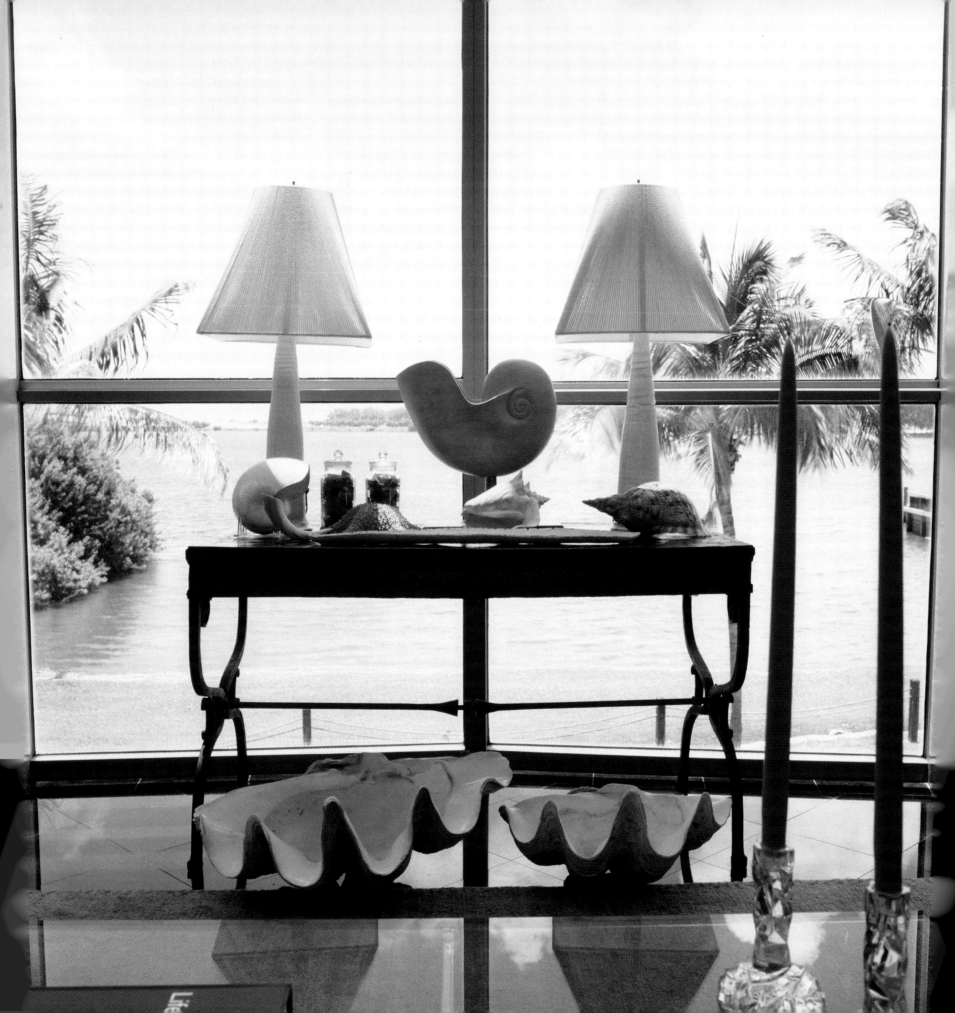

alison spear

Alison Spear Architect and Interior Design

The most important part of a room isn't the decorating, but it's about having a plan—a fabulous plan," said Alison Spear. "Whether it's about color, light, movement, or minimalism, it has to be one idea threaded throughout the design."

Alison is the principal of her own firm in Miami and Manhattan, and this concept-driven design approach has garnered her a stellar reputation for delivering superb residential designs for a who's who list of clientele that spans from New York to California.

She holds a bachelor of architecture degree from Cornell University and a master of science in architecture and urban design from Columbia University. She is a licensed architect in New York, New Jersey, Connecticut and Florida, and is a member of the American Institute of Architects (AIA), the New York Architectural League, the National Council of Registration Boards and the Miami Design Preservation League.

Alison's career began at Skidmore, Owings and Merrill and the New York City office of

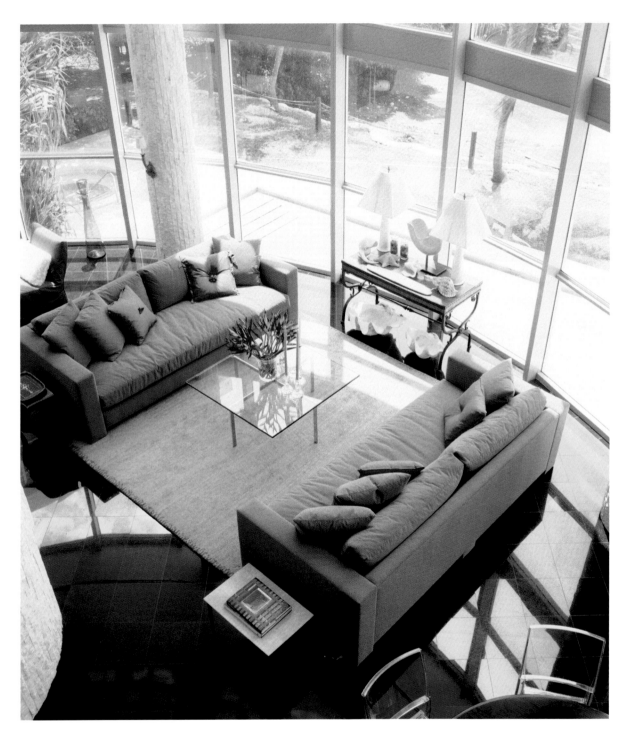

Arquitectonica. In 1989, she burst on the scene as a solo designer with her first project for *Bright Lights, Big City* author Jay McInerney, followed by projects for film director Francis Ford Coppola and Katie Ford, owner of Ford Models. In 1999, Alison designed the award-winning 20,000-square-foot Holly Hunt showroom in Miami's Design District and in 2002, Andre Balazs of New York City's famous Mercer Hotel chose Alison to revamp his Miami Beach 107-room Lido Hotel Spa.

When you talk to Alison, you can instantly hear the passion in her voice for interior decorating and architecture and it is this passion that motivates her to produce interiors that are both functional and attractive and meet the client's dreams and expectations. Her extensive worldwide travels to the Caribbean, South America, Central America, Mexico, England, France, Italy, Spain, Greece, India, China, Japan and Thailand have given her a cosmopolitan outlook, which continuously influences her designs.

LEFT
Spear designed the living room's sofas and upholstered them in Lowland fabric by Great Plains from Holly Hunt; the Barcelona cocktail table is Mies van der Rohe from Knoll, and the rug is by Odegard.

RIGHT
The master bedroom's Manuel Canovas-upholstered headboard and mirrored bedside tables are all Spear designs; the sconces are vintage Jules Leleu.

Far from a traditionalist, Alison's eclectic, creative designs often push the envelope, giving the client a spectacular final product with a twist of the extraordinary. For example, one recent project for a writer who required a flexible, portable space included removable and reusable furniture and shelving. "This was the concept throughout the whole space; it's not about personality," she explains.

Alison is proud of her involvement in the academic world and she is currently teaching at the University of Miami School of Architecture. The award-winning designer has received two American Institute of Architects Awards of Excellence and was selected as Interior Design Firm of the year. In 2004, *House Beautiful* magazine selected her as one of the top 125 Interior Designers of the year. Her designs have been profiled

in numerous publications including *Architectural Digest, Elle Decor, House Beautiful, House & Garden, Interior Design, The Miami Herald, Vogue* and more.

Alison revels in the true beauty of a home, "everything that one has in their home and around them should be beautiful," said Alison. "I don't like average, run-of-the-mill things." As a result, she is committed to giving her clients the best—and most beautiful—designs possible.

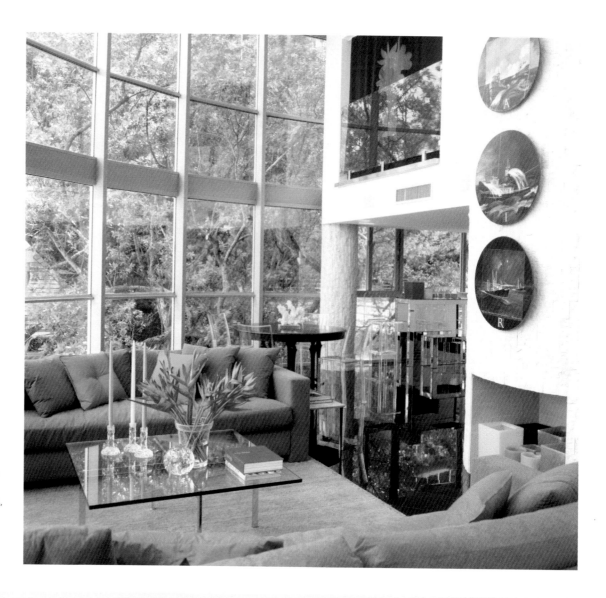

More about Alison…

WHAT IS ONE THING MOST PEOPLE DON'T KNOW ABOUT YOU?

Not only is Alison a terrific designer, but she was a volunteer fireperson when she lived in Ithaca, New York.

WHAT PERSONAL INDULGENCE DO YOU SPEND THE MOST MONEY ON?

Obviously from her training as a volunteer fireperson, Alison is fit and enjoys spending money on sports and sports training.

WHAT IS THE BEST PART ABOUT BEING AN INTERIOR DESIGNER?

Alison loves working with clients who are fun and open-minded.

WHAT COLOR BEST DESCRIBES YOU AND WHY?

Alison loves the Atlantic Ocean and calls it her favorite place to be, so what's the color that best describes her? Ocean blue/green, of course!

WHAT ONE ELEMENT OF STYLE OR PHILOSOPHY HAVE YOU STUCK WITH FOR YEARS THAT STILL WORKS FOR YOU TODAY?

Alison says that simplicity, contexturalism and personal style are long-standing elements that have worked throughout her career.

Alison Spear Architect and Interior Design
Alison Spear, AIA
3815 NE Miami Ct.
Miami, FL 33137
305-438-1200
FAX 305-438-1221
www.alisonspearaia.com

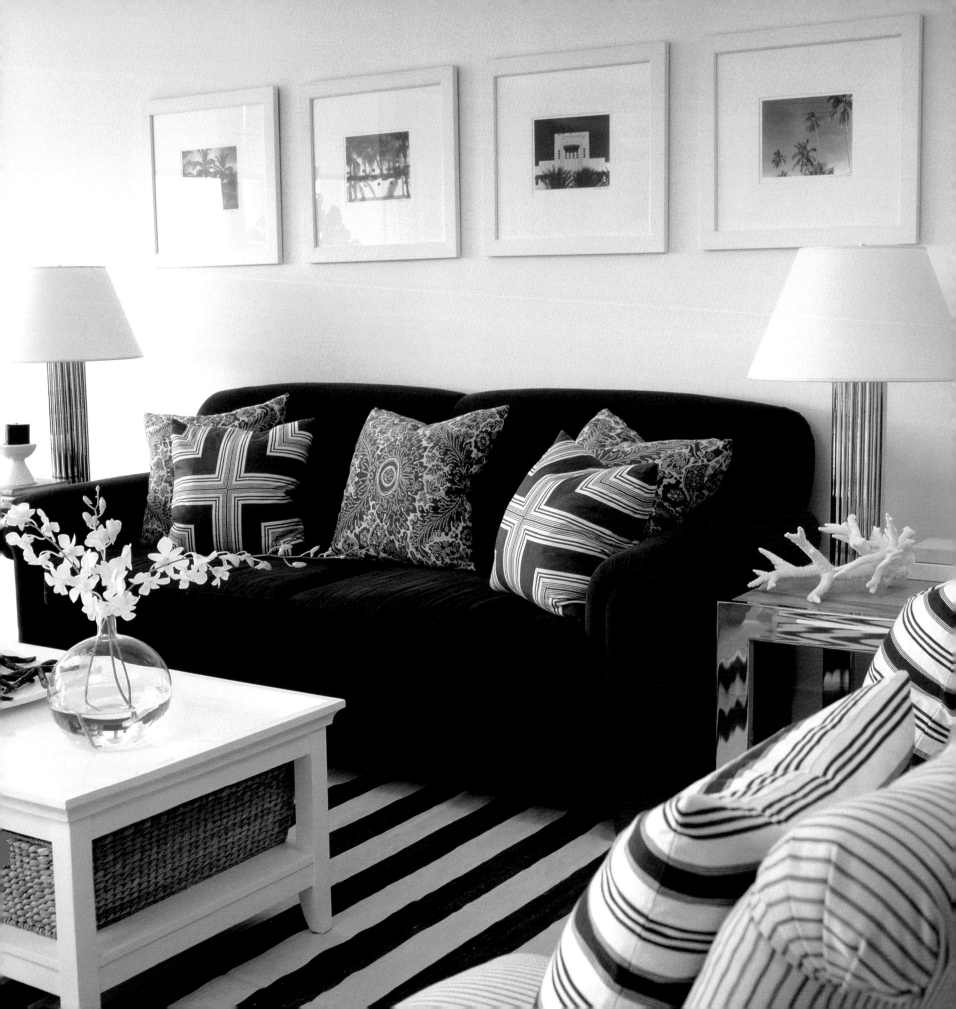

deborah wecselman
Deborah Wecselman Design

If interior designer Deborah Wecselman could impart one pearl of wisdom to first-time homeowners, it would be, "Don't just buy a shell of a home; invest some of your budget on decorating the inside because this is where you will spend most of your time."

Her cognition comes from 18 years of experience as an interior designer. In 1987, Deborah graduated from the Parsons School of Design in New York with a bachelor of fine arts and worked for world-famous fashion designer Ralph Lauren as a senior director of store design and special projects, responsible for marketing and space planning. Although she found the job quite satisfying, she and her husband relocated from New York to Florida and she saw this move as an opportunity to branch out and achieve her own design dreams. In 2000, she founded Deborah Wecselman Design, which now includes a staff of talented professionals, including an architect, a senior and junior associate, and a coordinator, who work hard to maintain the quality and excellent service of the firm.

Deborah's career was influenced by a trio of favorite and well-known architectural designers—David Hicks, David Adler and Paul Williams. "History has had the biggest influence on my designs," explains Deborah. "Everything has to have a source or a beginning and it is important to have an appropriate historical reference in design."

Her own extensive portfolio is absolutely captivating as her spaces stylishly marry architecture and interior design. She combines modern and classical architectural elements with confident strokes of bold colors and whimsical accessories. She also has a flare for the eclectic—whether it is the use of a distinctive lighting fixture or furniture style—and will often combine periods by commingling a vintage element into a modern, contemporary space.

Her favorite colors are brown and white with orange, and her favorite design style is the European look of the '40s and '50s. She is also enamored with the old 1940s Hollywood glamour.

RIGHT
Soft, relaxed and modern, this is an environment where one can entertain and enjoy the views of the city and ocean beyond.

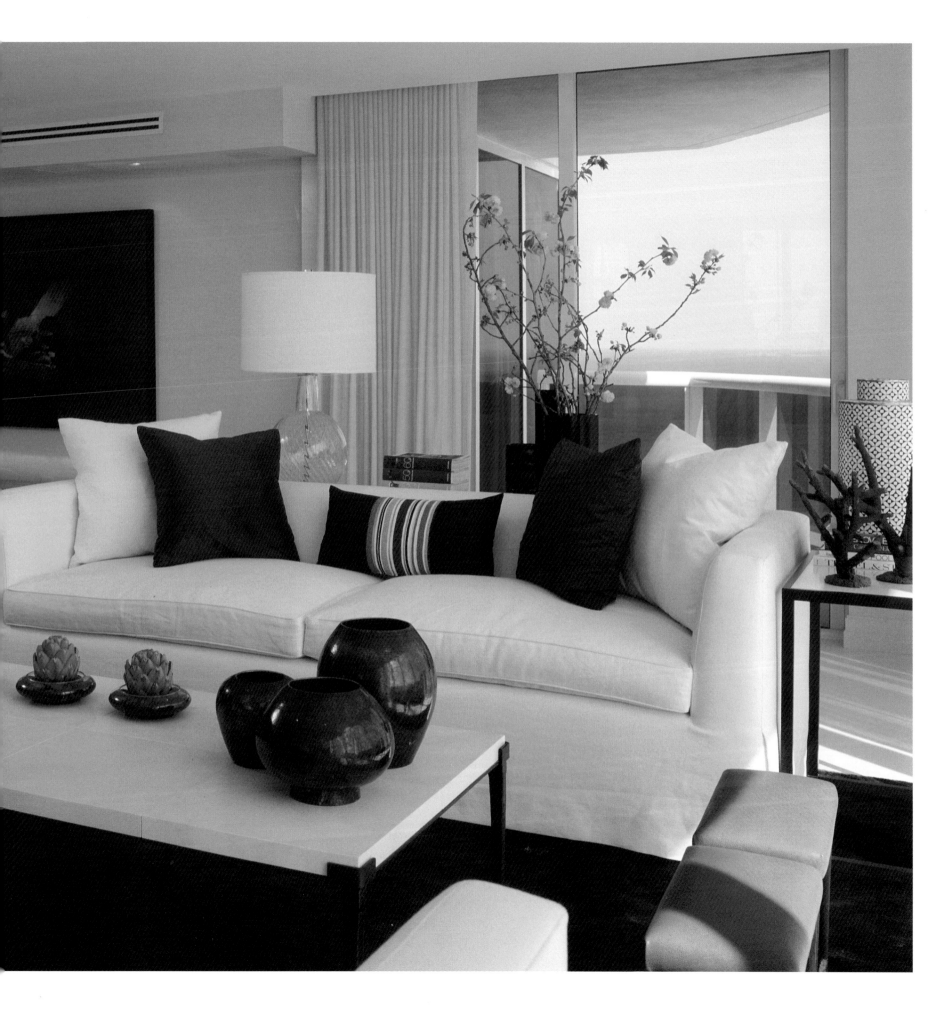

Deborah prefers to start the design process at the construction phase where she can thread the homeowner's wants and needs into the style of the home. She thrives on this creative process and the collaborative nature of working with her clients, who run the gamut from young and hip to older and sophisticated, first- and second-time homebuyers and condominium owners.

Deborah firmly believes that the home needs to be a reflection of its occupant, their lifestyle and their personality, and Deborah works hands-on with her clients to realize their vision and achieve their dreams. She is truly a talented artist, devoted to her clients and aiming for the best in expectation and execution and from concept to installation.

Deborah Wecselman's work has been profiled in several publications including *Florida Design*, *Miami Herald Home & Design*, and *Casa & Estilo*.

BELOW LEFT
This hip "media" room is a relaxed haven within a home that also doubles as an office.

BELOW RIGHT
Walnut cabinetry, Calcutta Gold marble cabinet tops and backsplash (custom by DWD) add luxury to this kitchen, while stainless steel decorative hanging light and zebra upholstered stools add a modern edge.

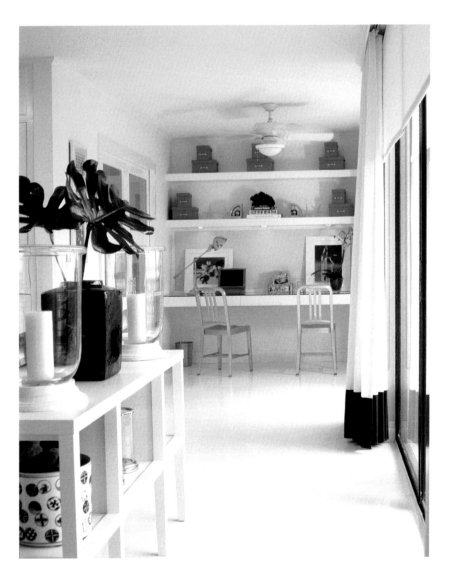

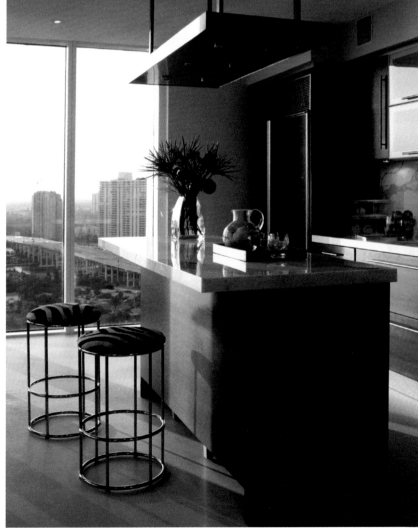

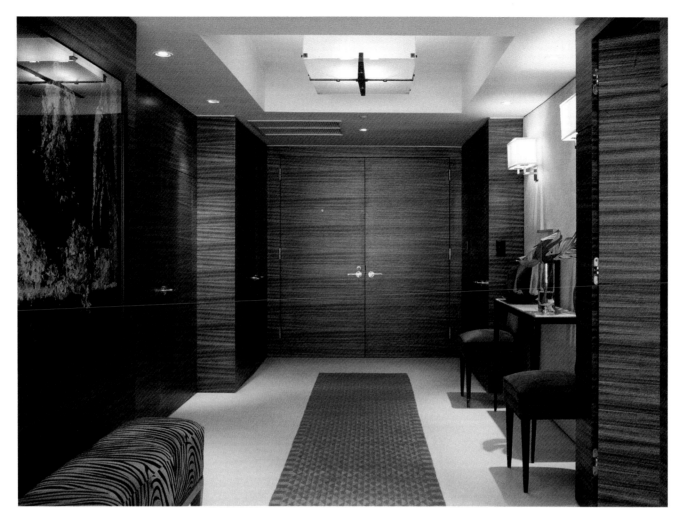

More about Deborah…

WHAT IS ONE THING THAT PEOPLE MAY NOT KNOW ABOUT DEBORAH?

Deborah says that most people are surprised to find out that she is of Latin (Peruvian) descent.

WHY DO YOU LIKE DOING BUSINESS IN FLORIDA?

Deborah enjoys doing business in Florida because she said that it has great potential and possibility.

IF DEBORAH COULD ELIMINATE ONE DESIGN OR ARCHITECTURAL BUILDING TECHNIQUE OR STYLE FROM THE WORLD, WHAT WOULD IT BE?

Deborah would prefer to eliminate the terms "fake Mediterranean," "MacMansions" and "faux painting."

Deborah Wecselman Design
Deborah Wecselman
1340 Biscaya Drive
Surfside, FL 33154
305-867-9296
FAX 305-867-7955
www.deborahwecselmandesign.com

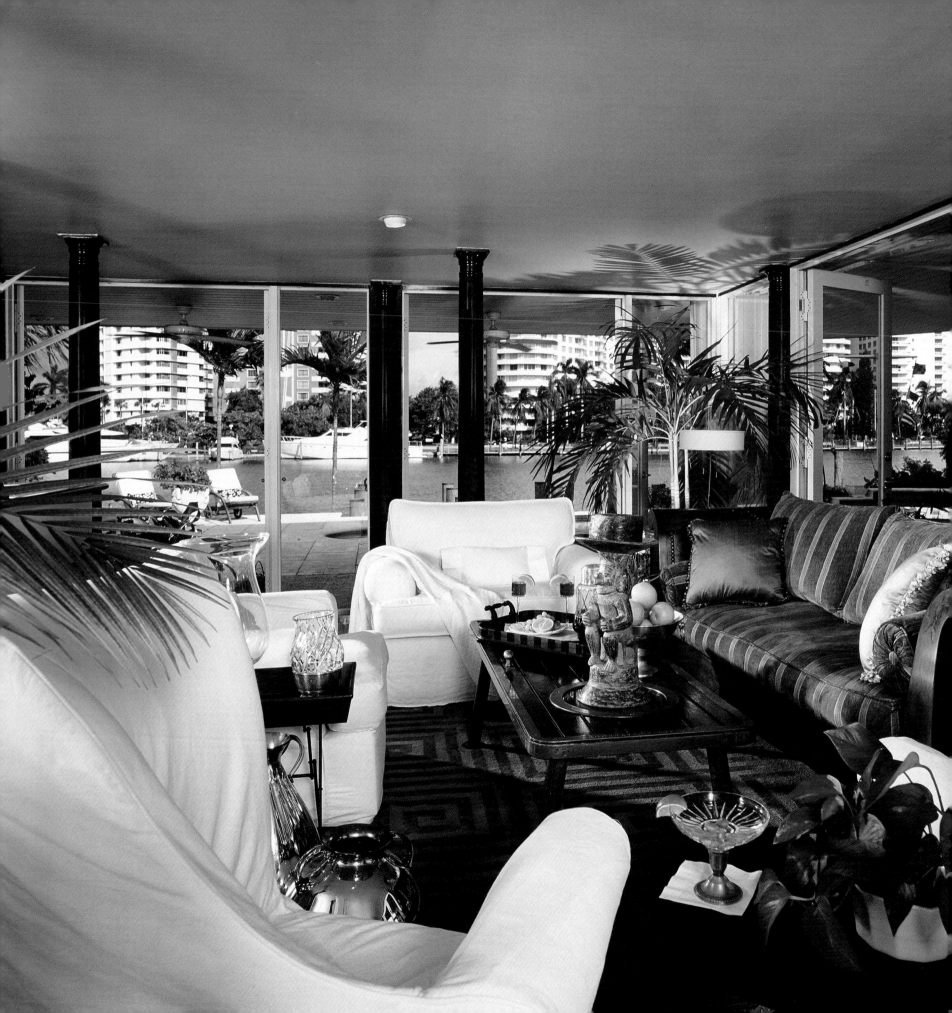

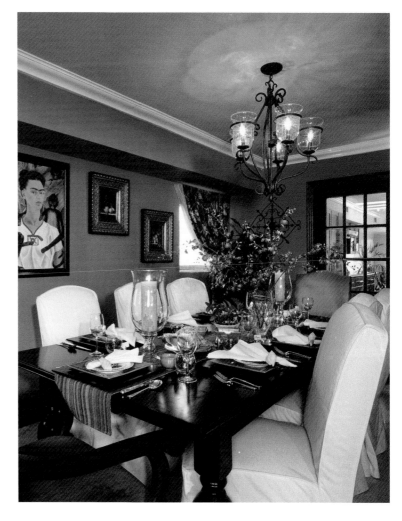

natasha younts
Gables Interiors

LEFT
Coffee table is an antique yacht door. All walls view intracoastal water.

ABOVE
Custom carved dining table is the center of attention in this intimate dining room.

The biggest influence in Natasha Darlene Lima Younts' award-winning career was not a top-notch interior designer, although she has worked with the best. Instead, she credits her mother, Vivian Gariepy, for planting the seeds that have led to her extremely successful design career.

Growing up in Rhode Island, Natasha was the oldest of five children to a French mother and a Portuguese father who firmly believed in old-world values, including aiding those in need. Her mom would often decorate neighbors' homes free of charge simply so they would have a nicer place to live.

"I grew up believing that everyone lived in a beautiful home and anything could be done," she remembers. As a young girl, she watched her mother conduct a personal labor of love—a beautiful restoration of their 19th century home. Walls were knocked out to create an open, airy environment, brick framework exposed the home's history, and trees were cultivated to grow indoors.

Her mother's design skills and ability to make dreams come true inspired Natasha to envision herself making the world more beautiful one day. In college, she majored in both fashion design and interior design, and had the

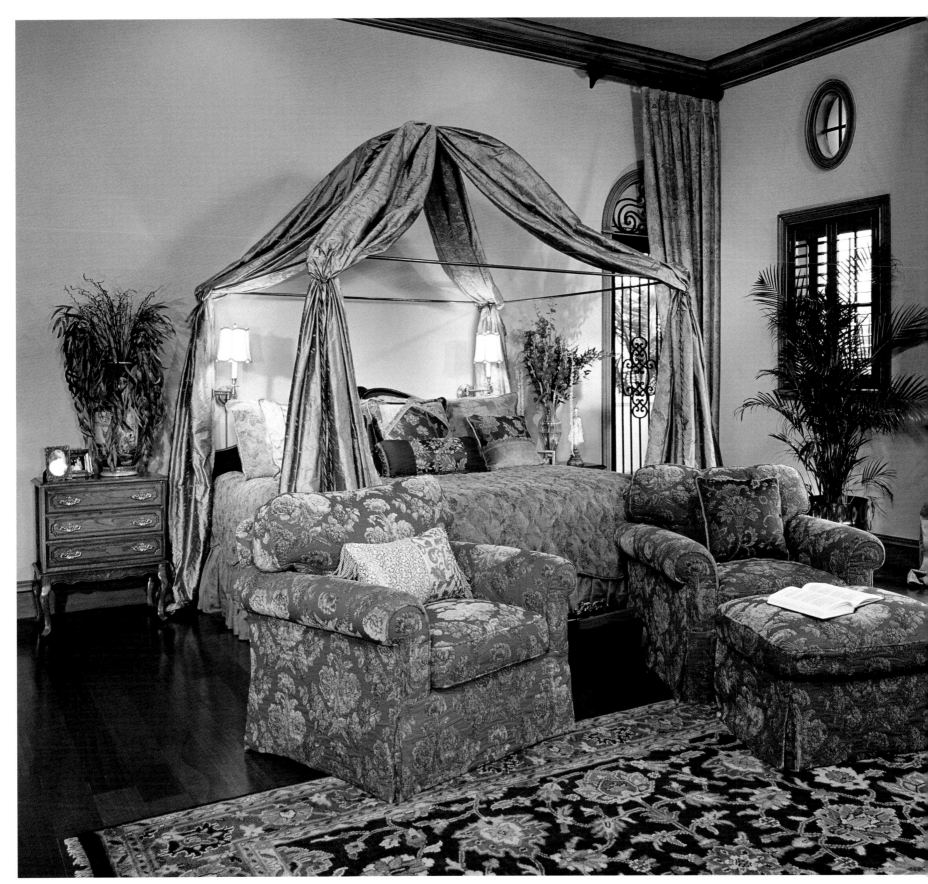

tremendous opportunity to work with Coty Award Winner Willi Smith, a prestigious fashion designer. After graduation, she relocated to California, started her own couture clothing company (Tasha Lima Designs), designed for the stars and coordinated parties for the Beverly Hills socialites.

Deciding it was time for a career change, she applied her extensive knowledge of fabrics and textiles and her passion for patterns to her second major, interior design—a smooth, natural transition. She moved to Florida and opened Gables Interiors, in a charming coral

rock house built in 1924, and was "ready to spoil our customers." The Gables Interiors team consists of 15 designers with culturally diverse backgrounds and experiences, enabling them to approach projects with a uniquely creative vision that their clients love. Her staff's cultural mix and her love and passion for South Florida—the cultural melting pot of the world—truly inspire Natasha.

Her designs can be traditional and contemporary or exotic and unusual, such as Hindu prayer rooms, African great rooms, charming Georgian parlors and a "palace" style home

LEFT
Custom woven fabrics from Italy adorn this ocean view bedroom.

BELOW
Hand-carved Tibetan window panels; eggplant rug is Tibetan antique.

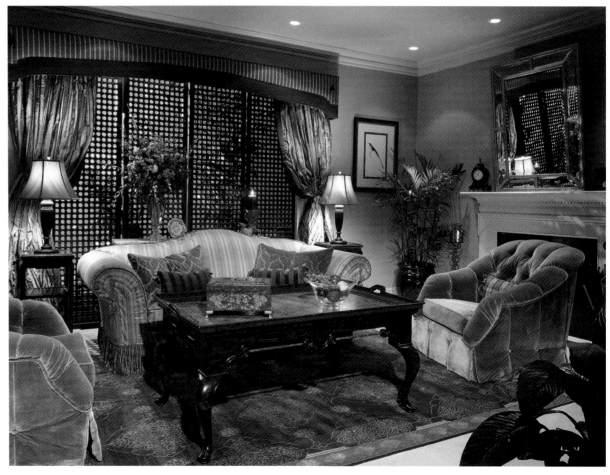

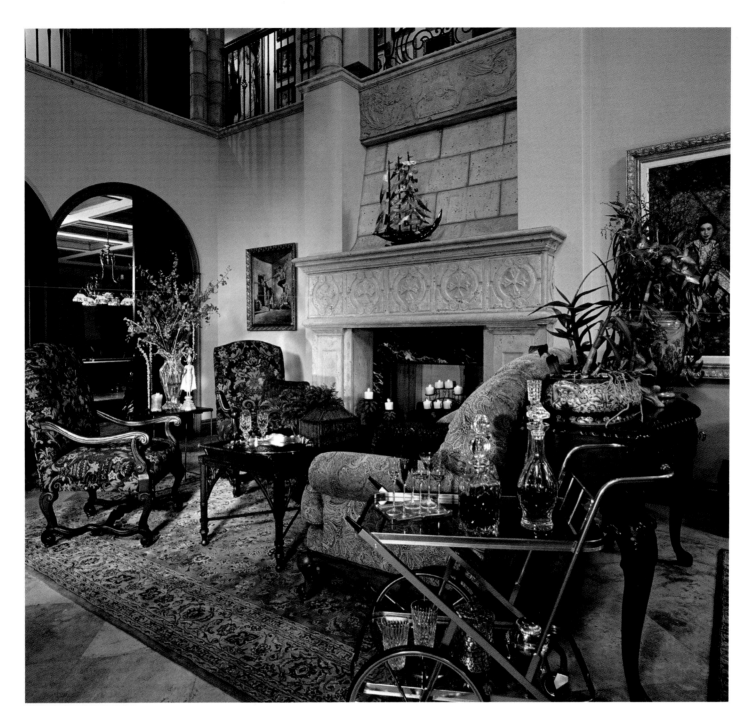

with hand-dipped goldleaf furniture. Today, Natasha is inspired by "helping my clients to express their personal style," and explains that "be it themes, history or color, your environment will create the desired mood."

Over the past 15 years, Gables Interiors has given its clients "the luxury they deserve," and their awe-inspiring designs have won numerous awards for residential, set and commercial design in New England, Atlanta, Beverly Hills and Miami. Gables has been featured in many publications, including *Florida Architecture*, *Benjamin Moore Ensembles*, *Florida Design*,

The Miami Herald, *Veranda* and *Best Coastal Homes* and was one of only 30 firms chosen nationally to be in the *United States Millennium Design Publication*.

Natasha has also been selected as South Florida's "Designer for the Stars" for seven straight years. She has even been honored on ABC television's *The View* with Barbara Walters as having designed "one of the most desired homes in the country." In addition to receiving national recognition for her work, Natasha founded the DSA, the Designer/Decorator Society of America.

More about Natasha…

WHAT IS THE BEST PART ABOUT BEING AN INTERIOR DESIGNER?

Making people happy to come home.

WHAT IS THE MOST UNUSUAL/ EXPENSIVE/DIFFICULT DESIGN OR TECHNIQUE YOU'VE USED IN ONE OF YOUR PROJECTS?

One wealthy client wanted gold leaf furniture; they aspired to have their home look like a palace—the Taj Mahal to be exact. Natasha gold-dipped dining room chairs and hand-applied gold leaf. The metals in the chandelier were also gold dipped.

WHAT ARE NATASHA'S FAVORITE BOOKS?

Anything written by the Bronte sisters and *Chanel* by Janet Wall.

Gables Interiors
Natasha Younts
5255 Collins Avenue, Suite 10E
Miami Beach, FL 33140
305-865-8150
www.gablesinteriors.com

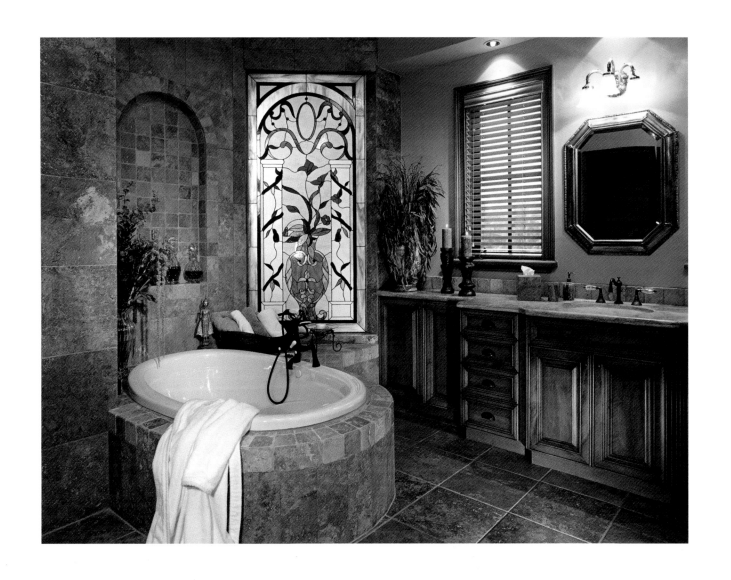

The Publishing Team

Panache Partners LLC is in the business of creating spectacular publications for discerning readers. The company's hard cover division specializes in the development and production of upscale coffee table books showcasing world class travel, interior design, custom home building and architecture, as well as a variety of other topics of interest. Supported by a strong senior management team, professional associate publishers, and a top notch creative team of photographers, writers, and graphic designers, the company produces only the very best quality of these keepsake publications. Look for our complete portfolio of books at www.panache.com.

We are proud to introduce to you some of the Panache Partners team below that made this publication possible.

Brian Carabet

Brian is the co-founder and owner of Panache Partners. With more than 25 years of experience in the publishing industry, he has produced and created more than 100 magazines and books. His passion in publishing is designing beautiful high-end products. "A Spectacular Home is one that is built for entertaining friends and family - without either it's just a house...a boat in the backyard helps too!"

John Shand

John is co-founder and owner of Panache Partners and applies his 25 years of sales and marketing experience in guiding the business development activities for the company. His passion towrd the publishing business stems from the satisfaction derived from bringing ideas to reality.. "My idea of a spectacular home includes an abundance of light, vibrant colors, state-of-the-art technology and beautiful views." .

Beth Benton

Beth is the associate publisher in South Florida for Panache Partners. .A native South Floridian, she has spent over ten years in the publishing industry and has a special affinity for interior design and architecture. "My idea of a spectacular home is one that provides me the comfort I desire and surrounds me with the art, music, literature and people I love."

Phil Reavis

Phil is Group Publisher of the southeast region for Panache Partners. He has a decade of experience in television and publishing. A native to the South, he chooses to live where his heart is. "What makes a home spectacular is my wife and two children. They inspire me every day."

Troy Campbell

Troy, the staff photographer, has been photographing architecture and interiors since 1994. His work has appeared in publications such as *Architectural Digest* and *Interior Design*. He believes a successful photograph is one that marries technical expertise with an artistic aesthetic. "A spectacular home is one that combines art with living."

Joseph Stern

Joseph, a resident of Boca Raton, is the staff photographer. He has over 25 years experience as an interior and architectural photographer. His work has appeared in many national and regional publications, including AD. "My idea of a spectacular home can be seen in my images of The Gables. The design and ocean view give the impression it is antique, even though it is a new home."

Additional Acknowledgements
Production Director - Donnie Jones, The Press Group
Project Management - Carol Kendall
Traffic Coordination - Elizabeth Gionta and Chris Nims
Design - Alisa Miller, Kathryn Karpf, Anne Rohr

Photography Credits

Index of Designers